6/03

WITHDRAWN

D0861881

Rosa Giorgi

Saints in Art

Edited by Stefano Zuffi
Translated by Thomas Michael Hartmann

The J. Paul Getty Museum
Los Angeles

Italian edition ©2002 Elemond S.p.A., Milan
Original graphic design: Dario Tagliabue
Original editorial coordination: Simona Oreglia
Original production coordination and layout: Anna Piccarreta
Original editing: Eileen Romano
Image research: Elisa Dal Canto and Daniela Tarabra

First published in the United States of America in 2003 by
Getty Publications
1200 Getty Center Drive, Suite 500
Los Angeles, California 90049-1682
www.getty.edu

Christopher Hudson, *Publisher*
Mark Greenberg, *Editor in Chief*
Ann Lucke, *Managing Editor*

Thomas Michael Hartmann, *Translator and Editor*
Hespenheide Design, *Designer and Typesetter*
Printed in Italy

Library of Congress Cataloging-in-Publication Data

Giorgi, Rosa.
 [Santi. English]
 Saints in art / Rosa Giorgi; edited by Stefano Zuffi; translated by
Thomas Michael Hartmann.
 p. cm.
Includes index.
 ISBN 0-89236-717-2 (pbk.)
 1. Christian saints in art—Dictionaries. 2. Christian art and
symbolism—Dictionaries. I. Zuffi, Stefano, 1961– II. Title.
 ND1430 .G5513 2003
 704.9'4863'03—dc21
 2002153393

On the facing page:
Caravaggio, *Saint Catherine of
Alexandria*, ca. 1599. Madrid,
Thyssen-Bornemisza Museum.

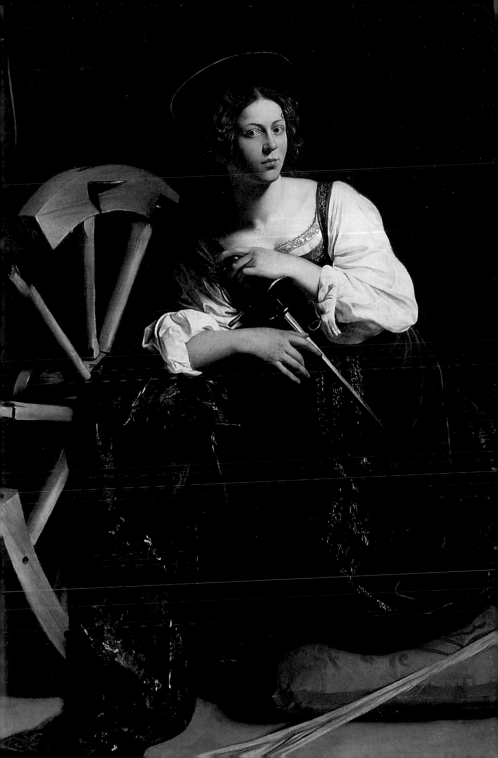

Contents

Introduction

The Vierzehnheiligen Sanctuary (of the Fourteen Holy Helpers) is one of the most original and sweeping architectural masterpieces of the late Baroque period. Balthazar Neumann built it in Bavaria, Germany, not far from Bamberg. The entire complex revolves around the multicolored statues of fourteen saints that circle the church's magnificent altar.

These saints are the special protectors of a variety of human activities; they cure sicknesses and keep negative outcomes at bay. Each saint is vividly characterized by elements to help identify him or her, such as costumes, objects, positions, or animals. These were reassuring to the believer, who was able to address a given patron without mistake or hesitation.

The sanctuary dates to 1743. The festive celebration of these fourteen figures occurred at the threshold of the Enlightenment, with the great political, industrial,

and even cultural and "visual" revolutions that it entailed. The "identifying code" of the saints, which was common from popular works to the most sophisticated masterpieces, had been defined by devotion and art during the course of a millennium. It remained substantially unchanged from the Middle Ages on, overcoming difficulties created by the iconoclasm of the Reformation and others brought on by the Counter Reformation. It was a common language for all of Europe, without social or intellectual distinctions.

Toward the middle of the eighteenth century, however, the concept of Biblia pauperum—stories and characters of Scripture and worship told through images, which most of Western art is based on—was on a collision course with other forms of visual communication. The accelerated pace of creation and new uses for images completely reversed the situation. Gregory

the Great could write at one time that paintings were for the illiterate what writings were for readers; today, on the other hand, this language appears reserved for scholars. The dance of the Fourteen Holy Helpers risks becoming an incomprehensible carousel of eccentric figures.

Unfortunately, visitors to museums and galleries are in jeopardy of missing an important part of the message of an artistic work portraying sacred episodes. The identities of the characters are no longer distinguishable, nor are the sense of the action, the development of the episode, and the reasons for the presence of special attributes, which often appear out of place.

Nevertheless, there has been in recent years a general growing interest in spiritual subjects and these exemplary figures from history, contemplation, and mysticism. This book is essentially a visual guide to apprehending and recognizing the most common saints in art—not just their physical characteristics, but their symbolic meaning and special historical emphasis. It is therefore an invitation to rediscover the concentration of meanings and fullness of communication in masterpieces of painting. At the same time, it is also a collection of information, facts, anecdotes, and events about saints, where hagiographic writing comes together with popular tradition, sacred legends with everyday life.

In the general spirit of these dictionaries, this volume includes a collection of "saints" who have been characterized as such by tradition, devotion, and above all, art. There are therefore figures from the Bible (Job) and the Gospels (John the Baptist, the Twelve Apostles, and Joseph). However, the primary figures of the Gospels—Christ and the Virgin Mary—are not included here; their vast, complex imagery will be included in a later volume.

This saint is typically armed as a Roman soldier or knight with a sword and crucifix in hand. He also appears as a Christian soldier holding an acacia branch, a symbol of the immortality of the soul, or wearing a crown of thorns. He is often featured with the execution of ten thousand martyrs.

Acacius

According to an Acts of the Martyrs that appeared in the twelfth century, Acacius was martyred with ten thousand others on Mount Ararat in present-day Turkey. He was a centurion during the reign of emperors Hadrian (A.D. 117–38) and Antoninus (A.D. 138–61) and was stationed in Armenia with nine thousand soldiers to battle rebels that numbered ten times as many. Acacius and his men faced this mismatched battle after an angel appeared to them and promised victory if they invoked the true God, Jesus Christ. They did so, and after they defeated the rebels, the angel led Acacius and the nine thousand soldiers to Mount Ararat, where they lived in contemplation for thirty days, nourished with manna from Heaven. Learning of this, Hadrian sent seven kings to Mount Ararat to coerce the converts into renouncing their faith. Acacius and his soldiers were whipped, crowned with thorns, and stoned. However, the rocks did not strike them but returned right back to the hands of those who threw them. These events caused another thousand soldiers to convert, and all ten thousand were either crucified or impaled as a voice from Heaven promised the salvation of bodies and souls to whoever prayed to the martyrs.

Name
From acacia, the spiny plant with which the martyr and his companions were whipped

Earthly Life
Second century, Armenia

Characteristics and Activity
A Roman soldier who chose martyrdom

Patron
The terminally ill

Special Devotions
His relics were worshiped in Cologne, Prague, Rome, Bologna, and Avignon

Connections with Other Saints
He is one of the Fourteen Holy Helpers, who were invoked during the Middle Ages in Bamberg and Regensburg and later in Germany, Italy, Sweden, and Hungary

Venerated
From the Crusades until the early 1500s in Switzerland and Germany

Feast Day
May 8

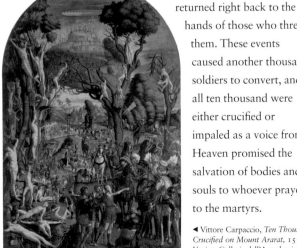

◄ Vittore Carpaccio, *Ten Thousand Crucified on Mount Ararat*, 1515. Venice, Gallerie dell'Accademia.

The martyrs are whipped with thorny acacia branches.

Before being executed, the ten thousand soldiers are stoned, yet a miracle occurs when the stones do not touch them but fly in reverse.

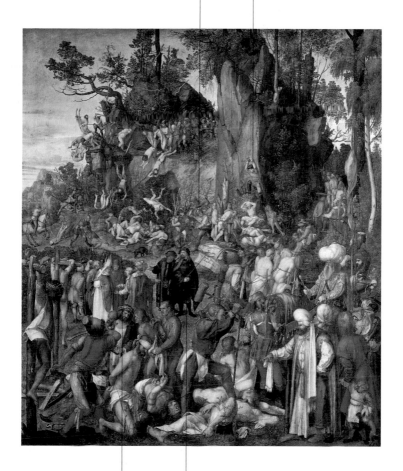

Since he was tortured with a crown of thorns before he was crucified, this type of crown is one of Acacius's attributes in art.

Two figures witness the martyrdom. One is the artist, Dürer, and the other is his contemporary, the renowned German humanist Conrad Celtis.

▲ Albrecht Dürer, *The Martyrdom of the Ten Thousand*, 1508. Vienna, Kunsthistorisches Museum.

She is a young woman who carries her severed breasts on a plate or holds pincers. Agatha also sometimes displays a lighted torch or candle, a symbol of her power against fire; a unicorn's horn, a symbol of her virginity; or a palm branch.

Agatha

Agatha was born in Catania, Italy, perhaps during the reign of Emperor Decius, who died in A.D. 251. She was a young woman from a noble Christian family who refused to offer sacrifices to the gods and bend to the will of the consul Quintianus. He obtained an imperial decree against Christians, and Agatha was first sent to a brothel, where she miraculously kept her virginity intact, and then was imprisoned and tortured. The young girl was filled with joy at the thought of meeting Christ after her martyrdom, but her attitude further inflamed Quintianus's anger. Her breasts were severed with pincers. During the night, however, Saint Peter visited Agatha in prison and healed her. The consul then forced her to walk over hot coals and shards of glass. Just as her punishment was beginning, however, Mount Etna began to erupt, and an earthquake shook the ground. The people of Catania urged Quintianus to stop torturing her. He sent Agatha back to prison, where she died of starvation.

Name
From the Greek word *agathé* (good), perhaps for its similarity to the pagan goddess Agathé, the Latin Bona Dea, who was already venerated at Enna as a goddess of fertility

Earthly Life
Third century, Sicily

Patron
Nannies, nurses, casters of bells (because the flow of bronze is similar to a lava flow, and because bells are similar in shape to breasts), male nurses, Sicilian weavers; she is invoked against breast illnesses, fires, and volcanic eruptions

Venerated
The saint is included in the Hieronymian Martyrology; in the sixth century two churches were dedicated to her and she is included in the Procession of the Virgin Martyrs in the Sant'Apollinare Nuovo Church at Ravenna

Feast Day
February 5

▲ Jacopo Durandi, *Saint Agatha* (detail), from the *Altarpiece of Saint John the Baptist*, ca. 1450. Nice, Musée des beaux-arts.

▶ Francesco Guarino, *Saint Agatha*, ca. 1650. Naples, Museo di San Martino.

Saint Agatha, a young Sicil-
ian woman, is shown here
with dark hair and eyes in
order to reflect characteristic
traits of her native region.

In the background, hot coals
are being prepared for
Agatha's next punishment. She
will have to walk over them.

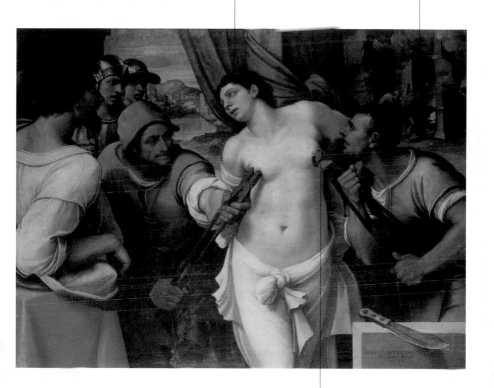

Pincers and severed
breasts are among
this saint's symbols.

▲ Sebastiano del Piombo, *The Martyr-
dom of Saint Agatha*, 1520. Florence,
Palazzo Pitti.

*The virgin Agatha's mysterious
healing occurred during the night.*

*Agatha shows her wounded and
mutilated body to the apostle Peter.*

*An angel is with Peter. The apostle
had also been visited in prison and
was freed by an angel.*

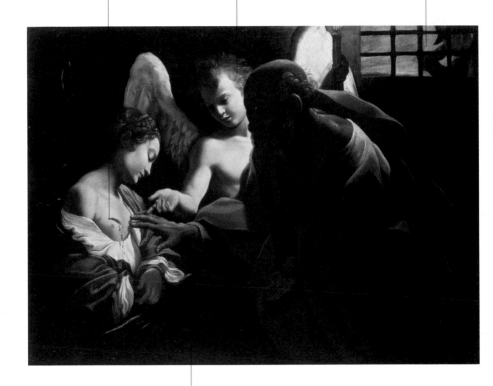

According to the Golden Legend, *Peter
heals Agatha in the name of Christ
without touching her. His delicate and
discreet gesture here is in this tradition.*

▲ Giovanni Lanfranco, *Saint Peter and
the Angel Visit Saint Agatha in Prison,*
1613–14. Parma, Galleria Nazionale.

This saint is the first to have an iconographic attribute, a lamb at her feet or in her arms. She often holds a palm of martyrdom, and long locks of hair often cover her body.

Agnes

Agnes's story is based on two different traditions—one Greek and one Latin, which Saint Ambrose and Saint Damasus followed—that actually described two distinct martyrs. The two stories were combined and enriched by a range of details. The Latin tradition tells of a twelve-year-old girl who was slain around A.D. 305 during Diocletian's persecutions, while the Greek version tells of an adult virgin. When she refused to offer sacrifices to the goddess Vesta, Agnes was punished by being taken to a brothel in the nude. God, however, caused her hair to grow so long that it covered her entire body and sent an angel to dress her in white. One young man dropped dead when he tried to rape her, and when a prefect interrogated her about this inexplicable death, Agnes responded that an angel dressed in white acted as her bodyguard and defended her. In order to convince the official, she offered a prayer of intercession and brought the would-be rapist back to life. It is also said that Agnes was cast into a fire, although she was unharmed because the flames parted. In the end, Agnes's throat was slit and she was martyred.

Name
Derivative of the Greek, meaning "pure" and "chaste"

Earthly Life
Fourth century, Rome

Patron
Virgins, engaged couples (because she chose to be engaged to Christ), and gardeners (because virginity is symbolized by an enclosed garden [*hortus conclusus*])

Special Devotions
At one time, lambs were blessed on her feast day, and their wool was used by the nuns of Saint Agnes in Rome to weave the copes of archbishops

Venerated
She was universally venerated

Feast Day
January 21

▲ Jacobello del Fiore, *Saint Agnes* (detail), from the beginning of the fifteenth century. Venice, San Giovanni in Bragora.

▶ Andrea del Sarto, *Saint Agnes* (detail), 1524. Pisa, Duomo.

The prefect who ordered the saint
to be killed watches her execution.

Angels bring a palm branch and a
crown of glory from Heaven, which
are traditional rewards for martyrs.

The two legends regarding Agnes
agree that she was martyred when her
throat was slit. Here the saint holds a
lamb in her arms, her symbol.

The remains of the fire that Agnes
was thrown into are shown here.
The flames parted in two and she
was left unharmed.

▲ Vicente Macip I, *The Martyrdom of
Saint Agnes*, from the first half of the
sixteenth century. Madrid, Prado.

This saint is typically dressed as a Dominican with a doctor's hat and a book in his lap, or as a bishop wearing a miter. His most common attributes are the book and the pen.

Albert
the Great

Albert was born into a noble family from Swabia, Germany, in 1206, and in 1223 he entered the Dominican order in Padua against his parents' wishes. He eventually taught at Hildesheim, Regensburg, and Cologne (where Thomas Aquinas was his student) and then taught theology in Paris. Between 1254 and 1257 he was the prior of the province, and in 1260 he was elected bishop of Regensburg. A short time later, in 1262, he abandoned his post guiding the diocese—since he could not identify any positive changes there—and returned to teaching. A defender of Scholasticism, he agreed with Saint Thomas Aquinas on the importance of Aristotelian philosophy, which he greatly admired, in Christian theology. Albert was also interested in the physical sciences, and wrote a commentary on the works of Arab scientists. He also wrote treatises on astronomy, chemistry, geography, and physiology. As a result, he was known not only as a bishop, but primarily as a Dominican teacher and learned doctor.

Name
Originally Germanic, meaning "all clear"; possibly the diminutive form of Adalbert, which means, "clearly noble"

Earthly Life
1206–1280; Germany, Italy, France

Characteristics and Activity
Dominican friar who dedicated himself to teaching theology and aiding students; he founded a number of study houses

Patron
Scientists and students of natural sciences; naturalists

Connections with Other Saints
Thomas Aquinas was his student in Cologne

Venerated
Beatified in 1622, he was finally canonized in 1931 by Pope Pius XI, who proclaimed him a Doctor of the Church; images of Albert were widespread long before this

Feast Day
November 15

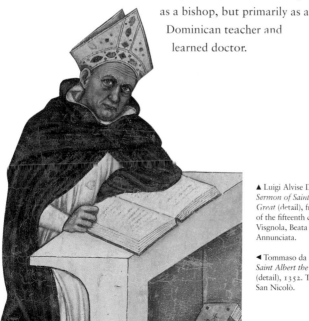

▲ Luigi Alvise Donati, *Sermon of Saint Albert the Great* (detail), from the end of the fifteenth century. Visgnola, Beata Vergine Annunciata.

◀ Tommaso da Modena, *Saint Albert the Great* (detail), 1352. Treviso, San Nicolò.

17

Alexander is typically dressed as a Roman soldier and holds a banner with a white lily, a symbol of the Theban Legion, which was made up of Egyptian soldiers from Thebes.

Alexander

According to the Acts of the Martyrs, Alexander was the commander of a company and standard-bearer in the Theban Legion, which was made up of Christian soldiers who were commanded by Saint Maurice and stationed in the East. In A.D. 301 the legion was sent west to combat the attacking Quadi and Marcomanni. As they were crossing Valais, Switzerland, they received orders to persecute Christians, to which they immediately refused. They were punished by being decimated and then nearly eradicated near Agaunum. Together with a number of comrades, Alexander managed to flee into Italy. In Milan he was recognized and imprisoned, but was able to travel to Como with the help of Saint Fidelis and Saint Materinus. He was then brought back to Milan and sentenced to death. As he was about to be beheaded, the executioner's arms froze, so Alexander was put back in jail and left to die. He then managed to escape to Bergamo, where he converted many people. He was finally beheaded publicly on August 26, A.D. 303. Because he was martyred in a square where an ancient column stood, Alexander is often portrayed with his foot resting on a column.

Name
Originally Greek, meaning "protector of men"

Earthly Life
Third and fourth centuries, Egypt, Switzerland, and North Italy

Characteristics and Activity
Christian soldier of the Theban Legion who fled the massacre at Agaunum and hid in Milan; he was martyred after he preached in Bergamo

Venerated
Since the sixth century, when his cult began around his grave

Feast Day
August 26

◀ Master of 1336, *Saint Alexander on Horseback* (detail), 1336. Bergamo, Chiesa di Santa Maria Maggiore.

▶ Vincenzo Foppa, *Saint Alexander* (detail), from the *Polyptych of the Graces*, 1483. Milan, Pinacoteca di Brera.

*Portrayed as a beggar or pilgrim with a staff, Alexis is usually
shown near stairs. At times he holds a letter.*

Alexis

According to a legend that was quite popular during the
Middle Ages, Alexis was the son of a Roman patrician, the
senator Euphemianus, and his wife, Aglaë. On his wedding
night, in order to retreat from the world, he left his bride
chaste and abandoned their house to set out on a pilgrimage.
For a while he lived in Edessa, in Syria, begging near a church,
but as soon as word spread of his sanctity he fled and set out
on a ship headed for Rome. Returning to his parents' house, he
did not let his parents or wife recognize him, although she was
still waiting for his return. He lived as a beggar under the stairs
there, and sometimes maids threw dirty water on him from
the upper windows. At his death, the bells of Rome began to
sound. He was recognized thanks to Pope Innocent, who had a
vision telling him to go to Alexis's body and read the letter held
in its stiffened hands. Only the pope was able to open the
saint's hands and read the name "Alexis" on the folded sheet
with an account of his life, thus revealing this man of God's
identity.

Name
Originally Greek,
aléxein, meaning
"protect," "defend
and drive back"

Earthly Life
Fifth century, Rome
and Edessa

**Characteristics
and Activity**
Eastern ascetic

Patron
Beggars and
gatekeepers

Special Devotions
Invoked by the
terminally ill

Venerated
He was venerated
in the Eastern
Church, then by
the Roman church
in the tenth century

Feast Day
July 17

Georges de La Tour, ▲
*The Discovery of Saint
Alexis's Body* (detail),
1647. Dublin, National
Gallery of Ireland.

Pietro da Cortona, ◄
The Dying Saint Alexis,
1638. Naples, Girolamini.

19

Aloysius is a young man dressed as a religious brother with a white surplice over a black cassock. Among his main attributes are the crucifix and the lily, to which a skull and scourge are sometimes added.

Aloysius Gonzaga

Aloysius was born into a noble family in 1568, the son of Ferrante Gonzaga, Marquis of Castiglione delle Stivieri. He was intended for a military career; at first his father sent him to Florence, then to Madrid as a page for his education. However, Aloysius, who, at age ten, had made a vow of chastity and had conducted a life of penance and fasting ever since, definitively renounced his hereditary rights when he was fourteen in order to embrace a religious life with the Jesuits in Rome. He entered the novitiate in 1585. His teacher and spiritual director was Saint Robert Bellarmine, who accompanied Aloysius to care for the poor. In 1590 Rome was struck by a violent epidemic of the plague, during which Aloysius cared for the sick in the hospitals. He caught the disease and died on June 21, 1591.

He is often shown in ecstasy before a crucifix or receiving his first Communion, which was given to him by Saint Charles Borromeo.

Name
French, meaning "famous in battle"

Earthly Life
1568–1591; Italy, Spain

Characteristics and Activity
Young nobleman who renounced his hereditary rights to enter the Society of Jesus, or Jesuits

Patron
Young people and students

Venerated
Beatified fifteen years after his death, canonized in 1726 by Pope Benedict XIII, although his veneration had been approved in 1621

Feast Day
June 21

▲ Giovanni Domenico Tiepolo, *Saint Aloysius Gonzaga* (detail), 1760. Milan, Pinacoteca di Brera.

▶ Giuseppe Chiari, *The Ecstasy of Saint Aloysius Gonzaga* (detail), from the second half of the eighteenth century. Rome, Collezione Lemme.

Ambrose is dressed as a bishop with a pastoral staff and whip. Sometimes he is portrayed on horseback or with bees, since his eloquence was considered as sweet as honey.

Ambrose

Ambrose was born in either A.D. 337 or 339 in Trier, Germany, where his father, who was from a noble Roman family, was prefect. In Rome Ambrose studied Roman law and rhetoric and became a brilliant lawyer. In A.D. 370 he was governor of Emilia and Liguria and resided in Milan. During that time there was serious dissent between Arians and Catholics regarding the nomination of a new bishop. Although the Council of Rome had condemned them, the Arians maintained considerable power. The contest for bishop became so bitter that Ambrose was forced to intervene. Since he was esteemed by both sides, they agreed to elect him bishop. Ambrose was baptized on November 30, 374, and consecrated bishop a week later. He dedicated himself to theology, moral renewal, and opposing the Arian heresy. He upheld the church's rights against the emperor and forced Theodosius to publicly atone for the massacre at Thessalonica. Ambrose died in 397.

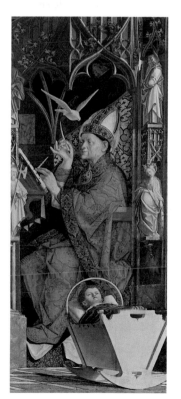

◀ Michael Pacher, *Saint Ambrose* (detail), from the *Altar of the Fathers of the Church*, 1480. Munich, Alte Pinakothek.

Name
Originally Greek, meaning "immortal"

Earthly Life
Fourth century; Trier, Rome, and Milan

Characteristics and Activity
Lawyer elected bishop of Milan who fought the Arian heresy and achieved important liturgical and pastoral reforms

Patron
Bees, beekeepers, and those who work with wax

Connections with Other Saints
Ambrose, Augustine, Jerome, and Gregory the Great are the four Doctors of the Western Church.

Feast Days
In the Roman Church, December 7, when he was consecrated bishop; in the Anglican Church, April 4, when he died

Saint Ambrose (detail), from ▲ the fifth century. Milan, Basilica di Sant'Ambrosio, Chapel of San Vittore in Ciel d'Oro.

21

The riding whip became Ambrose's emblem in the twelfth century and was reintroduced at the end of the fourteenth century. It denotes his strength in struggling against heretics.

This image of the bishop, with the rigid expression that was widespread during the time of Saint Charles Borromeo, was eventually replaced by his cousin Cardinal Federico Borromeo with the countenance of a benign, forgiving father at the beginning of the sixteenth century.

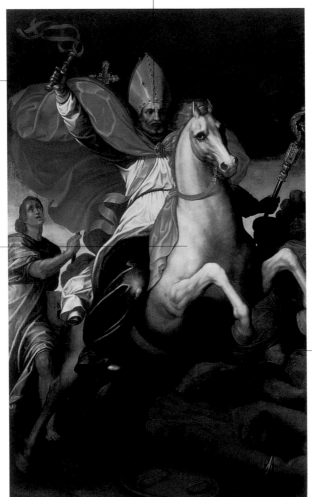

During the Battle of Parabiago in 1339, Ambrose miraculously appeared on a white horse and helped Luchino Visconti's troops triumph over their enemies.

In this image of Ambrose's appearance at Parabiago, the defeated Arians are portrayed as fallen soldiers who have been beaten and thrown to the ground.

▲ Ambrogio Giovanni Figino, *Saint Ambrose on Horseback Expels the Arians*, 1591. Milan, Civiche Raccolte d'Arte del Castello Sforzesco.

Ambrose, dressed as a bishop with a miter and cope, gestures in a fatherly manner toward Theodosius, whom he forces to atone for the massacre at Thessalonica.

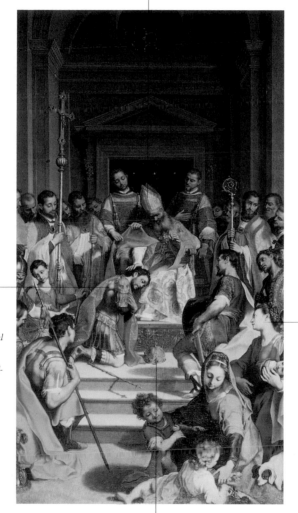

According to the funeral eulogy written by Ambrose at Theodosius's death, the emperor accepted his public penance. Here Theodosius is shown in tears kneeling before the bishop.

Theodosius's penance occurred in front of all the people of Milan.

▲ Federico Barocci, *Ambrose Pardons Theodosius*, 1603. Milan, Duomo.

The imperial symbols, signs of Theodosius's power, were placed on the ground to indicate the higher power that Ambrose represented.

Although Andrew was initially represented by a small Latin cross, from the tenth century on his attribute was the cross in the shape of an X. This was naturally called the cross of Saint Andrew and became widespread during the fourteenth century. His secondary attributes are a net and fish.

Andrew

Apostle

Name
Originally Greek, meaning "virility and courage"

Earthly Life
First century, Palestine

Characteristics and Activity
A fisherman called by Jesus to follow him

Patron
Fishermen and fish vendors; patron saint of Scotland

Special Devotions
Invoked by women in order to find husbands

Connections with Other Saints
One of the Twelve Apostles

Venerated
Especially venerated in the Middle Ages, when he took on the characteristics of a warrior-saint; the symbol of his cross was used as the insignia of knightly orders

Feast Day
March 9 (orginally November 30)

Andrew was a disciple of John the Baptist and among the first to follow Jesus. He was Simon Peter's brother. The two were born in Bethsaida, were citizens of Galilee, and moved to Capharnum to work as fishermen. In the Gospels Andrew is featured at the Miraculous Draught of Fishes, the Multiplication of Loaves and Fishes, and when the Greeks ask to meet Jesus. He is typically among the top four on any list of the Twelve Apostles. There is no trustworthy tradition indicating exactly where he preached or was martyred. Normally he is linked with Greece; the oldest written records attest to his presence in Scythia and Epirus. Andrew was thought to have brought the gospel message to those regions, and it was held that he was crucified in Achaia and buried there around A.D. 60. None of the sources speak explicitly of an X-shaped cross at his death; this detail was probably derived through popular imagination from his decision to be tied to a cross that was different from Christ's. The choice of an X could also have symbolic meaning, since in Greek it is the first letter of Christ's name.

▲ Simone Cantarini, *Saint Andrew* (detail), 1642–43. Florence, Palazzo Pitti.

▶ Girolamo Muziano, *Saint Andrew* (detail), 1580–81. Palermo, Galleria Regionale della Sicilia.

The X-shaped cross of Saint Andrew's martyrdom first appeared in the tenth century and became his attribute in art.

A light descended from Heaven as Andrew was being lowered from the cross; it enveloped him for a half hour, and when it returned to Heaven, Andrew died.

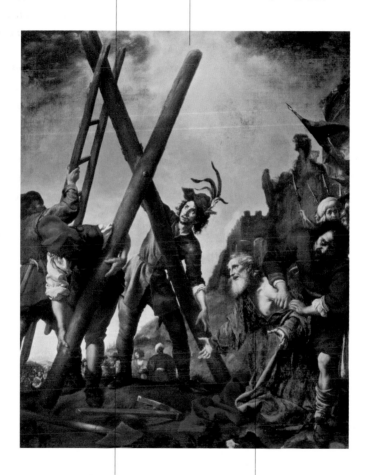

After two days of agony, during which the saint continued preaching, the crowd asked the consul that had condemned Andrew to take him down from the cross.

According to the Golden Legend, before he was martyred Andrew knelt before the cross, which had become holy after the Passion. This scene of the saint being stripped of his clothing does not follow the Golden Legend, in which he undresses himself and hands his belongings to his executioners.

▲ Carlo Dolci, *Saint Andrew Before the Cross*, ca. 1631. Florence, Palazzo Pitti.

Anne is typically portrayed as an elderly woman who often wears a green cloak and cares for her child, Mary.

Anne

Name
Originally Hebrew, meaning "have mercy, consent gracefully"

Earthly Life
First century B.C., first century A.D.

Characteristics and Activity
Mother of Mary

Patron
Lathe workers; sculptors; junk collectors; cleaners; tailors; navigators; miners; makers of socks, gloves, and brooms; carders; goldsmiths; mothers; the terminally ill

Connections with Other Saints
Joachim, Mary

Venerated
In the East during the sixth century, then universally in the twelfth century

Feast Days
July 26 in the West, July 25 in the East

The first records of Anne, the mother of the Virgin Mary, date to the second century. The *Protogospel of James*, an apocryphal text, narrates stories of Mary's infancy and her parents, Anne and Joachim. These episodes are interwoven with legends and based on recurring themes in the Bible such as a late and miraculous pregnancy. Nevertheless, the veneration of Anne certainly dates to earliest times, and there is proof of its existence in the sixth century in the East. In the tenth century the feast of Saint Anne was still strongly connected to the veneration of Mary, and the festival of the "conception of Saint Anne" (i.e., Mary's conception) was especially popular in Naples, England, and Ireland. The Western Church, however, would only fully acquire this tradition later on. Devotion to Saint Anne, together with Saint Joachim, and an official feast day, would only be inserted into the liturgical calendar in 1584, despite Luther's protests against ceremonies in her honor and images that displayed her with Mary and Jesus.

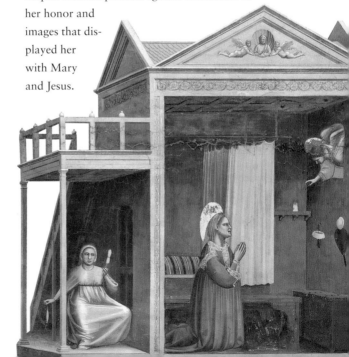

◆ Masaccio and Masolino da Panicale, *Saint Anne* (detail), 1425. Florence, Uffizi.

The angel indicated Jerusalem's Golden Gate as the meeting place for Anne to reunite with her husband Joachim.

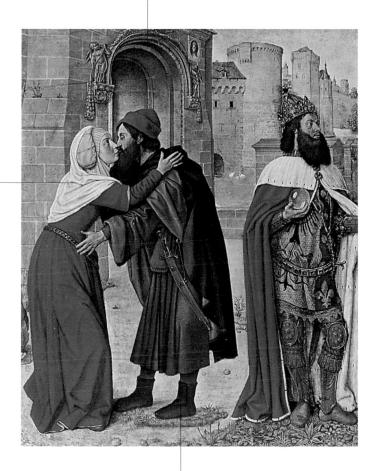

Anne did not know why Joachim had gone away and was worried by his absence. An angel appeared to her, telling her to go meet her husband. When they returned together, Mary was conceived.

Joachim was expelled from the temple because he had not had children during twenty years of marriage. Believing himself to be cursed by God, he sought shelter among shepherds. Then an angel visited him.

◄ Giotto, *The Annunciation to Saint Anne* (detail), 1304–6. Padua, Scrovegni Chapel.

▲ Master of Moulins, *Charlemagne, and the Meeting of Saints Joachim and Anne at the Golden Gate*, ca. 1500. London, National Gallery.

This elderly woman is Anne. She rests on a bed after giving birth.

Two women with new sheets approach to care for the newborn, representing a custom from the painter's time.

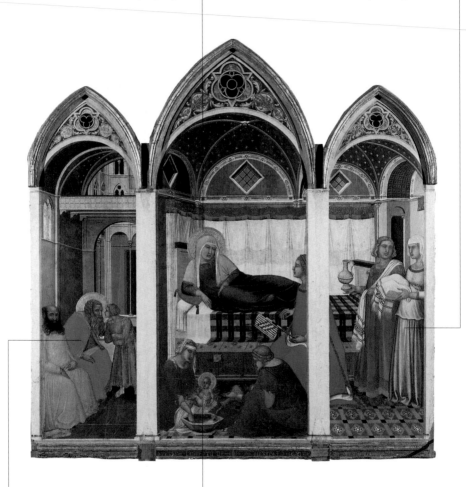

Joachim is Anne's husband and father of the Virgin Mary.

Anne brings Mary into the world after not giving birth in twenty years of marriage, just as the angel had announced to Joachim.

▲ Pietro Lorenzetti, *The Nativity of Mary*, 1342. Siena, Museo dell'Opera del Duomo.

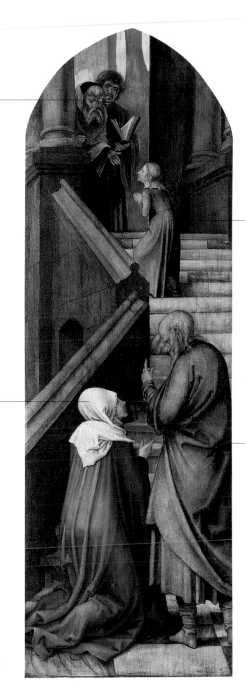

The priest welcomes the child Mary, who according to legend was brought to the temple when she was three years old.

Mary climbs the stairs of the temple, which traditionally had to number fifteen after the fifteen Gradual Psalms of the Bible.

Anne kneels and stops at the foot of the temple stairs.

Joachim comments to Anne on Mary being entrusted to the temple.

► Hans von Kulmbach, *The Presentation of Mary in the Temple* (detail), from the *Rosary Triptych*, ca. 1510. Madrid, Thyssen-Bornemisza Museum.

Angels here in Anne's house are not mes-
sengers from God, but rather a sign of an
environment protected from on high.

According to
apocryphal
gospels, the
child Mary
learned to
weave when she
was educated at
the temple.

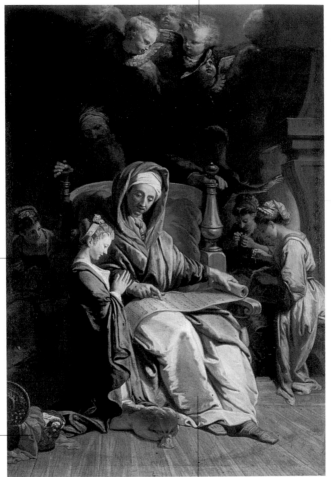

The basket is
one of Mary's
attributes in art.

Anne educates Mary at home.

▲ Jean Baptiste Jouvenet, *The Education
of the Virgin*, ca. 1700. Florence, Uffizi.

With this figure of Saint
Anne, the artist was actually
portraying his wife, Agnes.

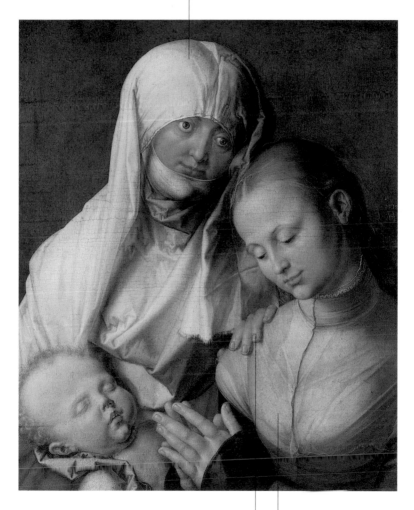

Anne's gestures indicate affection
toward Mary and protection over her.

Mary is shown here at a very young age
in order to adhere to the original sources
and as a contrast with her mother, Anne.

▲ Albrecht Dürer, *Virgin and Child
with Saint Anne*, 1519. New York,
The Metropolitan Museum of Art.

*With the help of Jesus,
Mary crushes the serpent,
a symbol of evil.*

Anne seems to be isolated in this painting, although the artist has emphasized her by giving her a statue-like image.

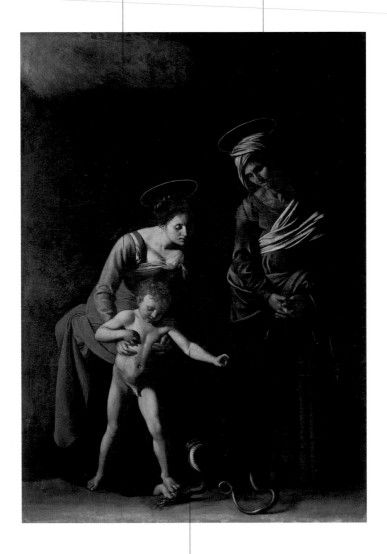

▲ Caravaggio, *Madonna dei Palafrenieri*, 1605–6. Rome, Galleria Borghese.

This depiction of Jesus with his mother and grandmother is one of the rare images of Anne outside narratives of Mary's life.

Dressed as a hermit with a T-shaped cane, Anthony appears with a bell or, first seen in Western imagery in the Middle Ages, a pig. The demon portrayed at his feet is a symbol of temptation overcome.

Anthony
Abbot

Historical records on the life of Saint Anthony are based on a biography written by Saint Athanasius, bishop of Alexandria in Egypt from A.D. 326 to 372. Anthony was born in Coma, Egypt, in 251. He sold all his belongings when he was twenty in order to follow an ascetic life. Between 286 and 306, he lived in solitude in an abandoned fort in Pispir, suffering and overcoming every sort of temptation. Images of the temptations of Saint Anthony originated from these stories, which were especially popular in the fifteenth century. Anthony's fame spread so much that he had to leave behind his hermit lifestyle to dedicate himself to his many disciples. Anthony made a living by cultivating gardens and weaving mats, maintaining the austerity of the ascetic life but ready to passionately intervene in the important questions of the church. In 311 he traveled to Alexandria to support Christians who were being persecuted by Maximinus Daia, and he returned there in 355 to refute Arianism. He was considered a living saint who could work miracles, and he aided many conversions. He died when he was more than a hundred years old in 356.

◀ Master of Saint Veronica, *Saint Anthony Abbot Blessing the Animals, the Poor, and the Sick,* ca. 1400–1410. Los Angeles, J. Paul Getty Museum.

Name
A noble Roman name of probable Etruscan origin; meaning unknown

Earthly Life
A.D. 251–356, Egypt

Patron
Butchers, sausage makers, basket weavers, and domestic animals

Special Devotions
Invoked against herpes zoster, or shingles, also commonly known as "Saint Anthony's fire"

Connections with Other Saints
Paul the Hermit

Venerated
Widely venerated in the Middle Ages and held as the "father of all monks"; one of the great figures of ancient Christian asceticism

Feast Day
January 17

Lelio Orsi, *The Temptation* ▲ *of Saint Anthony* (detail), ca. 1570. Los Angeles, J. Paul Getty Museum.

Anthony Abbot

The toad represents the demon that tries to block Anthony from being elevated to Heaven by angels.

The figures of animals and monsters dressed in religious costumes represent members of the clergy. They comment on the Scriptures without agreeing on interpretations.

This image derives from the proverb, "Wherever the Devil can't go personally, he sends his envoy."

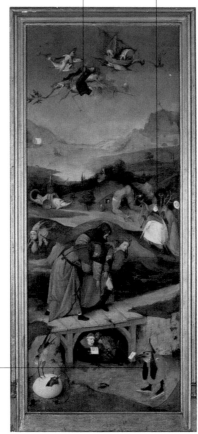
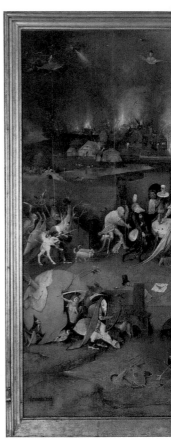

▲ Hieronymus Bosch, *Triptych of the Temptations of Saint Anthony*, 1505–6. Lisbon, Museu Nacional de Arte Antigua.

Among the various temptations that the Devil prepares for Anthony are blasphemous thoughts, which are symbolized here by this dark ceremony.

According to medieval thought, witches were sent by the Devil. They flew around and participated in covens.

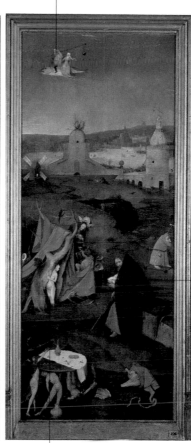

The book indicates the innate power of the Scriptures to help overcome temptation.

The nude woman corresponds to traditional depictions of Anthony's temptations.

When Anthony saw the soul of Saint Paul
the Hermit fly to Heaven, he returned to
bury him. Anthony was helped by two
lions, which dug the grave with their paws.

According to the Golden Legend, *a raven
brought food to Paul each day. On the
day Anthony visited, the crow brought a
double portion of bread.*

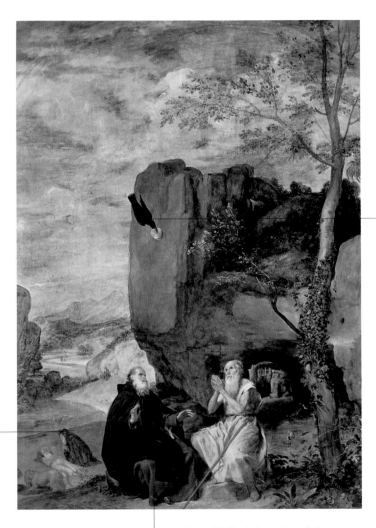

▲ Diego Rodríguez de Silva y Velázquez,
*Meeting Between Saint Anthony and
Saint Paul the Hermit,* ca. 1633.
Madrid, Prado.

Late in his earthly life, Anthony (also called
Anthony the Hermit) sought out fellow her-
mit Paul. Before managing to find Paul's
hermitage, Anthony encountered a number
of strange, monstrous animals. Finally a
wolf led him to the correct place.

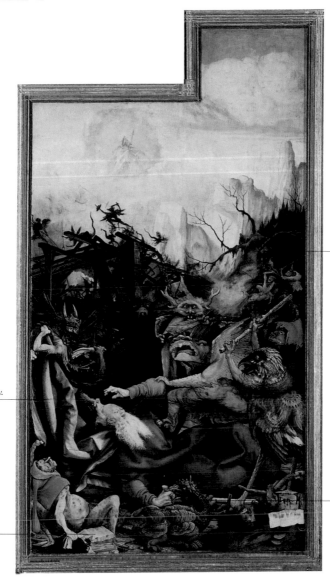

Even the natural
surroundings
seem rough and
hostile.

The demons,
which resem-
ble ancient
beasts, hurl
themselves at
Saint Anthony.

In an attempt
to weaken the
saint against
temptation, a
demon steals
the book of
Scriptures.

The saint holds a
walking stick in
the shape of a *T*,
which is his
attribute in art.

▲ Matthias Grunewald,
The Temptations of Saint Anthony,
1515. Colmar, Musée d'Unterlinden.

Anthony is typically depicted as a Franciscan and holds a book, fire, a burning heart, a white lily, or the child Jesus.

Anthony
of Padua

Name
Noble Roman name of probable Etruscan origin; meaning unknown

Earthly Life
1195–1231, Europe

Characteristics and Activity
Franciscan friar and preacher

Patron
Orphans, prisoners, castaways, barren women, pregnant women, sick children, glassblowers and glass vendors, novices, Portugal

Special Devotions
Since the 1600s he has been invoked to help find lost objects and by women to help find husbands

Feast Day
June 13

▲ Simone Cantarini, *Saint Anthony of Padua and Francis of Paola* (detail), 1637–45. Bologna, Pinacoteca Nazionale.

▶ Moretto da Brescia, *Saint Anthony of Padua* (detail), 1530. Milan, Museo d'Arte Antica al Castello Sforzesco.

Born in 1195 into a noble family of Lisbon, Anthony joined the regular canons of Saint Augustine and carried out his studies in Coimbra, Portugal. The martyrdom of five Franciscan missionaries in Morocco left such a strong impression on him that he decided to transfer to the Franciscan order, and he became a friar in 1220. Anthony began preaching in Africa, but because of his poor health, he transferred to Italy, where he was sent to the University of Bologna as a lector in theology. He also taught at Montpellier and Toulouse in France, where he struggled against the Albigensian heresy. Anthony was the minister provincial for his order in Emilia and Lombardy from 1227 to 1230, but then decided to stay in Padua to dedicate himself entirely to preaching. He died there unexpectedly when he was thirty-six. Devotion to Saint Anthony spread thanks to Saint Bernardino's sermons about him. Anthony was a great preacher, and at his death, his tongue was cut out as a relic; it is still kept in Padua today. This saint was sometimes confused with Saint Anthony Abbot, and because of this took on the attribute of the burning heart, a symbol of love for God. Anthony's image in art was influenced by legends and images of other saints, such as when he preached to fish, which was modeled after Saint Francis's preaching to birds.

Anthony presents the consecrated Eucharist to the mule.

The heretic master of the mule did not believe in the real presence of Christ in the consecrated host.

The mule was meant to eat fodder after having been starved for three days.

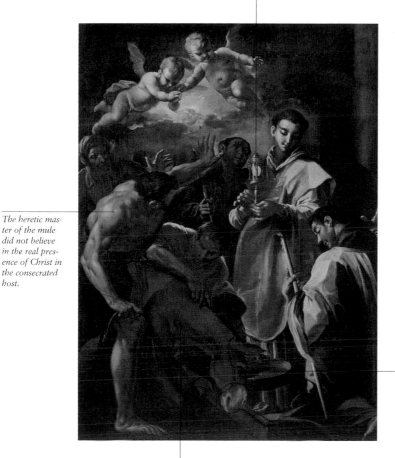

The mule kneels before the eucharistic host after three days of not eating and not being cured by the fodder that was prepared.

▲ Filippo Abbiati, *The Miracle of the Mule,* from the Arciconfraternita del Santissimo Sacramento Cycle, ca. 1700. Milan, Museo Diocesano.

The story of Anthony making a newborn
talk was taken from the lives of other,
older saints before him.

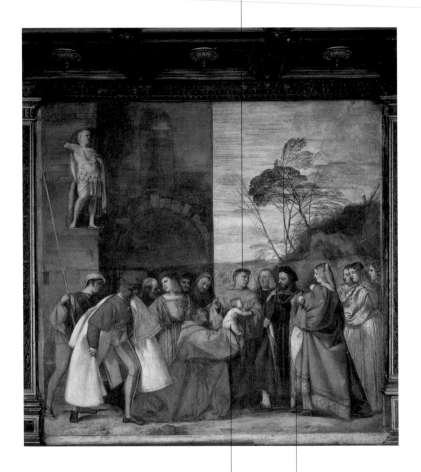

Anthony asks
the newborn
to point out
its father.

The newborn's
mother is no
longer accused
of adultery.

▲ Titian, *The Miracle of the Newborn*,
1511. Padova, Scuola del Santo.

▶ Guido Reni, *The Martyrdom of Saint
Apollonia* (detail), ca. 1606. New York,
Richard Feigen Collection.

This saint is generally portrayed as a young woman with pincers and sometimes with her extracted teeth. As a martyr, she often holds a branch of the palm of martyrdom.

Apollonia

According to a letter by Saint Dionysius, bishop of Alexandria, Egypt, to Bishop Fabian of Antioch, Saint Apollonia was an elderly deaconess of Alexandria who suffered martyrdom in A.D. 249. In the letter, Dionysius describes the persecutions against Christians under Emperor Philip. During a riot, Christians were dragged from their houses and killed after watching as all their belongings were taken. Apollonia was one of those abducted; her jaw was broken and her teeth knocked out. Her suffering did not stop there: she was brought outside the city and told to recite blasphemous phrases or be burned alive. The woman asked for a moment to decide, during which she suddenly freed herself from her tight bonds and threw herself voluntarily into the fire. Her character was later confused with another Apollonia, who died in Rome during the persecutions of Julian the Apostate. Images of the elderly deaconess soon changed into those of a young woman with pincers, suggesting that her teeth had been extracted.

Name
Originally Latin and linked to worship of the god Apollo; perhaps a derivation of the noble Etruscan name Apluni

Earthly Life
Third century, Alexandria

Characteristics and Activity
Martyr

Patron
Dentists

Special Devotions
Invoked for toothaches because her jaw was broken and because her legend tells of how before she died, she promised to help those who suffered from toothaches

Venerated
Her cult spread to the West immediately after her martyrdom

Feast Day
February 9

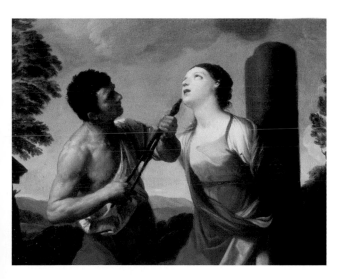

Ercole de' Roberti, ▲
Saint Apollonia (detail),
1475. Paris,
Musée du Louvre.

The saint is typically portrayed as a bishop studying. In the fifteenth century, he often had a child and seashell nearby; beginning in the seventeenth, he was also shown with a burning heart or pierced with arrows.

Augustine

Aurelius Augustinus was born on November 13, A.D. 354, in Tagaste, present-day Algeria. His father was Patricius, a pagan; his mother, Saint Monica, educated Augustine, although he was not baptized as a child. He studied rhetoric and philosophy and became a Manichean, virtually renouncing the Christian faith. At seventeen he began living with a concubine whom he stayed with for fourteen years; they would have a child, Adeodatus, who remained with Augustine until the child's early death in 389. Augustine eventually taught rhetoric and philosophy in Tagaste, Carthage, Rome, and Milan. In Milan, curious about the great oratorical abilities of Saint Ambrose, he followed the bishop's preaching. After a time of strong interior conflict, Augustine agreed to be baptized in 386. In 388 he returned to Africa to live in a religious community, and in 391 he was ordained a priest. He aided the bishop of Hippo for four years in this capacity and then replaced him in 396. He died on August 28, 430, as the Vandals were laying siege to the city of Hippo.

Name
From the Latin Augustum, which means, "consecrated by good omens," "venerable"

Earthly Life
Fourth century, present-day Algeria and Italy

Patron
Printers and theologians

Special Devotions
In German-speaking countries he was considered to be a healer of eye illnesses because of a mistaken interpretation of his name and its similarity with *augen* (eye)

Connections with Other Saints
Augustine, with Ambrose, Jerome, and Gregory the Great, is one of the four eminent Doctors of the Western Church

Feast Day
August 28

▲ Vincenzo Foppa, *Saint Augustine* (detail), 1468. Milan, Sant'Eustorgio, Portinari Chapel.

▶ Piero della Francesca, *Saint Augustine* (detail), 1465. Lisbon, Museu Nacional de Arte Antigua.

Ambrose, bishop of Milan, baptizes Augustine.

Monica, Augustine's mother, followed him to Milan and is present at his baptism with Simplician, who had tutored Augustine in the faith.

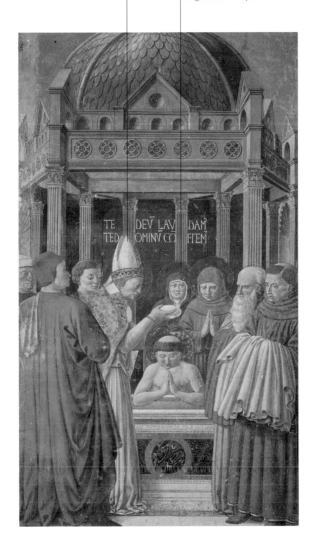

▲ Benozzo Gozzoli, *The Baptism of Saint Augustine*, 1465. San Gimignano, Chiesa di Sant'Agostino.

Augustine

The dog is not a specific attribute of Saint Augustine's, but is often used in Christian imagery as a symbol of loyalty.

The pastoral staff and miter are a bishop's emblems, and thus Augustine's as well. Here they lie deserted with apparent indifference, yet they recall his election as bishop.

44

For the humanist artists, portraying a
church father was also the chance to
show the latest progress in mathematics.

Augustine's
divine inspiration
is symbolically
represented by a
ray of light shin-
ing through the
window.

Augustine, shown
here as a scholar,
is a Doctor and
Father of the
Church.

The hourglass,
which is only
rarely associated
with a scholar, is
more often a
symbol of the
transience of
things (vanitas),
and therefore is a
hermit's emblem.

◄ Vittore Carpaccio, *Augustine in
His Study*, 1502–4. Venice, Scuola di
San Giorgio degli Schiavoni.

The Holy Spirit, shown here in
the form of a dove, inspires
Saint Augustine's writings.

Augustine's hand
indicates the num-
ber three, a sign of
the Trinity. This
refers to a vision the
saint had, in which
he was on a beach
trying to under-
stand the mystery of
the Trinity.

Among Augustine's
attributes in art are
books and other
scholarly objects.

In Augustine's
vision, a child was
trying to empty the
sea with a shell.
When Augustine
asked him if he
would ever succeed,
the child answered,
"Certainly before
you understand the
essence of God."

▲ Michael Pacher, *Saint Augustine*
(detail), from the *Altar of the
Fathers of the Church*, 1480.
Munich, Alte Pinakothek.

Barbara appears as a young woman with a palm branch or a peacock quill. Her emblem is a tower with three windows. She also holds a crown.

Barbara

There are no sure historical facts about Barbara, who probably died a martyr during the persecutions of Maximian in the early years of the fourth century. This saint became legendary after the Acts of the Martyrs were compiled in the seventh century and the subsequent publication of the *Golden Legend*. Barbara was the daughter of Dioscorus, king of Nicomedia. Her father intended to lock her in a tower that he built expressly for that purpose, so that no one would see her great beauty. This did not, however, prevent a number of suitors from asking for her hand in marriage anyway. During Dioscorus's absence, Barbara—who had converted to Christianity—decided to live as a hermit in the tower her father had built. She convinced the architects to add a third window in honor of the Trinity. When the father learned of his daughter's conversion, the king of Nicomedia was so blinded by rage that he handed her over to a judge so that she could be condemned to death and he could be her executioner. Barbara was beheaded, and her father was struck by a thunderbolt and reduced to ashes.

Name
Latin, originally Greek, meaning "foreigner"

Earthly Life
Fourth century, present-day Turkey

Patron
Architects, soldiers, gunsmiths, miners, builders, bell ringers, firemen, and those who constantly live in danger of a sudden death

Special Devotions
Invoked against lightning

Connections with Other Saints
She is among the Fourteen Holy Helpers and the Quatuor Virgines Capitales

Venerated
Venerated and depicted since the seventh century

Feast Day
December 4

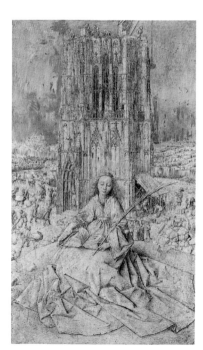

▶ Jan van Eyck, *Saint Barbara*, 1437. Antwerp, Koninklijk Museum voor Schone Kunsten.

Cosimo Rosselli, *Saint Barbara*, ▲ *Saint John the Baptist, and Saint Paul* (detail), 1468. Florence, Galleria dell'Accademia.

Furious at his daughter, Dioscorus
chases Barbara to punish her for such
outrage. He wears a turban, a typical
head covering from the Middle East
that defines him as a nonbeliever.

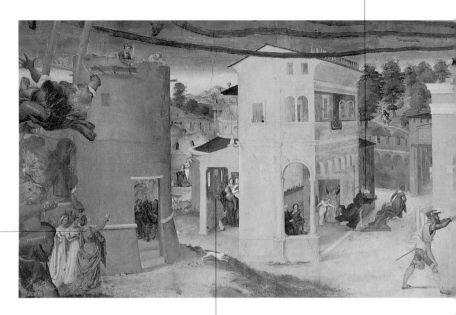

Barbara discusses construction with
architects at the tower where she intends
to live. She indicates the number three
with her hand for three windows in
honor of the Trinity.

Barbara refuses to worship
her father's idols and even
spits on them.

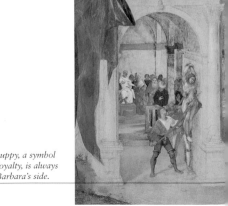

A puppy, a symbol
of loyalty, is always
at Barbara's side.

▲ ▶ Lorenzo Lotto, *Stories of Saint
Barbara* (details), 1524. Trescore
Balneario, Oratorio Suardi.

After she is arrested, Barbara is flogged, but the whip transforms into peacock feathers.

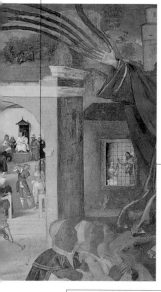

Christ visits Barbara in prison and cures her wounds.

Dioscorus is reduced to ashes by a lightning bolt, a just punishment for this man who had executed his own daughter.

An angel comes to Barbara's aid and covers her with a white cloak.

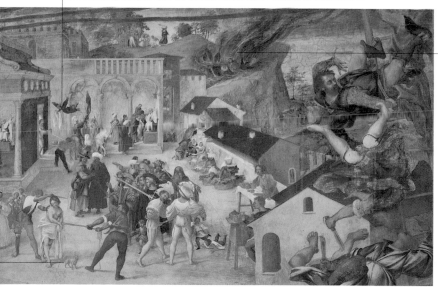

Barbara's devotion to the Trinity is represented by a sculpture. In art the saint is typically shown with the three windows that she has installed in the tower.

The tower where Dioscorus will imprison his beautiful daughter is being built.

While her father was away, Barbara converted to Christianity and studied the Scriptures.

▶ Robert Campin, *Saint Barbara*, 1438. Madrid, Prado.

His attribute is the knife with which he was skinned alive; he often carries his skin draped over his arm. In Spanish painting, he typically holds a demon in chains.

Bartholomew

Apostle

The Saint Bartholomew of the synoptic Gospels, according to a recent interpretation by biblical scholars, was probably the same figure as the Nathaniel of John's Gospel. Nathaniel, or Bartholomew, came to know Jesus through Saint Philip. Upon seeing him, Jesus said, "Behold a true Israelite, in whom there is no guile." Roman Martyrology tells of how he preached in India and Armenia. *The Golden Legend* gives a precise description of the saint ("His hair is black and crisped, his skin fair, his eyes wide, his nose even and straight, his beard thick and with a few gray hairs...."). It tells how in India he defeated demons that encouraged idol worship and converted the king of the region, Polemius, with his whole family after curing their possessed daughter. Bartholomew was captured by Polemius's brother, King Astrages, who had the apostle flayed and crucified, perhaps with his head down. According to another tradition, Bartholomew was beheaded.

Name
From the Aramaic Bertalemy, which means, "son of Talamy"

Earthly Life
First century A.D.

Characteristics and Activity
Apostle of Jesus; he possibly preached in India and suffered martyrdom there

Patron
Plasterers, tailors, leatherworkers, bookbinders, butchers, glove makers, farmers, housepainters, and tanners

Connections with Other Saints
The Twelve Apostles

Feast Days
August 24, August 25 in Epternach and Cambrai, June 13 in Iran

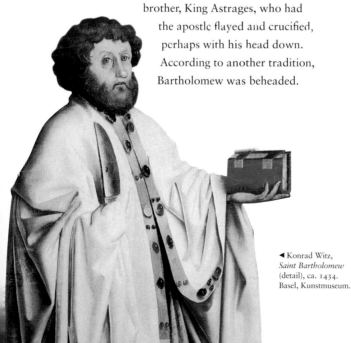

◄ Konrad Witz, *Saint Bartholomew* (detail), ca. 1434. Basel, Kunstmuseum.

Michelangelo, ▲ *Saint Bartholomew* (detail), from *The Last Judgment*, 1536–41. Vatican City, The Sistine Chapel.

51

Bartholomew

Bartholomew suffers martyrdom
as if he were lying on a surgeon's
operating table.

Images of Bartholomew being skinned
alive were especially common during the
course of the sixteenth century, because
of a particular interest in anatomy and
science, skin being detached from the
body became this saint's attribute in art.

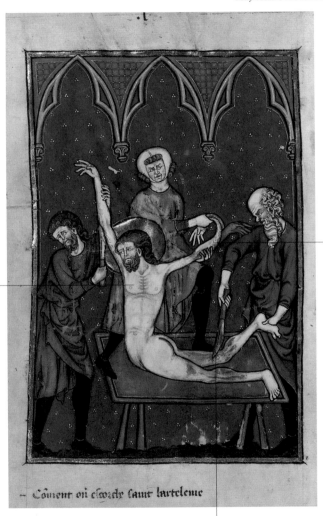

▲ Saint Bartholomew Skinned Alive, from
the Livre d'Image de Madame Marie,
ca. 1300. Paris, Bibliothèque nationale.

A knife that Bartholomew was martyred
with also became his emblem.

Basil is a mature man who usually wears a beard and bishop's vestments. A book and the dove of inspiration are among his attributes.

Born in A.D. 329 into an illustrious and religious family, Basil enjoyed the best education in Caesarea, Constantinople, and Athens. He became a monk, and before choosing a hermit's life, he spent some time in Syria and Egypt. From his hermitage in New Caesarea he practiced and preached a life of contemplation and stayed in close contact with Saint Gregory Nazianzen, who had been his classmate. He was forced to abandon his hermitage in 364, when the bishop of Caesarea called him to defend the church from the persecutions of Valens, an Arian emperor. Basil became bishop of the Caesarea diocese in 370. His pastoral activity was primarily focused on halting the unorthodox Arianism that the emperor enforced. A protector of individual liberties from political power, Basil combated heresy with a solid theology. The Council of Constantinople (381) later adopted his position. Basil was also outstanding in his charitable works, having distributed his inheritance to the poor and having organized aid for the needy. He authored many doctrinal writings, especially on the Holy Spirit.

Basil
the Great

Name
Originally Greek,
meaning "royal"

Earthly Life
A.D. 329–379,
Caesarea, Cappadocia

**Characteristics
and Activity**
Fought against the
Arian heresy and wrote
a rule for Eastern
monasticism

**Connections with
Other Saints**
Together with saints
Gregory Nazianzen,
John Chrisostom, and
Athanasius, Basil is
one of the four Fathers
of the Eastern Church

Venerated
His cult spread rapidly
in the West thanks to
Greek monks and Saint
Benedict, who felt that
the inspiration of the
"holy father Basil" was
fundamental

Feast Days
January 2 in the West,
January 1 in the East

▲ Pskov School, *Basil the Great* (detail), from the fifteenth century. Moscow, Tret'jakov Gallery.

▶ Domenichino, *Saint Basil*, 1608–10. Grottaferrata, Abbey, Santi Fondatori Chapel.

The meeting between the bishop
Basil and the emperor Valens hap-
pened in church, where the emperor
asked Basil to explain himself.

Basil, who had
been threatened
by a high-
ranking official
to accept
Arianism, had
refused to see
the emperor.

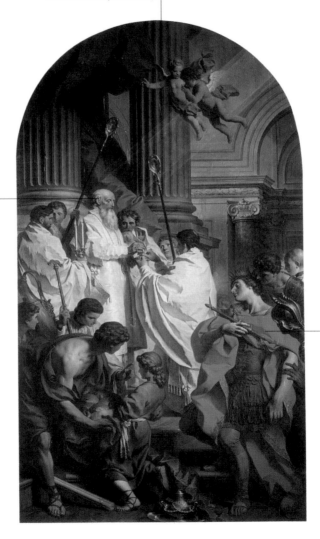

Standing before
Basil, who had
refused to
submit to
Arianism, the
emperor stag-
gers and faints.

▲ Pierre Hubert Subleyras, *Basil
and Emperor Valens*, from the first
half of the eighteenth century.
Saint Petersburg, Hermitage.

Bavo is typically shown as a hermit near a hollowed tree with the stone he used as a pillow. In acknowledgement of his noble origins, he is also portrayed as a knight with a sword and falcon.

Bavo

Bavo was born in A.D. 585 into a noble family of Brabant, present-day Belgium. When he was young, his life was privileged and depraved, and this continued even after his marriage to Agletrude, the beautiful daughter of a Merovingian count. After Agletrude's unexpected death, however, Bavo's life was in such upheaval that he decided to give all his belongings to the poor and convert with the help of Saint Amandus. His life was changed; he became a Benedictine monk at the monastery of Saint Peter in Ghent, which later took his name, and dedicated himself to missionary work in Flanders together with Amandus. In later years, he preferred solitude and completely embraced a hermit's life, living in a hollowed tree in a forest near Ghent. He died around 655. Images of Bavo frequently allude to his noble origins, showing him as a knight with a falcon. Artists also preferred to depict him as a hermit near his hollowed tree. It is said that he healed a number of people, and sometimes a man who had been run over by a cart and saved by Bavo is shown at the saint's feet.

Name
Germanic in origin

Earthly Life
Fifth and sixth
centuries, Belgium

**Characteristics
and Activity**
Left a privileged life to
serve the poor and
bring the gospel
message to his
country before
becoming a hermit

Patron
Invoked against
whooping cough

**Connections with
Other Saints**
Saint Amandus of
Maastricht, whom
Bavo converted

Feast Day
October 1

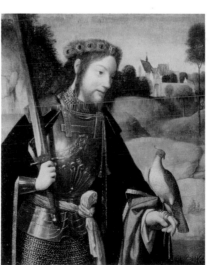

▶ Geertgen tot Sint Jans,
Saint Bavo, ca. 1500.
Saint Petersburg, Hermitage.

Hieronymus Bosch, ▲
Saint Bavo, a detail from
the exterior panel of the
*Universal Judgment
Triptych*, ca. 1510.
Vienna, Gemäldegalerie
der Akademie der
bildenden Künste.

Benedict
Abbot

Dressed in the typical black robe of an abbot, at times with a white cowl, Benedict is featured with the book of the rule he wrote, a crosier, a crow with bread in its beak, a chalice of snakes, a cane, and a bundle of sticks.

Name
Originally Latin, it derives from a form of "to bless," meaning "he who is blessed"

Earthly Life
About A.D. 480–547, Italy

Characteristics and Activity
Founded a new form of monastic life based on liturgical prayer and manual labor (*ora et labora*); considered the founder of Western monasticism

Patron
Farmers, Italian architects, chemists, engineers, speleologists

Special Devotions
Proclaimed patron saint of Europe in 1964

Connections with Other Saints
Scholastica, his sister; Maurus and Placidus

Feast Day
July 11

▲ Hans Memling, *Saint Benedict* (detail), 1487. Florence, Uffizi.

▶ Roman-Byzantine School, *Saint Benedict*, from the eighth century. Subiaco, Sacro Speco.

Benedict was born in Norcia, in Italian Umbria, around A.D. 480. He concluded his liberal studies in Rome, where he risked being caught up with the corrupt Roman youth. However, he preferred to retreat in silence and prayer in the forests of the Aniene River valleys at the border between Lazio and Abruzzo. Around 500 he took up residence in a cave near Sublacum, where he began life as a hermit. Many disciples followed him, and he founded a number of monasteries in the valley of the Aniene. Unfortunately, he aroused jealousy and envy in other religious friars, and, according to the *Golden Legend*, the monks of a nearby monastery attempted to rebel against the rigid discipline he imposed and poison him. His attributes derived from this episode include the cane he used to punish one of the monks—not to be confused with the bundle of twigs that symbolizes the norms collected in the Rule of Saint Benedict— and the chalice of snakes. Benedict later moved to Monte Cassino and founded the famous monastery there. A month before dying, he met with his sister Scholastica, who founded the women's branch of his order, and had a famous conversation with her. He died on March 21, 547.

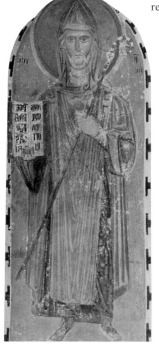

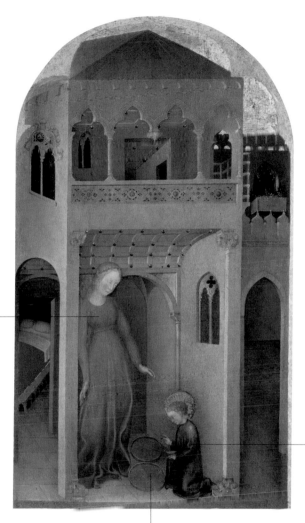

Benedict's nurse
borrowed a sieve
that fell and broke.

Benedict carries
out his first
miracle as a
young child.

After seeing his nurse cry,
Benedict reassembles the
sieve by praying to God.

▲ Gentile da Fabriano and Niccolò di
Pietro, *Saint Benedict Fixes the Broken Sieve
as a Child*, ca. 1415–20. Florence, Uffizi.

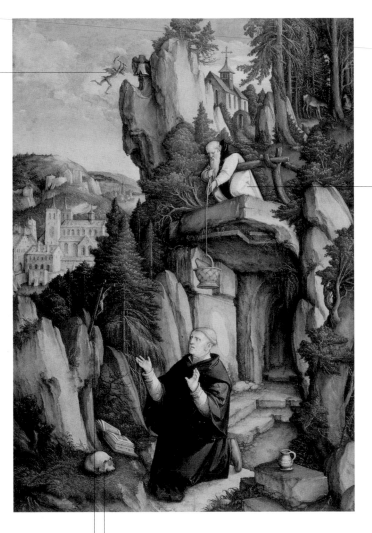

A demon breaks the bell that the monk Romanus used to let the saint know that he had brought food for him. As a result, Benedict did not eat for a number of days.

The skull is a symbol of the vanity of all earthly things that are destined to pass.

Romanus brought food to Benedict, who had retreated to a hidden cave near Sublacum.

The crucifix is an attribute of hermits.

▲ Master of Messkirch, *Saint Benedict the Hermit*, ca. 1540. Stockholm, Staatsgalerie.

Benedict appears
twice in this image.

The field
worker watches
as his scythe is
recovered.

Benedict is shown in a
black habit with the book
of the rule that he wrote.

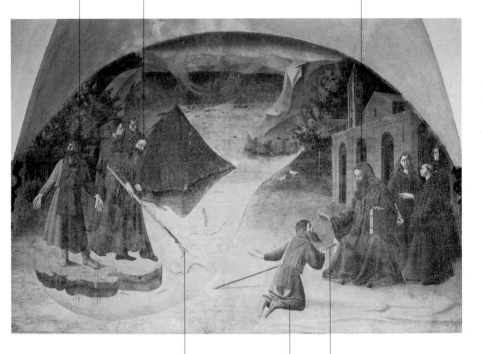

Benedict
recovers the
scythe from a
deep lake.

A poor field
worker begs
Saint Benedict to
help him recover
his lost scythe.

Only the wooden
shaft was left, with-
out the scythe blade.

▲ Master of Chiostro degli Aranci,
*Benedict Recovers a Scythe That Had
Fallen into a Lake*, ca. 1439. Florence,
Badia Fiorentina Cloister.

Benedict

▼ Sodoma, *Stories of Saint Benedict*,
ca. 1503. Monteoliveto Maggiore, Abbey.

*Benedict is at the
table with his monks.*

*The Crucifixion was normally
frescoed at the south end of the
dining hall.*

*According to custom, silence is
observed during the collective
meal as a monk reads aloud
from the Scriptures.*

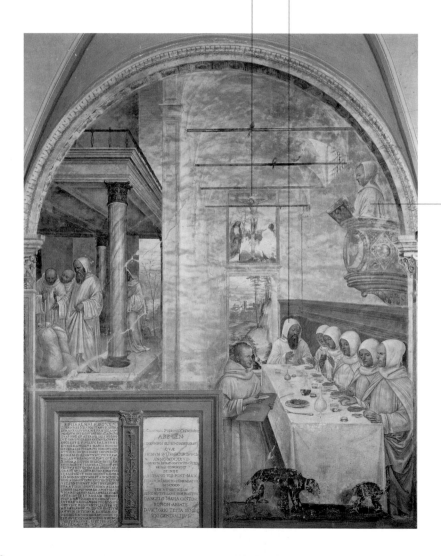

Depicted in a white habit holding an abbot's pastoral staff, Bernard often appears with a miter at his feet, a host of the Eucharist, a chained demon, a white dog, a book (as would a Doctor of the Church), and a beehive to symbolize his sweet eloquence.

Bernard

Bernard was born into a rich and noble family of Fontaines, near Dijon, France, in 1090. After having finished his secular studies, he entered the Benedictine order when he was twenty-two, together with thirty-one others, at Cîteaux, a reformed monastery in Burgundy where he would later found the Cistercian order. In 1115 Bernard was named abbot of a new monastery in Clairvaux, the first of many to be founded. The abbot was criticized at first by his order for being excessively severe, but he improved the conditions of the monastery, reducing the amount of time dedicated to prayer, improving the food, and consolidating the monastery's position with the help of the local bishop. His many writings—*Letters, De amore Dei* (On the love of God), and especially his sermons on the Canticle of Canticles—express the contemplative dimension of his spirit. He died in 1153. He is typically portrayed in the white robe of the Cistercians and the pastoral staff of an abbot. He is hardly ever shown wearing a miter, but this bishop's hat is most often placed at his feet, a symbol of his refusing that role. The symbol of the white dog originated from a dream his mother had as she carried him in her womb; this was interpreted as the coming of a dog to guard God's house and warn against evildoers.

Name
Germanic in origin, meaning "strong as a bear" or "strong bear"

Earthly Life
About 1090–1153, France

Characteristics and Activity
Founded the Cistercian order, which by the time of his death had multiplied its monasteries throughout Europe; preached during the Second Crusade

Patron
Beekeepers and candle makers because of his nickname, Mellifluous Doctor; sandpit workers

Connections with Other Saints
Bruno

Venerated
Even before his death

Feast Day
August 20

Reliquary Cover (detail), from ▲ the second quarter of the eighteenth century. Veroli, Cathedral.

Pier Francesco Foschi, *Madonna* ◄ *Enthroned with the Child and Saints Benedict and Bernard* (detail), ca. 1540. Florence, Barnaba.

Bernard

The Virgin Mary appears to Bernard as the abbot is writing one of his sermons.

The saint is meditating on the gospel story of the angel's Annunciation to Mary.

▶ Filippino Lippi, *The Madonna Appears to Saint Bernard*, 1486. Florence, Badia.

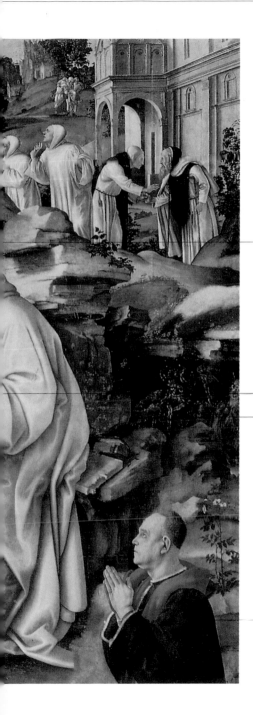

Substine et abstine, or *"suffer and abstain,"* is a motto exhorting the monks to submit to abstinence. The phrase sums up the reforming work of Bernard.

The austerity of this saint's life can be seen under his cowl, where sleeves of sackcloth are noticeable.

An attribute of Bernard's is a demon in chains, a symbol of victory over temptation.

Piero Pugliese commissioned this work. He paid 250 ducats for it.

The story of Saint Bernard's embrace of the crucified Christ, who allows him to drink the blood that flows from the wound in his side, was commonly portrayed after the Council of Trent (1563). This work is an early example.

The writing of Jesus' condemnation, "Jesus the Nazarene, king of the Jews," can be seen on his cross.

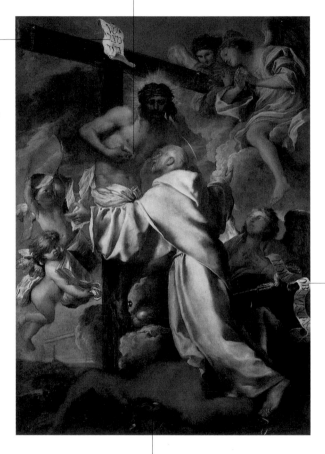

On the abbot's pastoral staff lies a piece of paper with his 1133 call to peace, which was addressed to the people and governing officials of Genoa.

Once again Bernard's attribute of a demon in chains, a symbol of victory over temptation, is present.

▲ Giovanni Benedetto Castiglione, *The Crucified Christ Embraces Saint Bernard,* after 1462. Genoa, Sampierdarena, Chiesa di Santa Maria della Cella e San Martino.

Bernardino is typically clad in a Franciscan cowl and is identifiable because of his worn appearance. Among his attributes are the name of Jesus (IHS) and three miters at his feet.

Bernardino
of Siena

Bernardino was born in 1380 at Massa Marittima, in Italian Tuscany, into a noble Sienese family, the Albizeschi. He became an orphan at the age of three and was raised in Siena by his uncle and aunt. During the plague of 1400, he tended to the sick in a hospital together with some friends. After the epidemic, he cared for his ailing aunt until her death. In 1404 he became part of the Order of Friars Minor, was ordained a priest, and, in 1417, traveled throughout Italy preaching. Bernardino was adept at identifying the evils of society and reawakening people's faith. He promoted devotion to the holy name of Jesus, which became his main attribute in imagery. Bernardino was named vicar general for the friars of the Strict Observance in 1437, and became one of the greatest supporters of their reform. He wrote theological treatises and organized theology schools, declaring that for a friar, ignorance was just as dangerous as riches. He refused the position of bishop three times, in Siena, Ferrara, and Urbino; in art these acts are symbolized by three miters placed at his feet. He died at Aquila as he was journeying toward Naples in 1444.

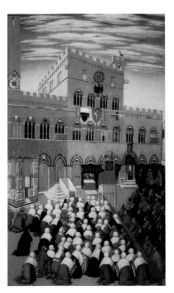

▲ Ferrara artist, *Saint Bernardino of Siena* (detail), ca. 1480. Crema, Museo Civico Ala Ponzone.

▶ Sano di Pietro, *Saint Bernardino Preaches at Piazza del Campo*, ca. 1445. Siena, Duomo.

Name
A diminutive form of Bernard, which was originally Germanic and meant "strong as a bear" or "strong bear"

Earthly Life
1380–1444, Italy

Characteristics and Activity
A priest belonging to the Franciscan order and a ceaseless preacher of penance and poverty to combat gambling, usury, superstition, and political struggle.

Patron
Preachers, advertisers, wool workers, weavers, and boxers

Special Devotions
Invoked against hemorrhages and hoarseness

Venerated
Canonized four years after his death by Pope Nicholas V

Feast Day
May 20

Blaise

Blaise is shown in a bishop's clothing. Among his attributes are the comb for wool that he was tortured with and the candles that were brought to him in prison. Sometimes he is shown with a pig.

Name
Originally Latin, meaning, "stutterer"

Earthly Life
Fourth century, Armenia

Characteristics and Activity
Bishop of Sebastea; beheaded during the persecutions of the emperor Licinius

Patron
Doctors, stonemasons, shepherds, farmers, wool carders, wind-instrument players, mattress makers, and laryngologists

Special Devotions
Invoked against sore throats

Connections with Other Saints
One of the Fourteen Holy Helpers

Venerated
The first evidence of his cult dates to the eighth century

Feast Day
February 3

▲ Hans Memling, *Saint Blaise* (detail), from the *Lubecca Triptych,* 1491. Lubecca, Sankt-Annen-Museum.

The limited number of sure facts about Saint Blaise include that this proper young Christian was elected bishop of Sebastea in present-day Turkey, then decapitated during the persecutions of the emperor Licinius at the beginning of the fourth century. Later traditions gathered in the *Golden Legend* add many details to enrich his story. During the persecutions of Diocletian, Blaise hid in a cavern and lived as a hermit in prayer. Discovered by a group of nobles who were hunting in that region, he decided to return and preach the gospel. His symbols are linked to a number of episodes in his life. One woman brought her son, who was about to suffocate after swallowing a fish bone, to the future saint. Blaise saved the boy by praying and holding his hands over the child. He later ordered a wolf to return the pig it was about to devour to the woman it had been stolen from. This woman visited Blaise in prison after he was arrested for his faith, and she brought him a candle and the same pig. These became attributes for the saint. Blaise was probably beheaded in A.D. 316 after having been tortured with iron combs that shredded his skin.

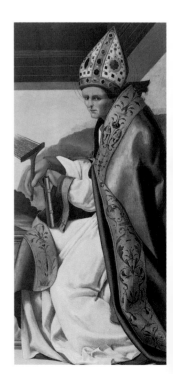

▶ Pedro Fernández de Córdoba, *Saint Blaise,* ca. 1511–12. Barcelona, Museu Nacional d'Art de Cataluña.

A bishop's attire is Saint Blaise's primary artistic attribute.

By laying his hands on him and praying, Saint Blaise saved a child who was suffocating after having swallowed a fish bone.

The child's mother brought him to Saint Blaise

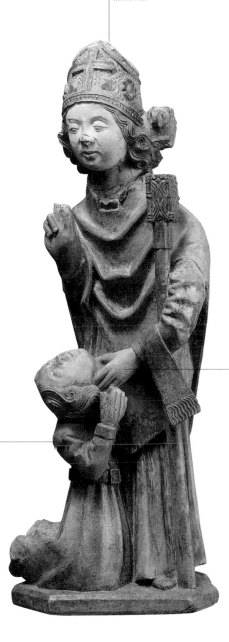

▶ Portuguese School, *Saint Blaise*, 1475–1500. From a private collection.

One of Saint Blaise's
main attributes is a
bishop's hat, or miter.

Saint Blaise was inflicted with a
particular form of torture: his body
was lacerated with iron wool combs.

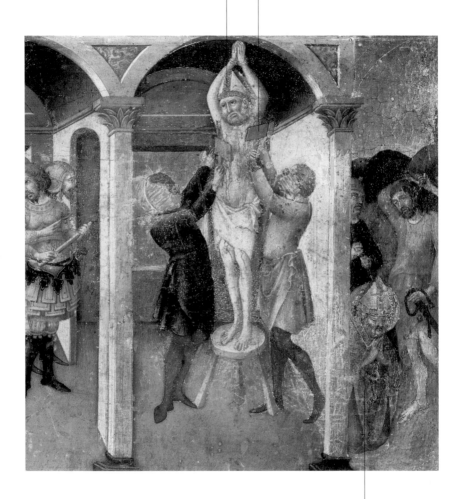

Saint Blaise is beheaded.

▲ Sano di Pietro, *The Martyrdom of
Saint Blaise* (detail), from the fifteenth
century. Siena, Pinacoteca Nazionale.

Bonaventure normally wears a cardinal's hat and robes over a Franciscan habit. Among his attributes are the book, crucifix, angel, and monstrance.

Bonaventure

Bonaventure was the name taken by Giovanni Fidanza—the son of a doctor from a noble family of Bagnorea, near Orvieto, Italy—as he entered the Franciscan order. He completed his theology studies in Paris, earned his teaching license in 1248, and became a teacher at the Franciscan school in Paris in 1253. He held that the divine mysteries should be approached less rationally and through prayer, which was a clear departure from Saint Augustine. Bonaventure was elected minister general of the Franciscans in 1257. The number of brothers had risen, and there were rivalries between various factions that each declared their fidelity to Saint Francis. The young minister refuted the extreme position of the Spirituals and was wary of brothers who were suspected of heresy. In 1273 he accepted his appointment as cardinal and bishop of Albano after having evaded the position of archbishop of York in 1265. His presence was a determining factor at the Council of Lyons in the move toward unity with the Greek Church. Since his canonization as a saint was delayed, his presence in art was rare until the sixteenth century. He is usually portrayed wearing a cardinal's clothing over a Franciscan habit. The mantle, or cope, of this Seraphic Doctor (*doctor seraficus*) has a border decorated with seraphim, the highest order of angels.

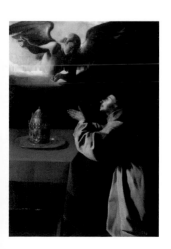

◀ Francisco de Zurbarán, *Saint Bonaventure in Prayer* (detail), 1627. Dresden, Gemäldegalerie.

Name
A well-wishing name meaning "good luck"

Earthly Life
About 1218–1274, Italy and France

Characteristics and Activity
Franciscan friar elected minister general of the order who played a fundamental role, often called the "second founder of the order" and Seraphic Doctor

Patron
Theologians, farmers, porters, and weavers

Connections with Other Saints
Francis, Thomas Aquinas

Venerated
There are no traces of an immediate cult in his honor; he was canonized in 1482 and declared a Doctor of the Church in 1588

Feast Day
July 15

Cavazzola, *Saint Bonaventure* ▲ (detail), from the beginning of the sixteenth century. Verona, Museo di Castelvecchio.

Bonaventure

The king of Aragon attended the funeral of Bonaventure, who died in Lyons.

Pope Gregory X had named Bonaventure cardinal of Albano; here he gives him last rites on his deathbed.

Saint Bonaventure is depicted wearing a bishop's attire over a Franciscan cowl.

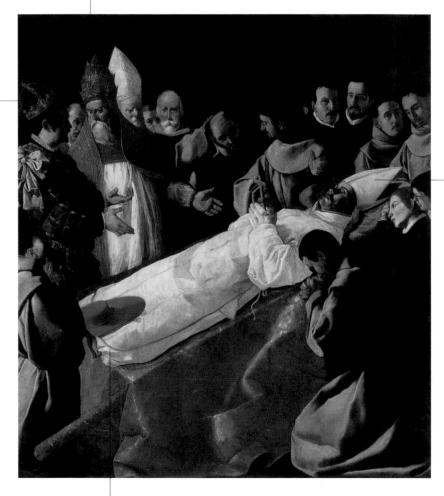

A cardinal's hat is sometimes shown hanging from a tree. When the hat was brought to Bonaventure for the first time, he was working in the kitchen; instead of putting the prestigious hat on immediately, he decided to finish cooking.

▲ Francisco de Zurbarán, *The Burial of Saint Bonaventure*, 1627. Paris, Musée du Louvre.

Bridget is dressed either as a widow, a pilgrim, an abbess, or a noblewoman. She may hold the Brigettine cross, and her heart may have a cross that sprouts from it. She is also shown either with a monogram of Christ (IHS), a candle (since she used to pour hot wax on her hands each Friday), a book, a pen, or an inkwell.

Bridget was born in Finstad, Uppsala, in Sweden, and was the daughter of the governor of Upland. When she was fourteen she married the nobleman Ulf Gudmarrson and had eight children with him. In 1335 she was invited to the royal court to be a lady-in-waiting of Queen Blanche of Namur, the wife of King Magnus II. Bridget's arrival at court had a strong influence there because she was detached from worldly conveniences and, above all, because she cared for those in need. With her husband, she departed on a pilgrimage to Santiago de Compostela in Spain, and upon their return, Ulf retreated to the Cistercian monastery of Alvastra, where he died in 1344. As a widow, Bridget founded the Order of the Most Holy Savior, or Brigettines, at the convent of Wadstena, which featured women and men who shared a prayer life together. Bridget traveled to Rome in order to obtain the pope's approval for the new community, and she died there in 1373. In art she is sometimes portrayed with two scrolls that represent the men and women who followed her.

Bridget
of Sweden

Name
Celtic in origin; in the Middle Ages, Bridget was a variation on Brigantia, a local goddess, meaning "tall"; therefore, "tall, strong, and powerful"

Earthly Life
1303–1373, Sweden

Characteristics and Activity
A widow, she devoted herself to an ascetic and contemplative life; this Franciscan tertiary founded a new order of men and women dedicated to the Most Holy Savior; her *Revelations* was widely read

Patron
Pilgrims, travelers, Sweden

Connections with Other Saints
Saint Catherine of Sweden was her daughter; Bridget followed Saint Augustine's rule

Feast Day
July 23

Giovanni di Francesco, ◄ *Madonna and Child with Saint Bridget and Saint Michael* (detail), 1440. Los Angeles, J. Paul Getty Museum.

Brigid is depicted in the white habit of an abbess with a black veil. A cow often lies at her feet in memory of the days when she tended the animals of the convent, and sometimes she holds a candle.

Brigid
of Ireland

Name
Celtic in origin; in the Middle Ages, Bridget was a variation on Brigantia, a local goddess, meaning "tall"; therefore, "tall, strong, and powerful"

Earthly Life
Fifth and sixth centuries, Ireland

Characteristics and Activity
Founder and abbess of the convent of Kildare

Patron
Milkmen, poets, blacksmiths, healers, cows, and yard animals

Connections with Other Saints
Traditionally, Saint Patrick baptized her

Venerated
Widely venerated in Ireland and churches of Irish origin in the rest of Europe

Feast Day
February 1

There are very few historical facts concerning Saint Brigid. Biographies written shortly after her death (around A.D. 525) are connected to Irish pagan traditions. She is said to have been born into a poor family of Faughart, a few miles from Kildare in the county of Leinster, Ireland, and to have been baptized by Saint Patrick. While still very young, Brigid chose a religious life and founded the convent of Kildare. Her biographies trace a life that seems to be the very personification of charity; its most famous episodes range from the multiplication of food, the ability to calm storms, and the distribution of butter to the poor, to the extraordinary transformation of water into beer. Initially her task at the monastery was to tend the cows, and thus her image—a nun in a white habit and black veil—often includes a cow.

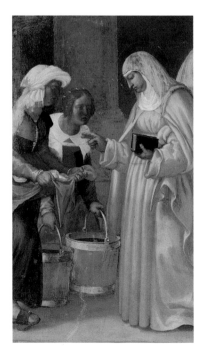

◄ Lorenzo Lotto, *Saint Brigid Blesses Water and Transforms It into Beer* (detail), 1524. Trescore Balneario, Oratorio Suardi.

He wears the white robe of the Carthusians. Among his attributes are the crucifix, a skull, a miter at his feet, the cross with green olive leaves, and seven stars. He sometimes stands on a globe as a sign of his disdain for earthly things.

Bruno

Bruno was born in Cologne, Germany, around 1032. He became a clergyman at the church of Saint Cunibert in Cologne, and in 1056 he transferred to Reims, France, where he was a lecturer in grammar and theology at the cathedral school for eighteen years. Spurred by his desire to become a monk, Bruno left Reims, lived for a while as a hermit, and then moved to the diocese of Grenoble. There Bishop Hugo offered Bruno and his followers the territory of Carthusia, where an oratory surrounded by cells was built. The rule of the new order joined the religious life inspired by Saint Benedict with the lifestyle of monks in Egypt and Palestine. Six years later, Bruno moved to a hermitage amid the ruins of the Baths of Diocletian in Rome, after being called there by Pope Urban II to develop an ecclesiastical renewal. He was offered the position of archbishop in Reggio Calabria but instead founded a new hermitage at La Torre, where he died in 1101.

Bruno's image in art, with his white Carthusian habit, sometimes features his arms crossed over his chest or his forefinger over his mouth, a sign of the silence imposed by his order. Other special attributes of his are three olive branches that echo Psalm 52 ("But I am like a green olive tree in the house of God") and seven stars from Saint Hugo's vision, which represented Saint Bruno and his first companions.

Name
Originally Germanic, meaning "of brown color"

Earthly Life
About 1032–1101, Germany and France

Characteristics and Activity
Founder of the Carthusian order

Patron
The Carthusian order

Special Devotions
Invoked against the plague

Connections with Other Saints
Hugo, the bishop of Grenoble, helped Bruno and his companions by giving them land in Carthusia

Venerated
Bruno was actually never canonized; his cult was spread by the Carthusians in the fifteenth century

Feast Day
October 6

Jusepe de Ribera, ▲ *Saint Bruno* (detail), 1634. Weimar, Kunstsammlungen.

◀ Nicholas Mignard, *The Vision of Saint Bruno* (detail), 1638. Avignon, Musée Calvet.

73

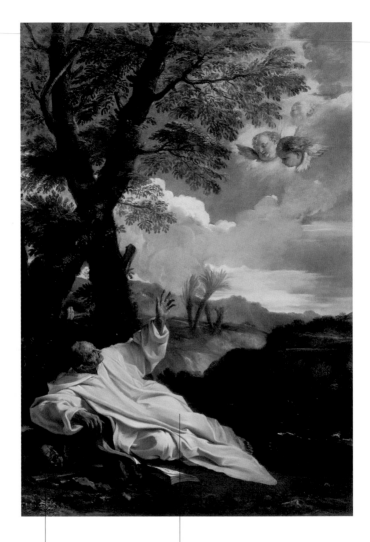

The skull is a typical
hermit's emblem, since it
symbolizes the transience
of earthly things.

Bruno wears the white
habit of the Carthusians.

▲ Pier Francesco Mola, *The Vision of
Saint Bruno,* ca. 1660. Los Angeles,
J. Paul Getty Museum.

The saint is typically dressed as a cleric with a black cassock and white surplice. His attribute is a winged heart. This "hunter of souls for Heaven" often holds either the child Jesus in his arms, a rosary, a skull (a symbol of penance), or a lily.

Cajetan

Cajetan, or Gaetano, was born in 1480 in Vicenza, Italy, into a noble Thienese family. He studied law at the University of Padua, and after becoming a cleric, he moved to Rome. There Pope Julius II requested he take on the tasks of special secretary and pronotary. Working in close contact with the Roman Curia, he felt a pressing need to revive the spirit of the clergy, and with Peter Caraffa (the future Pope Paul IV), he introduced the Oratory of Divine Love in Rome. He was ordained a priest in 1506. Together with Caraffa in 1524, he founded the Theatines (from the Latin form of Chieti—Theate—where Caraffa was bishop), gave up all his material belongings, and dedicated himself to the community. That same year Pope Clement VII approved the institute, which aimed at spiritual and corporal charity. Later Cajetan founded other houses in Naples and Venice, promoting charitable works such as benevolent pawnshops (*montes pietatis*) to eradicate usury and hospices for the terminally ill. He dedicated himself to outreach among the poor and was opposed to Protestant doctrines (such as that of the Waldensians) that were infiltrating society at the time. He eventually died in Naples in 1547.

Name
Originally Latin, *caetanum*, which indicated provenance from Caeta, present-day Gaeta, Italy

Earthly Life
1480–1547, Veneto, Rome, and Naples

Characteristics and Activity
Founded a congregation of priests called the Theatines to restore the true apostolic life to the clergy; they were so named because they were founded with the bishop of Chieti (Theate in Latin)

Patron
The Theatines

Venerated
Canonized by Pope Clement X in 1671

Feast Day
August 7

Giovanni Battista ▲ Piazzetta, *Saint Anthony of Padua, Saint Cajetan of Thiene, and a Guardian Angel* (detail), from the first half of the eighteenth century. Venice, San Vidal.

► Giovanni Battista Tiepolo, *The Apotheosis of Saint Cajetan of Thiene* (detail), ca. 1757. Rampazzo, Parish church.

She is a young noblewoman who often wears a crown. Among her attributes are the Catherine wheel, an instrument of torture; the palm branch, a prize for martyrdom; the sword with which she was beheaded; and a mystical marriage ring.

Catherine
of Alexandria

Name
From the Greek, *kataros,* or "pure"

Earthly Life
Fourth century, Egypt

Characteristics and Activity
Martyred after opposing Maxentius's persecutions

Patron
Orators, philosophers, notaries, tailors, milliners, spinners, wainwrights, nannies, and nurses because milk flowed from her severed head

Special Devotions
Invoked for nursing babies, by castaways, and against migraine headaches

Connections with Other Saints
One of the Fourteen Holy Helpers and the Quatuor Virgines Capitales

Venerated
Her cult dates from the ninth century, when it was believed that angels brought her body to Mount Sinai

Feast Day
November 25

Information regarding Catherine of Alexandria has legendary origins. According to the *Golden Legend*, she was a beautiful young Christian, the only daughter of King Costus, and confronted the emperor Maxentius about his persecution of Christians. Failing to convince her to make sacrifices to the Roman gods, Maxentius sent for the wisest of men to dispute with her, and fifty philosophers and orators arrived and attempted to dissuade her from her faith in Christ. Catherine rebutted their claims so well that they converted. This, of course, roused the emperor's wrath, and he condemned the wise men to be burned on a pyre. Catherine was sentenced to imprisonment and starvation. During the next twelve days, Christ sent a dove to bring her nourishment. Maxentius then decided to execute her with spiked wheels. The wheels, however—which eventually became her symbol in art—were broken through divine intervention, and the young woman was saved. In the end, she was beheaded, and milk flowed from her severed neck.

▲ Jacobello del Fiore, *Saint Catherine of Alexandria and Saint Mary Magdalene* (detail), from the first half of the fifteenth century. Venice, Chiesa di San Giovanni in Bragore.

◀ Rogier van der Weyden, *Saint Catherine of Alexandria* (detail), 1426–30. Vienna, Kunsthistorisches Museum.

Saint John the Baptist wears sheepskin under his cloak—an interpretation of the gospel description of the hermit's clothing.

There is a huge fire in the background; the emperor Maxentius ordered that the wise men who converted after arguing with Catherine be burned on a pyre.

Saint John the Evangelist holds a chalice in memory of the poison that he was forced to drink when he refused to offer sacrifices to Artemis.

Catherine is shown richly dressed and wears a crown, recalling her royal origins.

Images of Catherine's mystical wedding surfaced in the fifteenth century, probably because her traditional symbol, the wheel, was sometimes so tiny that it resembled a ring.

Saint Catherine has the symbols of her martyrdom at her feet: the jagged wheel that was broken and the sword with which she was beheaded.

Saint Barbara reads a book, a sign of her knowledge of the Scriptures. Behind her is the tower where she was imprisoned by her father.

▲ Hans Memling, *Madonna Enthroned and Child with Four Saints*, ca. 1474–79. Bruges, Memlingmuseum.

Catherine of Alexandria

Emperor Maxentius had tried to convince Saint Catherine to renounce Christ. Not succeeding, he ordered that she be killed with spiked wheels.

Divine intervention interrupts the atrocious torture. An angel descends from Heaven, armed with a sword to destroy the spiked wheel that is about to tear into Catherine.

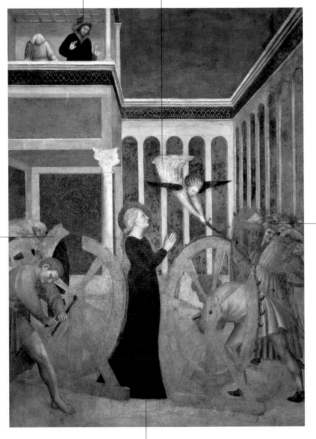

Here the instrument of torture has been broken just before shredding its young victim.

The crowd watching Catherine's martyrdom seems terrified by the extraordinary event. According to the Golden Legend, fragments of the wheel fell upon the spectators and killed them.

Standing with her hands clasped in prayer, Catherine looks toward the angel as if she had been expecting him, a sign of this saint's steady faith.

▲ Masolino da Panicale, *The Martyrdom of Saint Catherine*, from the beginning of the fifteenth century. Rome, San Clemente.

Thanks to miraculous intervention, the spiked wheels break.

Saint Catherine wears a crown, and she is represented in an extremely elegant dress that is worthy of a princess.

An angel waits with a white shroud to wrap Catherine's body and bring it to Mount Sinai.

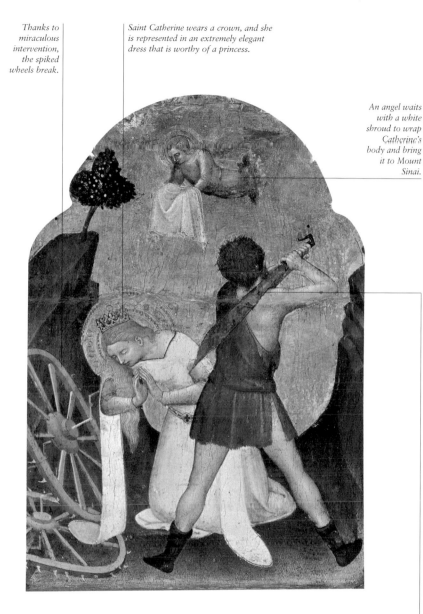

▲ Giovanni da Milano, *The Beheading of Saint Catherine*, ca. 1350. Prato, Galleria Comunale.

The sword that beheads Catherine becomes her secondary emblem in art.

Catherine is clothed in a Dominican habit. She is marked by stigmata and holds a cross, a lily, or a book.

Catherine
of Siena

This saint was born in 1347, the twenty-fifth child of Giacomo Benincasa, a wool dyer of Siena, Italy. After a vision she had, she decided at an early age to remain a virgin and entered the third order of the Dominicans when she was eighteen. Although her parents were opposed to it, she led a life of intense sacrifice for a number of years, dedicating herself to prayer and remaining cloistered in her room at home. In 1370 she decided to open herself up to the world outside and was committed to aiding the sick in the hospital. She formed a group of disciples who followed her on various prayer trips she took. Her mysticism and ideals survive in the various writings that she dictated, from *Dialogue* to *Letters*. She intervened in huge disputes that afflicted her city, Florence, and the papacy. She urged Pope Gregory IX to leave his Avignon "captivity"—when the papacy was too influenced by French politics—and return to Rome. When an antipope was later elected in Avignon, she supported Pope Urban VI and wrote a number of letters to the pope, heads of state, and cardinals across Europe. She died in Rome on April 29, 1380. Among the

Name
Originally Greek, meaning, "pure"

Earthly Life
1347–1380, Siena

Characteristics and Activity
Dominican tertiary, at first she led a life a prayer and penitence; later she occupied herself with the problems of the Church, encouraging the pope at Avignon to return to Rome

Patron
Nurses, Italy

Special Devotions
Invoked against the plague, migraine headaches, and for a good death

Venerated
Proclaimed patron saint of Italy in 1939, and a Doctor of the Church in 1970

Feast Day
April 29

▲ Andrea di Vanni d'Andrea, *Saint Catherine of Siena* (detail), ca. 1390. Siena, Chiesa di San Domenico.

episodes in her life most commonly shown in art is the moment at which she received the stigmata.

◄ Domenico Beccafumi, *Saint Catherine of Siena Receiving the Stigmata* (detail), 1513–14. Los Angeles, J. Paul Getty Museum.

Pope Gregory IX seems to
bless the saint and signal his
acceptance of her words and
his decision to leave Avignon.

Saint Catherine speaks with
authority to the pope, attempting
to convince him to return to
Rome and bring an end to his
Avignon "captivity."

Giovanni di Paolo, *Saint Catherine* ▼
Before the Pope in Avignon, ca. 1460.
Madrid, Thyssen-Bornemisza Museum.

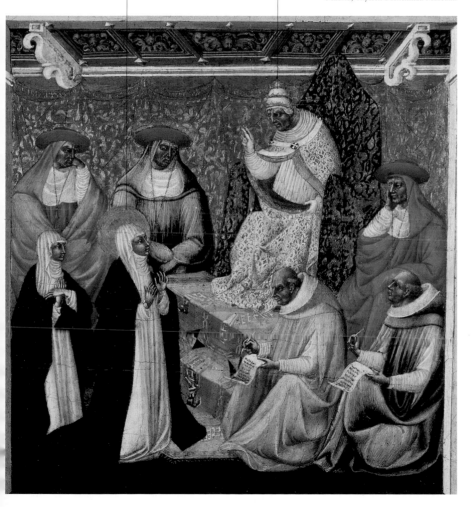

The priest had refused to give
Catherine Communion every day,
since at the time this was only
allowed for special cases.

The church faithful represent the
collective celebration of this scene.

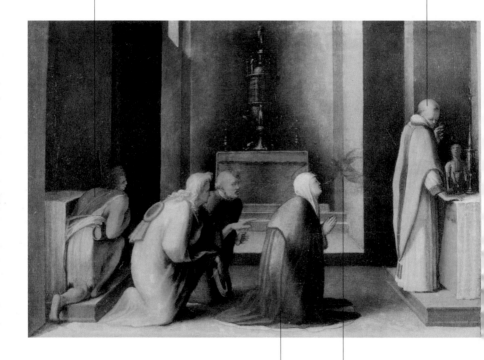

An angel gives the Eucharist
to Saint Catherine.

The kneeling saint is dressed
as a Dominican.

▲ Domenico Beccafumi, *The
Miraculous Communion of Saint
Catherine of Siena,* ca. 1513–15.
Los Angeles, J. Paul Getty Museum.

Ever since the fourteenth century, Cecilia has been portrayed with musical instruments, especially the organ, which probably originated from an error in transcribing her story.

Cecilia

The events of Cecilia's life were rearranged in the *Golden Legend* and based on an account of her passion. The young Christian had taken a vow of virginity, although she was still given in marriage to a pagan named Valerian. On their wedding night, she revealed to him that because she promised God her virginity, an angel protected her body. Valerian asked her to explain, then converted and asked to be baptized. He was suddenly able to see the Lord's angel and received a crown of roses. Cecilia was given a crown of lilies. Valerian's brother

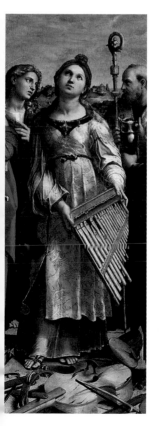

Tiburtius also converted, and both siblings were martyred. Cecilia, too, was later condemned to be beheaded because she refused to offer sacrifices to the Roman gods. Images of Saint Cecilia in art do not have much connection with the events of her life; ever since the fourteenth century, her characteristics have been linked to music. This originated from an arbitrary transcription of the text of her passion, where the liturgy of the saint repeats *canticus organis* three times. This referred to the music at her wedding feast, but Cecilia did not listen to this music at all, since she was entirely absorbed in offering God her virginity.

Name
A Roman name perhaps of Etruscan origin, long connected with *cieco* (blindness); according to medieval etymology she was instead linked with *cielo* (heaven) and *gigli* (lilies), a "heavenly lily"

Earthly Life
Third century, Rome

Characteristics and Activity
Roman martyr and virgin

Patron
Musicians, luthiers, poets, and singers

Venerated
Originally defined in Rome, after her relics were transferred there in the ninth century, her cult spread to the rest of Italy, France, and all of Europe

Feast Day
November 22

Raphael, *Ecstasy of Saint* ◄ *Cecilia* (detail), 1516. Bologna, Pinacoteca Nazionale.

Cecilia

After converting and being
baptized, Valerian's brother
Tiburtius sees Cecilia's angel.

The angel brings Valerian a crown of
sweet-smelling roses from Heaven
and a palm branch, a reward for his
imminent martyrdom.

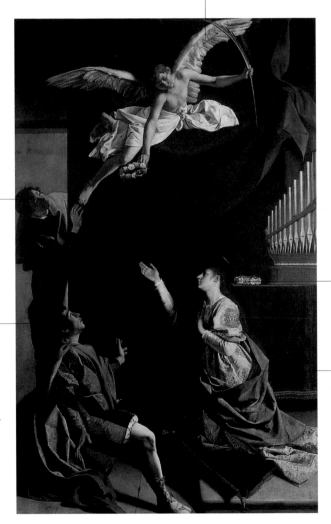

Behind Cecilia
is the crown of
flowers that the
angel gave her
next to an
organ, her
emblem in art.

Cecilia's
husband is
stupefied to
see the angel—
a defender of
her virginity—
about whom
the girl had
confided in him.

Saint Cecilia,
who is recogniz-
able because of
her halo, greets
the angel that
reveals himself
to her husband
Valerian.

▲ Orazio Gentileschi, *The Martyrs
Valerian and Tiburtius and Saint Cecilia
Are Visited by an Angel*, ca. 1607.
Milan, Pinacoteca di Brera.

Charles is dressed as a cardinal and is recognizable thanks to his curved nose. Sometimes he has a rope around his neck, a symbol of penance, which he typically wore during processions. His motto was humilitas (humility).

Charles Borromeo

Charles Borromeo was born in 1538 in Arona, Italy, on Lake Maggiore, into an aristocratic family of Lombardy. At the age of twenty-two, having just graduated from his studies in Milan and Pavia, he was named cardinal of the Milan diocese and secretary of state by his uncle, a member of the Medici family who had risen to the pontifical throne with the name Pius IV. Charles transferred to Rome to carry out his duties as secretary of state, and there he was able to make an important contribution in reconvening and concluding the Council of Trent. In 1564 he was ordained a priest and consecrated bishop; a year later he received permission from the pope to live in his diocese in Milan and, in 1566, began his important role of reformer there. He adopted an austere life and safeguarded the formation of the clergy by founding seminaries that others were modeled after. He also relied on the work of religious orders such as the Jesuits and the Barnabites. Through his pastoral visits, the bishop followed his huge diocese and even reached some of the valleys of the Alps. Charles was close to the faithful during the plague of 1576 and cared for those who caught the disease. He died in Milan on November 3, 1584.

▲ Cerano, *The Glory of Saint Charles* (detail), from after 1610. Milan, San Gottardo in Corte.

▶ Morazzone, *The Glory of Saint Charles* (detail), 1618. Inverigo, Santa Maria della Noce.

Name
Originally a Germanic word that was latinized in the Middle Ages, meaning "man"; it later meant "freeman" and became a title at the court of the Franks

Earthly Life
1538–1584; Milan and Rome

Characteristics and Activity
Bishop and cardinal of Milan after the Reformation, he put the Council of Trent's rules into place through pastoral and charitable actions, especially during the plague epidemic of 1576

Patron
Protector of the clergy, catechists, teachers, and starch makers

Special Devotions
Invoked against the plague

Venerated
He was venerated immediately after his death (November 3, 1584); canonized in 1610

Feast Day
November 4

85

Saint Charles Borromeo's tears in front of the crucifix signify his emotional involvement with the mystery of the Passion.

The crucifix identifies penitent hermits. Here it emphasizes the necessity of penance, which Charles preached and practiced.

The people who surround the cardinal witness his austere life.

Bread and water indicate how frugal his meals were when he ate alone.

▲ Daniele Crespi, *Saint Charles Fasting*, ca. 1627. Milan, Santa Maria della Passione.

Saint Charles Borromeo, shown here in cardinals' clothing, visits victims of the plague and brings them the Eucharist.

The Lazzaretto, an isolation hospital, was built near Milan's eastern gate, just outside the walls of the city.

Those suffering from the plague are comforted by the cardinal's visit.

▲ Tanzio da Varallo, *Saint Charles Borromeo Gives Communion to Those Suffering from the Plague*, 1616. Domodossola, Santi Gervasio e Protasio.

Beginning at the end of the fifteenth century, the Lazzaretto hosted those with contagious illnesses. During the plague of 1576, it was instrumental in containing the disease.

Christina is a young woman who appears with various instruments of torture and martyrdom, such as a knife, arrows, or a millstone.

Christina
of Bolsena

Name
A Latin name from a recent era derived from *Christus*, which spread after Christianity became the religion of the Roman Empire

Earthly Life
Third century, Tyre and Bolsena

Characteristics and Activity
Virgin martyred under the emperor Diocletian

Feast Day
July 24

Originally, Saint Christina was venerated in two places that were quite distant from each other: Bolsena, Italy, and Tyre, in present-day Lebanon.

Some have thought that there were two saints of the same name who lived during the same period. It is uncertain whether she was an Italian saint who was originally from the East, or an Eastern saint who was venerated early on in Italy. What is certain is that she was martyred during the emperor Diocletian's persecutions in the early years of the fourth century. Her legend was based on an account of her passion from much later that is, therefore, of little historical value. It tells of a young woman who suffered heavy doses of torture that were inflicted upon her because she refused to offer sacrifices to the gods. The events of her life seem to recycle themes from other young martyrs, such as Barbara (Christina, too, was very beautiful and locked in a tower by her father) or Agatha (Christina's breasts were also torn off). According to the same tradition, Christina died by being lanced with a spear. The earliest depiction of the saint dates to the sixth century; this young martyr appears in the *Procession of the Virgin Martyrs* at Ravenna's church of Sant'Apollinare Nuovo.

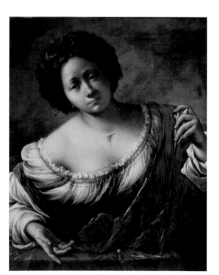

▲ Lorenzo Lotto, *Sphere of Santa Cristina al Tiverone* (detail), 1504–5. Santa Cristina di Quinto di Treviso, Parish church.

▶ Francesco del Cairo, *Saint Christina*, 1640. Milan, Civiche Raccolte d'Arte del Castello Sforzesco.

This saint is depicted as a giant who carries the child Jesus on his shoulders. Byzantine iconography can show him with a monkey's head in memory of his ugliness and wickedness before his conversion.

Christopher

The only certain thing about Saint Christopher is his recorded death in Asia Minor and early veneration in fifth-century Bithynia (Turkey). Christopher was originally named Reprobus, a Canaanite of huge stature who wished to serve the most powerful being on earth. He served a king for a long time, but left when he realized that the king was afraid of the Devil. He found the Devil and offered him his services, but when he saw the Devil avoid a crucified man, he understood that even the Devil feared someone more powerful. Then he met a hermit who began to speak to him of the power of Christ. The holy man advised him to stay near a river and ferry poor travelers across, since serv-

ing the humble was a way of serving Christ. One day a child asked to be ferried across. During the trip, however, the infant became immensely heavy; Reprobus thought he was carrying the weight of the entire world. The child then revealed himself to be Christ his creator, and the staff of Reprobus—who has been called Christopher ever since—began to sprout leaves as a sign of his wonderful burden. Christopher was probably martyred under the emperor Decius.

▲ Titian, *Saint Christopher* (detail), 1523–24. Venice, Palazzo Ducale.

◄ Lorenzo Lotto, *Saint Christopher* (detail), 1531. Berlin, Gemäldegalerie.

Name
"Christ bearer," a name with mystical and allegorical meanings that were supported by this saint's legend

Earthly Life
Third century, Asia Minor

Characteristics and Activity
Helped ferry the needy across a river and, after carrying the child Jesus, converted to Christianity; he died a martyr

Patron
Mountaineers, climbers, athletes, drivers, boaters, railroad workers, tram drivers, porters, dockworkers, pilgrims, postal workers, travelers, and fruit vendors

Special Devotions
Invoked against unexpected death, hurricanes, hail, and toothaches

Feast Days
July 25 in the West, May 9 in the East

These doglike features from Eastern iconography can be explained by the tradition of Christopher asking God to give him horrible features in order to avoid temptations.

In this case, Christopher, or "Christ bearer," does not carry the child Jesus, but the cross.

According to Eastern legends, Reprobus belonged to a tribe of cannibals who were recruited into the imperial army. He converted to Christianity and began preaching, which eventually led to his martyrdom.

◄ Anonymous, *Saint Christopher Cynocephalus*, 1685. Athens, Byzantine Museum.

Although they portrayed Christopher as great in stature, sixteenth-century northern European artists did not portray the saint with the same massive proportions that their Italian contemporaries did.

One peculiar detail here is this recovery of a drowned man's body, which emphasizes how imprudent it is to set out on a trip without Christopher's guidance.

The infant Jesus asks Reprobus to ferry him across. After this, he is called Christopher, or "Christ bearer."

The hermit who taught Christopher his Christian faith marvels at the miraculous scene.

Northern Renaissance painters considered the ferrying as a metaphor for the soul's journey toward redemption.

▲ Joachim Patinir, *Saint Christopher*, 1515. Madrid, El Escorial, Patrimonio Nacional.

The staff helps Christopher to reach the other bank despite the child's incredible weight. After being stuck in the ground, the staff takes root as a palm tree, which foreshadows the saint's martyrdom.

Some of the arrows that were shot do not strike Christopher, although they wound the eye of Dagnus, king of Samos. After being treated with clay mixed with the saint's blood, he was cured and converted.

Christopher is tied to a pole for his martyrdom.

This is one of the archers whom the king orders to execute Christopher.

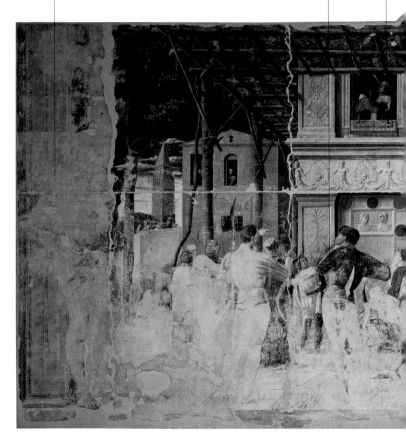

▲ Andrea Mantegna, *The Martyrdom of Saint Christopher and the Conveyance of His Body*, 1450–57. Padua, Church of the Eremetani, Ovetari Chapel.

In the end, since the arrows did not wound him, Christopher's enormous body is beheaded and then dragged away by a group of men.

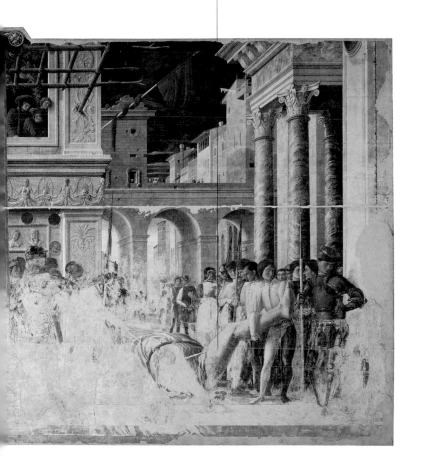

Clare
of Assisi

Clare is dressed in the habit of her order, and she sometimes holds the pastoral staff of an abbess. Among her emblems are the monstrance she used to chase the Saracens away from Assisi, the lily, the cross, a book, and a lamp or processional lantern.

Clare of Assisi, Italy, of the noble Offreduccio family, left her parents' house at the age of eighteen. Having been fascinated by Saint Francis's example, she decided to join him, renouncing all her belongings and becoming a nun. She began her religious life at a Benedictine monastery of Bastia and Sant'Angelo di Panzo, and then she and some of her friends moved into a tiny convent near the church of Saint Damian that Francis had prepared for them. She became abbess of the new community in 1215. Among the women who asked to share in the group's extreme poverty—they depended on alms and renounced any material goods or earnings—were Clare's mother and sister. Clare gave the new order its rule, which was approved in 1228 by Pope Gregory IX and confirmed by Pope Innocent VI in 1253, which was the year she died. Clare is generally shown with the black or brown frock of her order, a lily, a cross, and sometimes an abbess's pastoral staff. Her main attribute is the monstrance she used to expel the Saracens, who had been enlisted by Frederick II, from Assisi in 1244. The lamp and lantern also appear in the oldest depictions of her, perhaps in reference to her name ("clarity").

Name
Originated from the Latin adjective *clarum* (clarity), meant in the physical and moral sense

Earthly Life
1194–1253, Assisi

Characteristics and Activity
Inspired by Saint Francis, she decided to follow his example; she founded the order of the Poor Clares

Patron
Embroiderers, cleaners, gilders, ironers, and the blind; she was chosen as the patron saint of television because she saw the funeral rites of Saint Francis "projected" at Saint Damian's

Connections with Other Saints
Francis

Venerated
She was canonized by Pope Alexander IV in 1255, two years after her death

Feast Day
August 11

Christ welcomes Clare's soul to Heaven. This image is a variation of the sleeping virgin (dormitio virginis) theme, which developed from the Byzantine representation of the death of the Virgin Mary.

The solemnity of this occasion, which is narrated in the Legend of Saint Clare, *is emphasized by two angels with censers and a number of musicians in this vision's golden sky.*

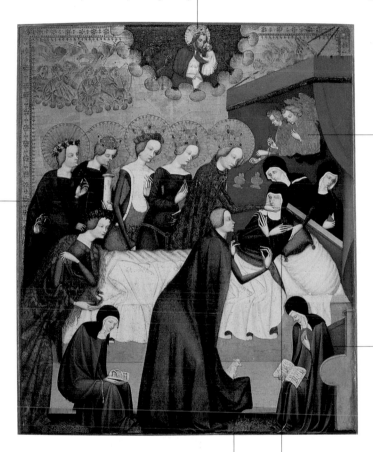

Before dying, Clare sees a group of virgins: Margaret with a dragon, Martha with a bucket, Barbara with the tower, Catherine with a wheel, and Dorothy with flowers.

Clare's sister Agnes, who is identifiable by this lamb, speaks with her.

On her deathbed, Clare is embraced by the most beautiful of the virgins who appeared.

The Poor Clares (although sources recall that it was the friars who did this) watch over Clare while reading selections from the Passion.

◄ Lorenzo Lotto, *Saint Francis and Saint Clare* (detail), 1526. Jesi, Pinacoteca Civica.

▲ Master of Heiligenkreuz, *The Death of Saint Clare*, ca. 1400–1410. Washington, D.C., National Gallery.

Clement is dressed in papal robes, and his main attribute is the anchor; tradition has it he was martyred with one. In reality it was introduced because it was a generic symbol of Christianity.

Clement

Name
Latin in origin, this name spread with Christianity and came to mean "merciful"

Earthly Life
First century, Rome

Characteristics and Activity
The fourth bishop of Rome, his writings include *Epistle to the Corinthians,* a witness to the authority of ministers of the Christian Church

Patron
Milliners, children, boaters, captains, gondoliers, sculptors, sailors, marble workers, and stonemasons

Special Devotions
Invoked against children's illnesses

Feast Days
November 23 in the West, November 24 in the East

The most ancient sources concerning the life of Saint Clement—who was pope after Saint Peter, Linus, and Cletus—are the apocryphal Acts of the Martyrs that were written in the fourth century. They are hardly reliable, having been embellished with too many details. The version reported in the *Golden Legend* was also invented. According to traditions regarding Saint Clement, he was exiled to Crimea (Ukraine) because of his successful pastoral activity in Rome. During his banishment, he was forced to work in a mine, where one day he made water well up from a miraculous spring. There he continued his work preaching and converted many people, so much so that seventy-five new churches had to be built for the new believers. The iconographic tradition of the anchor at his tomb, a symbol of his solid faith, influenced his legend, which claims that he was cast into the sea with an anchor around his neck.

◀ Giovanni di Paolo, *Saint Clement* (detail), ca. 1482. Avignon, Musée du Petit Palais.

Clement is thrown from the ship with an anchor around his neck. As bishop of Rome, he wears a bishop's costume and the three-tiered crown, or papal tiara.

When Clement was thrown into the sea, two of his most faithful disciples remained on the shore. They prayed to see his body, and the sea's waters retreated so much that the two were able to walk out and reach a marble temple, where they found the saint's relics.

The anchor, Saint Clement's attribute in art, is traditionally considered the instrument of his martyrdom, but this idea probably originated from a decoration of this symbol of faith on his sepulcher.

▲ Bernadino Fungai, *The Martyrdom of Saint Clement*, ca. 1500. York, City Art Gallery.

The saint is typically portrayed as bishop or pope. His main attribute is the hunting horn (corno, resembling his name), and sometimes brandishes a sword.

Cornelius

Name
Derived from the Latin *cornus*, meaning "abundance and prosperity"

Earthly Life
Third century, Rome

Characteristics and Activity
After the persecutions of the emperor Decius, he was chosen to be bishop of Rome and had to face significant difficulties within the Church regarding whether to readmit or refuse those who had abandoned their faith during the persecutions

Patron
Protector of animals with horns, his attribute in art

Special Devotions
Invoked against epilepsy and children's convulsions

Connections with Other Saints
Cyprian of Carthage sustained Cornelius's policy of forgiving apostates

Feast Day
September 16

Both the clergy and the people elected Cornelius, a member of the Cornelian family (*gens Cornelia*), to be bishop of Rome in A.D. 251. This occurred immediately after the persecutions of the emperor Decius, and the papal throne had been vacant for almost a year. The new pope had to face difficult situations after the persecutions, particularly within the church itself. There had been disputes concerning what policy to take with Christians who had disavowed their faith and abandoned their Christian lifestyles during the persecutions. Cornelius favored forgiveness, as opposed to Novatian, who was strongly critical of these people and became Cornelius's rival bishop in Rome. Cornelius, however, counted on Saint Cyprian of Carthage, who also supported the pardon and readmission of these believers into the Church after adequate penance. When persecutions sprang up once again in 253, Cornelius left in exile to Centumcellae (Civitavecchia) and died a short time later. His death was probably a result of the extreme poverty that he forced himself to live under, although according to Cyprian, he died a martyr and was beheaded.

▲ Paolo Veronese, *Saints Anthony Abbot, Cornelius, and Cyprian with a Page* (detail), 1576. Milan, Pinacoteca di Brera.

◄ Stefan Lochner, *Saints Anthony the Hermit, Cornelius, and Mary Magdalene* (detail), ca. 1440–45. Munich, Alte Pinakothek.

The two are always shown together, and their emblems are medicine jars and surgical instruments.

Cosmas and Damian

According to a late tradition that has little historical credibility, Cosmas and Damian were twin brothers, two doctors who cured the sick poor without charging them. They were probably from Cyrrhus, in Syria. News of their extraordinary healing abilities (which according to the *Golden Legend* were inspired by the Holy Spirit) reached the proconsul of the area, who tried everything to make Cosmas, Damian, and their three brothers offer sacrifices to the Roman gods and renounce their Christian faith. The two doctors were inflicted with all sorts of torture and their brothers were imprisoned, yet each time a curious intervention saved Cosmas and Damian. The rocks that were hurled at them flew backwards as did the arrows, and the torture rack broke. Finally the proconsul ordered the two doctors and their brothers to be beheaded. After their death, veneration of Cosmas and Damian spread immediately, and those who invoked them received a miracle. In art they are shown with objects related to their profession, such as medicine jars and surgical instruments.

▲ Fra Angelico, *Crucifixion and Saints* (detail), ca. 1441–42. Florence, Convento di San Marco.

▶ Rogier van der Weyden, *Madonna of the Medici* (detail), ca. 1450. Frankfurt, Städelsches Kunstinstitut.

Names
Cosmas comes from the Greek word *kosmas* (ordered good); Damian possibly means "tamer" or "of the people"

Earthly Life
Third and fourth centuries, Syria

Characteristics and Activity
Doctors, brothers, and martyrs; they cured people and animals

Patrons
Doctors, surgeons, dentists, pharmacists, midwives, barbers, and hairdressers

Special Devotions
Invoked against the plague, swollen glands, kidney disease, kidney stones, and common colds

Venerated
The two were venerated immediately, as shown by the construction of basilicas in Rome and Constantinople in their memory

Feast Days
September 26 in the West, July 1 or November 1 in the East

According to the Golden Legend, *Cosmas and Damian healed the deacon Justinian even before being invoked. The two are dressed similarly to emphasize that they are related.*

A glass and bottle near the sickbed are simply objects to decorate the scene and should not be mistaken as ampoules and medicine jars that are the saints' attributes.

▲ Fra Angelico, *The Healing of a Leg,* 1440–50. Florence, San Marco.

Justinian is operated on as he sleeps. He is guardian of the church that Pope Felix built in honor of Cosmas and Damian.

That the saint is
an apparition
is indicated by
his transparent
body.

The difficult operation consists of
saving a gangrenous leg. The leg
being transplanted was from an
Ethiopian who had died the day
before; thus the leg is dark-skinned.

Diego
of Seville

Diego is generally depicted as a young man in a Franciscan habit and cowl. The most common image of him shows the saint carrying flowers in the folds of his habit.

Name
Originally Spanish, a variation of the name Iago, or James

Earthly Life
About 1400–1463; Spain and Rome

Characteristics and Activity
A Franciscan dedicated to aiding pilgrims and the sick

Venerated
His cult spread predominantly in Spain; Emperor Philip II promoted his canonization in 1588, which influenced the saint's image in art

Feast Day
November 13

▲ Francisco de Zurbarán, *Saint Diego de Alcalá*, ca. 1640. Madrid, Museo Lázaro Galdiano.

▶ Jusepe de Ribera, *Saint Diego de Alcalá*, 1646. Toledo, Cathedral.

Diego was born around 1400 into a poor family of the little town of San Nicolas del Puerto in Andalusia, Spain. When he was still young, he followed a hermit, sharing the holy man's ascetic lifestyle and carrying out menial jobs to support himself. After briefly returning to his family, he decided to join the Franciscans, becoming a friar and entering the monastery at Arrizafa near Cordoba. He was the guardian of the monastery of Fuerteventura in the Canary Islands through 1445 and then was assigned to another near Seville. He was diligent in aiding the poor and, since he was a lay brother, he had the job of cooking for the other monks at the convent. It is said that he was continually speaking with God and that one time, while in the kitchen, he was raised up to Heaven while angels prepared lunch in his place. Because Diego's generosity was well known, one day another friar suspected him of taking food from the kitchen to give to the poor by keeping it hidden within the folds of his habit. When the brother checked, however, he

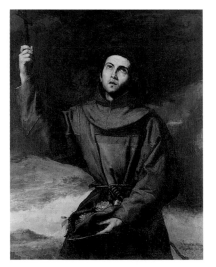

found only flowers. From this episode comes the best-known image of Diego, which shows flowers in his habit. For the jubilee of 1450, Diego traveled to Rome, where he tended to sick brothers in the monastery of Ara Caeli. He eventually returned to Spain and lived in Alcalá until his death on November 12, 1463.

This saint is dressed as a bishop and holds his own severed head.

Dionysius, or Denis, was probably born in Italy, where he was ordained priest and bishop. The pope sent him with another five bishops to preach in Gaul. Dionysius carried out this work with two companions, a priest named Rusticus and a deacon named Eleutherius, both saints as well. They reached Paris, where Dionysius's preaching was so effective that a Christian center was organized on an island of the Seine River. Because of their activity, the three were persecuted, imprisoned, and beheaded around A.D. 250 during the emperor Domitian's reign. The stories of their persecution, torture, and martyrdom can be

Dionysius

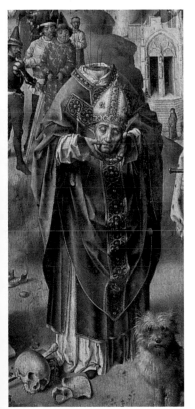

found in the *Golden Legend*. According to the work, Dionysius was scourged, stretched on a red-hot grill, given as food to wild beasts, and tortured on a cross. He was then sent back to jail, where he celebrated Mass with a group of other Christian prisoners. Suddenly Christ himself appeared to bring them the Eucharist. Dionysius's image in art was inspired by his martyrdom: having been decapitated, he typically carries his own head in his hands.

Name
A Latin version of the Greek *Dionysios,* an adjective for the god Dionysos

Earthly Life
Third century, France

Characteristics and Activity
The first bishop of Paris, he preached the Christian faith in France, where he was martyred with his companions

Patron
France

Connections with Other Saints
One of the Fourteen Holy Helpers

Venerated
His cult especially spread in the ninth century, partly because he was confused with Dionysius the Areopagite, a disciple of Saint Paul

Feast Day
October 9

Master of Dreux-Budé, ◄
The Crucifixion of the Parliament of Paris (detail), ca. 1452.
Paris, Musée du Louvre.

As Dionysius was celebrating Mass in jail with other prisoners, Christ appeared in a great light and presented the Eucharist to the bishop.

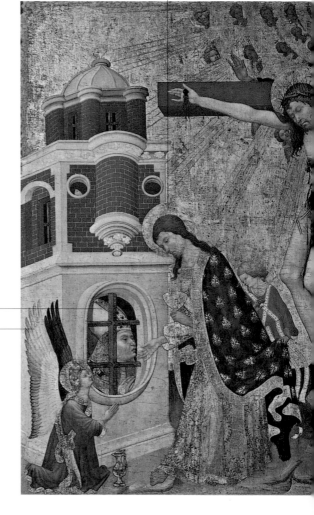

For bringing the gospel message to Gaul, Dionysius was imprisoned with two companions, the priest Rusticus and the deacon Eleutherius.

An angel wears a stole diagonally. This is the uniform of a deacon, someone in service of Christ.

▶ Henri Bellechose, *Stories of Saint Dionysius*, 1416. Paris, Musée du Louvre.

After Dionysius's death, his companion Eleutherius, shown here with the tonsure (shaved head) and cloak of a religious brother, is led to his martyrdom.

The center of this composition is the Crucifixion. Here God the Father offers his son as sacrifice for humanity's redemption.

Dionysius is martyred with an axe, although it does not become his attribute in art. The headless image of the saint was considered much more incisive by artists.

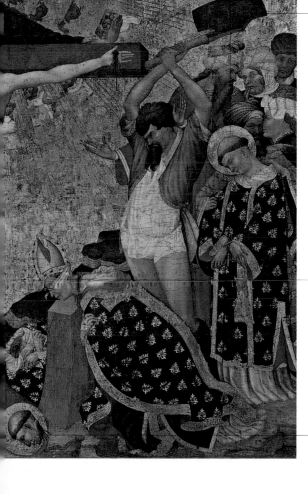

Dionysius's head and his bishop's miter are on the block. This is the moment of highest tension; they are about to be lopped off.

Rusticus's head lies on the ground, apart from his body, which is behind the cross.

With his white habit, black cloak, and tonsure (shaved head), Dominic has a star on his brow and a lily in hand. In later depictions, a dog accompanies him because of its similarity in Latin with the name of his order (Domini canes, "dogs of the Lord"), and it can hold a torch in its mouth.

Dominic

Name
A common name in Christianity linked to *domenica* (Sunday), the day of the Lord

Earthly Life
About 1170–1221; Spain, France, and Italy

Characteristics and Activity
Founder of the Order of Preachers, or Dominicans, he focused on educating the religious communities

Patron
Astronomers, since his attribute in art is a star; orators; and seamstresses

Venerated
Canonized in 1234, he was first venerated in Toulouse, where he had preached, and in Bologna, where he died

Feast Day
August 8

▲ Fra Angelico, *Coronation of the Virgin* (detail), ca. 1440–46. Florence, San Marco.

Dominic di Guzmán was born in Calaroga, Spain, the fourth child of the city's governor. An uncle of his who was a priest educated him initially, and he later completed his studies at the University of Palencia. In the meantime he had joined the cathedral staff at Osma. In 1204 he traveled to Denmark with Bishop Diego de Azevedo. This was Dominic's first opportunity to experience the Albigensian heretics in Toulouse, and there he probably felt the importance of what would become his life's mission: their reconciliation with the church. To this end, he focused on founding an order of preaching friars and forming communities that could be centers for the study of sacred culture. The new order was approved by Pope Honorius III, who required that the group follow a rule that already existed; Dominic chose Saint Augustine's and eventually added other statutes. The new order spread rapidly throughout Europe. In 1221 Dominic died in Bologna, Italy, where the first general chapter of the order had been held the year before. Dominic's typical image in art includes the white habit of the Dominicans and a black cloak, and he wears the tonsure. His emblems are a star on his forehead— a symbol of wisdom—and a lily.

◀ Niccolò dell'Arca, *Saint Dominic*, 1474–75. Bologna, San Domenico.

In memory of
Pope Honorius's
dream before he
approved the
Dominican
order, here the
saint supports
the church of
Saint John
Lateran in
Rome, which
threatened to
crumble. Saint
Dominic would
later sustain the
church.

The primary
element identify-
ing Saint Dominic
is the white habit
and black cloak
of his order.

He holds a
branch of flower-
ing lilies, a sign
of chastity.

Just before
Dominic was
born, his mother
dreamed of
having a dog
with a torch in
her womb that,
as soon as it was
born, would set
the entire world
on fire. She
interpreted this
dream as a pre-
diction that her
child would set
the world
aflame with
his words.

▲ Francesco del Cairo, *Saint Dominic*,
ca. 1560–70. Milan, San Vittore al Corpo.

On his way from Toulouse, Saint Dominic presides over an auto-da-fé, the burning of heretics.

A Dominican accompanies Raymund the Albigensian.

Heretics who do not accept reconciliation with the church are condemned.

▲ Pedro Berruguete, *Saint Dominic di Guzmán Presides Over an Auto-da-fé,* ca. 1495. Madrid, Prado.

The Dominicans held that the Virgin
Mary appeared to Saint Dominic in
1210 and gave him the Rosary to con-
quer heresy. In reality, this form of
prayer spread after 1470.

The lily symbol-
izes Dominic's
chastity.

A book is a
symbol of
dedication to
the order's
formation.

Dominic wears
the white habit
and black cloak
of the order that
he founded.

▲ Guido Reni, *The Virgin Appears
to Saint Dominic and the Mysteries
of the Rosary*, 1596. Bologna,
San Luca.

The prayer of the Rosary consists of
meditations on the mysteries of various
episodes in the life of Christ and the
Virgin Mary.

Mary attempts to stop her son from flinging arrows, repeating her hope in saints Dominic and Francis.

Dominic and Francis met in Rome, which is represented here with an obelisk among large buildings.

Christ is ready to shoot three arrows against the world's pride, concupiscence, and greed.

As Dominic held vigil in prayer, Christ appeared to him holding three arrows.

· QVANDO BEATA VIRGO OSTĒDIT ꝰCꝑO BEATV FRACISCV ET BEATV DOMINICV PROREPARATIONE MVNDI ·

Francis and Dominic, the two founders of orders of preachers, met the day after Dominic's vision.

▲ Benozzo Gozzoli, *Meeting Between Saint Francis and Saint Dominic; Stories from the Life of Saint Francis*, ca. 1450–52. Montefalco, San Francesco.

Dorothy is a young woman wearing a crown of flowers. She carries fruit and cut flowers in the folds of her habit or in a basket.

Dorothy

There are no sure historical facts about Saint Dorothy. She is said to have been martyred in Caesarea, Cappadocia (now Turkey), during the emperor Diocletian's reign at the beginning of the fourth century. Accounts of her martyrdom, which are not very reliable from a historical point of view, tell of how she was perhaps the daughter of a senator and was persecuted because she refused to marry and offer sacrifices to the gods. Blows and torture had no effect on her; she seemed to feel only the caresses of dove feathers. It was therefore decided that Dorothy should be beheaded, and while she was brought forth to be executed—she was quite serene about it—she told the crowd that she was deserting this cold world for a place without winter or snow. A young student mockingly asked her to send him some roses and apples from the paradise she spoke of. Dorothy promised she would. The next winter the young man, who was named Theophilus, received a

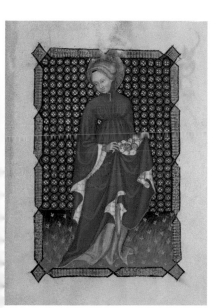

basket filled with fruit and flowers from a boy, who was actually an angel. Theophilus immediately converted and was also martyred. Images of Dorothy show a young woman with fruit and flowers in her habit or basket, as if she herself was bringing them to Theophilus.

Name
From the Greek, meaning "gift of God"

Earthly Life
Fourth century

Characteristics and Activity
Virgin martyred under Diocletian's reign

Patron
Gardeners, brewers, and newlyweds

Connections with Other Saints
One of the Quatuor Virgines Capitales

Venerated
She was mainly venerated in the West, especially in Italy and Germany

Feast Day
February 6

Ambrogio Lorenzetti, ▲
Madonna and Child and Saints Mary Magdalene and Dorothy (detail), ca. 1345.
Siena, Pinacoteca Nazionale.

Anselmo Rozio di Modena, ◄
Saint Dorothy, 1390.
Modena, Biblioteca Estense.

Eligius

Eligius is portrayed as a goldsmith in his shop and displays the tools of a goldsmith or farrier. Other times he wears bishops' clothing. He is also shown with a horse, from which he detaches and reattaches a horseshoe in order to work the iron easier.

Name
Originally Latin, probably derived from the verb *eligere*, meaning "chosen by God"

Earthly Life
About A.D. 588–660, France

Characteristics and Activity
A talented goldsmith, he was ordained priest and bishop of Noyon

Patron
Goldsmiths, blacksmiths, and farriers

Venerated
Especially venerated during the Middle Ages

Feast Day
December 1, moved to June 25

Eligius was born around A.D. 588 in Chaptelat, near Limoges, France, into a rich and virtuous family of Roman origin. It seems his first main activity was working as a farrier; he then became a goldsmith. Eligius went on to head the royal mint and was a counselor of the royal treasury; he was quite esteemed for his skills as a craftsman and for his extraordinary ability not to waste material. One day King Clotaire marveled to see that Eligius had managed to make two thrones with the gold that the sovereign had given him to make just one. After this episode, he was taken into the service of Clotaire II, and, after Clotaire died, Eligius kept the same position with the king's successor, Dagobert. When Bishop Acarius died in 639, however, Eligius decided to become a priest, and he was appointed bishop of Noyon in 641. He became an able preacher and was untiring in his mission. As a result, many German pagans converted and many monasteries were founded. After being active in a number of areas in Flanders, Eligius died on December 1, 660.

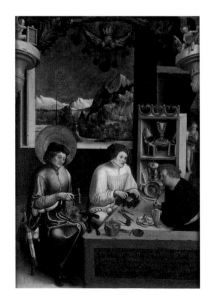

▲ Gian Giacomo Bardelli, *The Miracle of Saint Eligius* (detail), 1579. Crema, San Bernardino.

◄ Manuel Deutsch Niklaus, *Saint Eligius in His Workshop*, 1515. Bremen, Kunstmuseum.

These two characters in Eligius's work-shop form part of an anecdotal scene.

The chalice is an attribute of Eligius's because it is both the work of a gold-smith and liturgical, in reference to his ordination as priest.

In art Eligius is typically shown in his workshop, conducting the life he led before becoming a priest and bishop.

Rings symbolize the saint's work for society.

▲ Petrus Christus, *A Goldsmith in His Shop, Possibly Saint Eligius*, 1449. New York, The Metropolitan Museum of Art.

Saint Eligius's face here is probably a portrait of the sculptor Pietro Francavilla.

A painting of the Virgin Mary and Child in Eligius's shop is a sign of his devotion.

Scales, pincers, and a crucible are all goldsmiths' tools and attributes of Eligius's.

▲ Jacopo da Empoli, *The Honesty of Saint Eligius*, 1614. Florence, Uffizi.

King Clotaire marvels at Eligius's talent and honesty as he is shown the two thrones that Eligius made with gold that was only supposed to be enough for one.

When he was a farrier, Eligius had a boy who detached and reattached horses' hooves in order to shoe them. It was said that the boy was Christ teaching Eligius how to detach the Devil's hooves.

The cope, miter, and pastoral staff are the emblems of Eligius the bishop.

▲ Gian Giacomo Bardelli, *The Miracle of Saint Eligius*, 1579. Crema, San Bernardino.

Nails and horseshoes are attributes of Eligius's that recall his previous work as a farrier.

She is an elderly woman who watches over her child, John the Baptist.

Elizabeth

Name
Originally Hebrew, this name could mean "God has judged" or "God is perfection"

Earthly Life
First century B.C. and first century A.D., Palestine

Characteristics and Activity
A relative, perhaps a cousin, of the Virgin Mary and mother of John the Baptist

Patron
Sterile and child-bearing women

Connections with Other Saints
John the Baptist and the Virgin Mary

Feast Days
November 5 in the West, September 5 and November 30 in the East

▲ Lucas Cranach the Elder, *Saint Elizabeth* (detail), 1514. Madrid, Thyssen-Bornemisza Museum.

► Jakob Strüb, *The Visitation* (detail), ca. 1505. Madrid, Thyssen-Bornemisza Museum.

Saint Luke's Gospel narrates that Elizabeth was already advanced in age when she conceived. She was married to Saint Zechariah, and the two were righteous in the eyes of God. One day, as Zechariah neared the temple altar alone, an angel appeared to him (according to the *Golden Legend* this was the archangel Gabriel, who also appeared to Mary afterward). The angel announced that a son called John would be born to the couple. However, Zechariah was incredulous and was punished for his doubts by suddenly becoming mute. Elizabeth did conceive, and, when she was in her sixth month, her young cousin Mary visited her. When they met, the young John stirred in her womb. According to the *Golden Legend*, Mary was the first to hold the child when he was born. Zechariah was still unable to speak then; his tongue was loosed only when the child's name was to be decided. He wrote on a slate that the child's name would be John, just as the angel had said, and his voice returned. Despite protests from their relatives, Elizabeth agreed.

After the episode of John's birth, Elizabeth is no longer mentioned in the Gospels. In art, however, she often appears when the child Jesus meets his cousin for the first time with his mother, Mary.

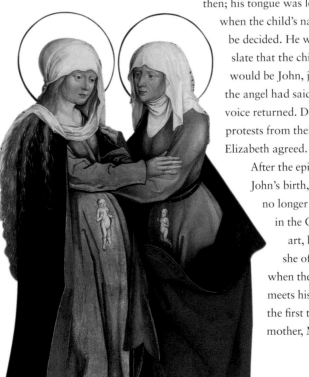

The Golden Legend *lists nine privileges of the Baptist; one of these is to have been first held by Mary, Mother of God.*

Elizabeth rests in bed after giving birth.

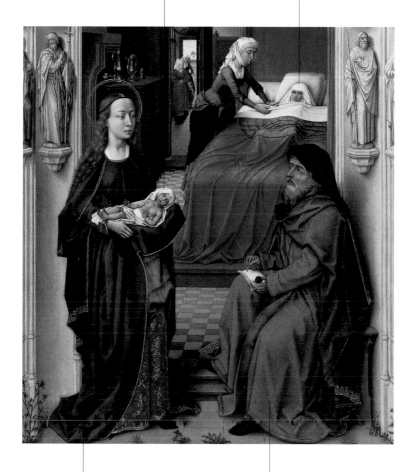

Mary had gone to help her cousin Elizabeth during her pregnancy. She was the first to take little John into her arms.

Zechariah writes the name to give to the child: "His name is John." After writing this, he regains his voice.

▲ Rogier van der Weyden, *Saint John the Baptist Triptych*, ca. 1450–55. Berlin, Gemäldegalerie.

Princely clothes and a crown are often Elizabeth's costume, although she also wears the Franciscan habit. She holds alms; a pitcher; a basket of bread, fruit, and fish; and an apron full of roses.

Elizabeth
of Hungary

Elizabeth was the daughter of King Andrew II of Hungary. She was born in Pressburg (modern-day Bratislava in the Czech Republic) and was raised with her arranged husband-to-be, Ludwig IV, in Thuringia, Germany, at the castle of Wartburg. In 1221 she married him and became a countess. It was a happy marriage with the birth of three children. Elizabeth led a simple life and was always attentive to the needy. She generously gave alms and founded hospitals to cure the sick poor.

Name
Originally Hebrew, this name could mean "God has judged" or "God is perfection"

Earthly Life
1207–1231; Thuringia, Germany

Characteristics and Activity
From a noble family, she was educated as a princess and dedicated herself with generosity to aiding the sick, elderly, and poor, especially after her husband died

Patron
Bakers and the third order of Franciscans

Venerated
She was canonized in 1235, and in 1236 construction of a church dedicated to her was already under way

Feast Day
November 17

▲ Matthias Grünewald, *Saint Elizabeth* (detail), 1509. Karlsruhe, Staatliche Kunsthalle.

▶ Hans Holbein the elder, *Elizabeth with the Three Beggars*, 1516. Munich, Alte Pinakothek.

Her husband left for a crusade under Emperor Frederick II and died of the plague after only three months. After a short while, Elizabeth distanced herself from the court of her brother-in-law Henry and took another direction in life, refusing all marriages that others offered her. In 1228 she took her belongings and moved to Marburg, near her spiritual director, Master Conrad. There she entered into the third order of Franciscans and lived in absolute poverty. She aided the elderly, the sick, and the poor and even built a hospital. After a couple of austere years, Elizabeth died of deprivation.

He is shown as a bishop, and his symbols are nails, boilers, ravens, and a windlass—a sailor's device that was believed to be the instrument with which he was martyred.

Erasmus

Bishop Erasmus was originally from Antioch (Turkey), but in order to flee the persecutions of Diocletian, he took refuge among the mountains of Lebanon. He lived there in isolation for seven years, nourished by ravens who brought him food. He was discovered and then captured, beaten, and tortured in boiling pitch by one of Diocletian's officials. After he was imprisoned, an angel freed him and brought him safely to the province of Illyricum, in the present-day Balkans. There he preached and converted a great deal of people. He then was recaptured, tortured with nails under his fingernails, and finally executed. There does not seem to be any written tradition stating that Erasmus's intestines where pulled from his body with a windlass. This is one example where imagery influenced hagiography. Since sailors chose him as their patron, he began to be shown with the nautical device. The windlass then became popularly imagined as an instrument of torture, and thus the atrocious punishment of having one's intestines extracted with the device was invented.

▲ Dieric Bouts, *Triptych of the Martyrdom of Saint Erasmus* (detail), 1458. Leuven, Sint-Pieterskerk.

◄ Matthias Grünewald, *Conversation between Saints Erasmus and Maurice* (detail), 1520–25. Munich, Alte Pinakothek.

Name
A Latin derivative of the Greek adjective *erasmios,* meaning "desirable" or "lovable"

Earthly Life
Third and fourth centuries; Syria and Formia, Italy

Characteristics and Activity
Bishop of Formia, he died a martyr around A.D. 303

Patron
Sailors, fishermen of the Mediterranean

Special Devotions
Invoked against colic and birth pains

Connections with Other Saints
One of the Fourteen Holy Helpers

Venerated
First venerated in Italy, in Gaeta where he was martyred, then in Germany from the fourteenth century on

Feast Day
June 2

The angels bring the palm branch—
a martyr's reward that eventually
became a symbol of martyrdom—
and a crown of glory.

This statue of a Roman god
symbolizes the false idols that
Erasmus refused to worship.

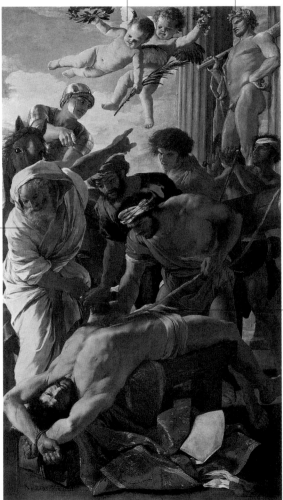

Erasmus's
bowels are
removed from
his abdomen
with a windlass.
This image has
no foundations
in historical
sources but was
invented when
the windlass
became his
symbol after he
became patron
saint of sailors.

The man
pointing to
the sculpted
idol demands
yet again that
Erasmus
abandon his
Christian
faith.

▲ Nicholas Poussin, *The Martyrdom
of Saint Erasmus*, 1628. Vatican City,
Pinacoteca Vaticana.

The saint's clothes lie near the
torture table where Erasmus is
tied down. The miter and chasuble
indicate he is a bishop.

Eustace can be dressed as a soldier or a knight. He either holds a crucifix, or he appears with a stag that has a crucifix between its antlers. His attribute is a bull-shaped furnace.

Eustace

Placidas, as Eustace was called before his conversion, was a Roman soldier under the emperor Trajan and an honorable man who was devoted to the Roman gods. One day while hunting, he pursued a stag that led him into a thick forest. A crucifix appeared between the animal's horns and spoke to him, saying, "I am Jesus, whom you honor without knowing." Placidas promised to convert to the Christian faith with his wife and two children, and that same night he had himself baptized by the bishop of Rome. From then on, Placidas took the name Eustace. However, Eustace, his wife, Theopistis, and their children suffered a number of trials. They left Rome by ship, and the captain seduced Eustace's wife. Then Eustace's children were abducted to Egypt. The family lost each other, found each other, and finally returned to Rome. Then, after they refused to worship the Roman gods, they were sent to the arena to be fed to wild beasts. Since the animals simply ignored them, they were slain inside a burning bronze bull.

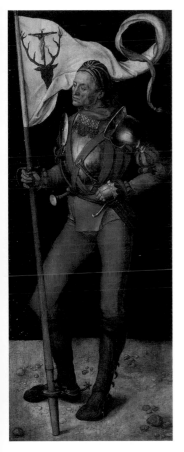

Name
Greek in origin

Earthly Life
Third century

Patron
Forest rangers

Connections with Other Saints
One of the Fourteen Holy Helpers; the legend of Saint Eustace influenced the life of Saint Hubert

Venerated
Venerated in France since the twelfth century and in Germany since the fourteenth

Feast Day
September 20

Master of Cori, *Saint ▲ Eustace the Hunter* (detail), 1467. Cracow, Muzeum Nardowe.

Albrecht Dürer, ◄ *Saint Eustace* (detail), from the *Paumgartner Altar*, 1501–4. Munich, Alte Pinakothek.

To *attract Placidas and "hunt him while he hunts,"* the stag enters a thick forest in order to separate the soldier from the rest of the troops.

Startled by the
unexpected
apparition,
Placidas's horse
seems to want
to draw back.

▲ Pisanello, *The Vision of Saint Eustace*,
ca. 1430. London, National Gallery.

According to sources, which the artist only partly followed here, a gleaming crucifix appeared between the stag's horns.

The stag speaks to Placidas. After their first meeting, the stag appears to him yet again and unveils the trials that await the new convert.

The legend of Saint Eustace was especially popular because it provided an opportunity to portray one of the favorite pastimes of the Middle Ages and the Renaissance: hunting with dogs.

Florian
of Lorch

Name
Originally Latin,
linked to "flora"

Earthly Life
Third and fourth
centuries, Austria

**Characteristics
and Activity**
Roman official who
was drowned because
of his faith

Patron
Firemen

Special Devotions
Invoked during fires
and floods

Venerated
Popular in Austria
and Bavaria

Feast Day
May 4

Florian is a soldier with a lance and banner. Among his attributes are the palm of martyrdom, the millstone that was tied around his neck to drown him, and a bucket of water for extinguishing fires.

Details regarding Saint Florian are based on an account written in the eighth century that states he was a veteran of the Roman army who lived in Mantem, near Krems, Austria. During the persecutions of Diocletian, Aquilinus, the governor of Noricum, arrested forty Christians in Lorch (Germany). Florian wished to share their fate and set out in the direction of that city, but before entering it he met some soldiers, to whom he confessed that he believed in Christ. He was immediately arrested and brought to Aquilinus, who was reluctant to condemn him because he knew that many people held Florian in high esteem. He tried convincing Florian to offer sacrifices to the Roman gods, but his attempts were in vain. Aquilinus then had him flogged and sentenced him to be thrown into the Enns River with a millstone tied around his neck. According to tradition, he was executed on May 4, A.D. 304. The martyr's body was later found and buried by a certain Valeria, who had been directed by Florian in a dream. Images of Saint Florian originally portrayed him as a soldier

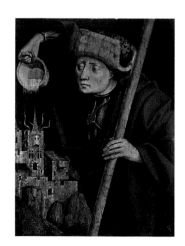

with a banner or with a millstone. In time, however, he became a protector against the dangers of water (since he was martyred by drowning) or, more commonly, of fire.

▲ Francesco del Cossa, *Saint Florian* (detail), after 1470. Washington, D.C., National Gallery.

◄ Michael Pacher, *Saint Florian Extinguishes the Fire in the Citadel* (detail), from the beginning of the sixteenth century. From a private collection.

Since he was esteemed and loved by many, no one dared to throw Florian into the river. They tried to convince him to jump on his own. Suddenly a young man appeared and pushed him in.

Saint Florian's attribute in art is the millstone that Aquilinus had tied around his neck before ordering that he be thrown into the river.

▲ Albrecht Altdorfer, *The Martyrdom of Saint Florian*, ca. 1516–25. Florence, Uffizi.

Florian was whipped before being condemned to death.

Florian's connection with water, and his special protection against floods and fires, comes from his being martyred in the Enns River.

The Four Crowned Martyrs

Names
Refers to four martyrs
whose names are
unknown

Earthly Life
Fourth century

**Characteristics
and Activity**
They refused to sculpt
a statue of Aesculapius
and were executed as a
result

Patrons
Sculptors, stone-
masons, and builders

Feast Day
November 8

▲ Anonymous, *The Four
Crowned Saints* (detail),
from the fourteenth cen-
tury. Campione d'Italia,
Santa Maria dei Ghirli.

The legends and traditions regarding the Four Crowned Martyrs remain somewhat convoluted despite attempts to name each of these characters. In the *Golden Legend,* Jacobus de Voragine explained the double identities that were hidden behind the title of the "Four Crowned Ones." Four martyrs, whose names were unknown and only later discerned through divine revelation, were given this title. They were named Severus, Severian, Carpophorus, and Victorinus, and they were commemorated on the same day as another five martyrs: Claudius, Nicostratus, Symphorian, Castorius, and Simplicius, who were stonemasons by trade. This identical feast day led to the first four being confused with the second five. Artists portraying the four did not thoroughly research their identities—this was first attempted in the Middle Ages—but instead identified these saints as holy stonemasons who were possibly natives of Pannonia. Due to their extraordinary abilities, these sculptors were called to work for Diocletian but were martyred after refusing to sculpt a statue of the Roman god Aesculapius.

Here the Four Crowned Martyrs are portrayed without specific attributes, although they are shown with imperial cloaks that give them Roman traits.

Here they are shown bare-headed without crowns, respecting the Classical characteristics of these figures.

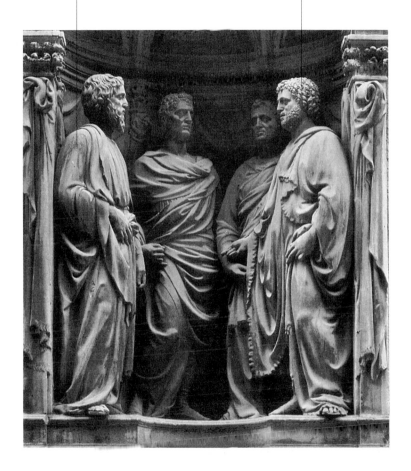

◄▲ Nanni d'Antonio di Banco,
The Four Crowned Saints (detail),
from the *Fabbri Tabernacle*,
1410–14. Florence, Orsanmichele.

Frances is shown in the black habit and white veil of the Benedictines. She typically distributes bread to the poor, and a guardian angel often appears at her side. One common image of her shows the Virgin Mary placing the child Jesus in her arms.

Frances
of Rome

Name
Originally a Germanic adjective meaning "Frank," which later became "French"

Earthly Life
1384–1440, Rome

Characteristics and Activity
An exemplary wife and mother, she dedicated her life to prayer and aiding the poor; she founded the Oblates of Mary

Patron
Auto drivers, perhaps because of the presence of her guardian angel

Venerated
Canonized in 1608

Feast Day
March 9

▲ Guercino, *Saint Frances of Rome* (detail), 1656. Turin, Galleria Sabauda.

▶ Orazio Gentileschi, *The Vision of Saint Frances of Rome*, 1615–19. Urbino, Galleria Nazionale delle Marche.

Frances was born in 1384 into the Bussa de'Leoni family of Roman nobles. Ever since she was a child, she developed a clear desire for a religious life but, having been educated to be docile, she did not oppose the marriage to Lorenzo de' Ponziani her parents arranged for her when she was thirteen. The young woman completely accepted her situation and was a model wife and mother during a difficult time in Rome's history. In 1408 Ladislaus of Naples, an ally of the antipope, conquered the city, and Frances's family suffered because they were papal supporters. However, this did not stop Frances from continuing her charitable works, and she sold her jewels and was generous with the supplies of her house. In order to aid the poor better, in 1425 she founded the Oblates of Mary, a group of virgins and widows who committed themselves to virtuous

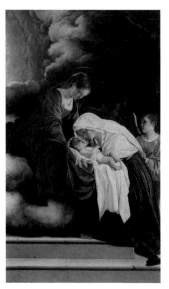

and loving lives and followed the Rule of Saint Benedict. After her husband died in 1436, Frances became the superior of the congregation that she had founded, a position she held until her death four years later. Frances's image is linked to her charitable work. Her white veil and black habit were the result of her congregation's adoption of the Benedictine rule.

Frances's first work of charity was bringing food to the poor.

Frances stayed in Rome her entire life, and she lived in one of her family's buildings in the Trastevere area.

A white veil over a black habit is characteristic of the Benedictines. The congregation that Frances founded dressed this way after they chose to follow the Rule of Saint Benedict.

▲ Baciccio, *Saint Francesca Romana Giving Alms*, 1675. Los Angeles, J. Paul Getty Museum.

Francis is typically portrayed wearing a brown habit and belt. His main symbols are the wounds of the stigmata. The oldest images of Francis depict him as a short, slender, and sickly man. He usually holds a crucifix, which he adored.

Francis
of Assisi

Name
Originally a Germanic adjective meaning "Frank" and then "French"; Francis was baptized Giovanni and called Francesco, since his mother was from Provence

Earthly Life
1181–1226, Assisi

Characteristics and Activity
Founded the Order of Friars Minor

Patron
Businessmen, rope makers, ecologists, flower growers, merchants, tapestry makers, and poets; the patron saint of Italy

Connections with Other Saints
Clare of Assisi

Venerated
Canonized in 1228, he quickly became one of the most popular saints in Christianity

Feast Day
October 4

▲ Giotto, *Saint Francis Preaches Before Honorius III* (detail), 1295–1300. Assisi, Upper Basilica of San Francesco.

Francis was born in Assisi, Italy, in 1181, the son of the textile merchant Peter Bernardone. He spent his youth with fun-loving friends and dreamed of becoming a knight. When he was twenty-three, as he traveled to Apulia to fight alongside Walter de Brienne, Francis had a vision at Spoleto. He returned home and began to convert. After meeting a leper and receiving a message from the crucifix at the church of Saint Damian, he chose to live alone and embrace poverty. This, of course, conflicted with his father's wishes. In 1208, dressed in sackcloth and living off alms, Francis began preaching for people to repent, and his first companions began to join him. The first version of the new order's rule was presented to Pope Innocent III, who approved it. They began their mission in Italy and beyond. Francis traveled to the Middle

East to proclaim Christ to the Sultan. When he returned to Assisi, he faced internal difficulties in his order and ceded its direction at the beginning of 1220 to Pietro Cattani. In 1224 he received the stigmata on Mount Verna. A short time later he caught a serious eye disease. Despite being practically blind, he still composed *Canticle of Brother Sun* before dying on October 3, 1226.

Francis's father has to be restrained because of his anger at his son, Francis, who declares that he only recognizes God as his father.

Francis publicly renounces all his belongings, stripping himself of everything and returning everything to his father.

This scene, which is a combination of two episodes narrated by sources, is set outdoors in Assisi. In the first (left), people insult and throw stones at Francis, in the second (right), Francis renounces everything in front of the bishop, an event that really happened inside the cathedral.

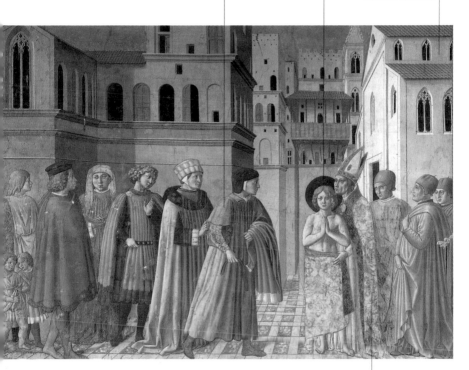

The bishop of Assisi was called to be a judge when Francis relinquished all the belongings he had received from his family. He admired the young man's deed, and from then on, he protected and supported him.

◄ Anonymous, *Francis of Assisi*, thirteenth century. Subiaco, Sacro Speco.

▲ Benozzo Gozzoli, *Stories of Saint Francis; Francis Renounces His Belongings*, ca. 1450–52. Montefalco, Museo Comunale.

The crucified Christ, with wings of a seraphim, marks Francis's body with the stigmata. This was the saint's vision on Mount Verna.

This tiny house on the mountain is the hermitage that was built in 1213 on a spur of Mount Verna.

Innocent III dreams that Francis saves the crumbling Lateran church.

Francis preaches to the birds which flock to listen to him near Bevagna.

▲ Giotto, *Saint Francis Receives the Stigmata*, ca. 1300. Paris, Musée du Louvre.

Kneeling with his eleven friars, Francis receives confirmation of their rule from Pope Innocent III.

Francis is portrayed here as a young man without a beard, as he must have looked soon after his conversion. His religious status is shown by his tonsure, or shaved head.

This mystical marriage symbolizes the vow of poverty. This rendering is based on the allegorical light opera Sacrum commercium, *which was written during the second half of the thirteenth century.*

The stigmata are artistic attributes that are fundamental in identifying Saint Francis. They are included here, even though this scene historically took place before Francis received the marks of Christ's wounds.

The personification of poverty has a halo around her head that is different from the ring that illuminates Saint Francis.

The rope that Francis ties his habit with has three knots, which symbolize his three vows of poverty, chastity, and obedience.

▲ Francesco di Giorgio Martini, *Marriage with Lady Poverty,* ca. 1458–60. Munich, Alte Pinakothek.

These wounds on Francis's hands, feet, and side are the same that Christ suffered on the cross. They were so extraordinary that they became the saint's main attribute in art.

Brother Leo was on Mount Verna with Francis. His presence in this scene of the stigmata shows he was an eyewitness to the event.

The crucified Christ, shown here with wings of seraphim, appeared to Francis in a vision on Mount Verna and imprinted the stigmata on Francis's body.

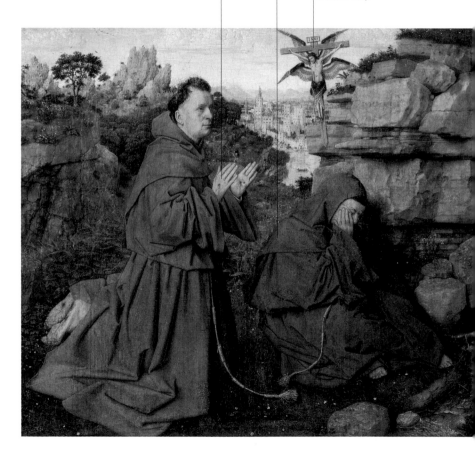

▲ Jan van Eyck, *The Stigmata of Saint Francis*, 1432. Turin, Galleria Sabauda.

▶ Giovanni Battista Piazzetta, *Saint Francis in Ecstasy*, 1729. Vicenza, Palazzo Chiericati, Pinacoteca Civica.

The figure of an angel, who sometimes plays an instrument while comforting Francis in ecstasy, is a typical example of devotion after the Council of Trent (1563).

Francis's traditional artistic attributes—the stigmata, the habit, and the rope belt—remain. The rosary, a devotional prayer that was only introduced after 1470, is also included.

Brother Leo is present during this ecstasy, just as he is in scenes of the stigmata.

The skull, a hermit's emblem, became a symbol of vanity (vanitas) in representations of the penitent or meditating Francis that spread after the Council of Trent.

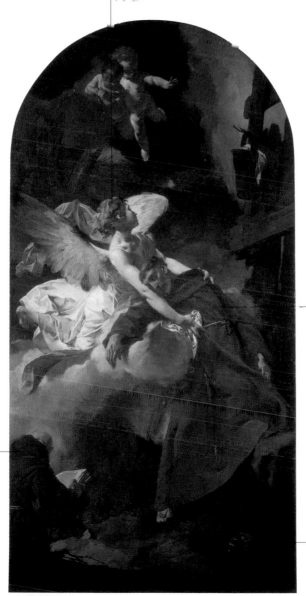

This brother who gazes upward had a vision of Francis's soul flying toward Heaven.

Francis's soul rises to Heaven "like a star, as big as the moon, shining like the sun and carried by a bright cloud" (from Thomas of Celano's First Life).

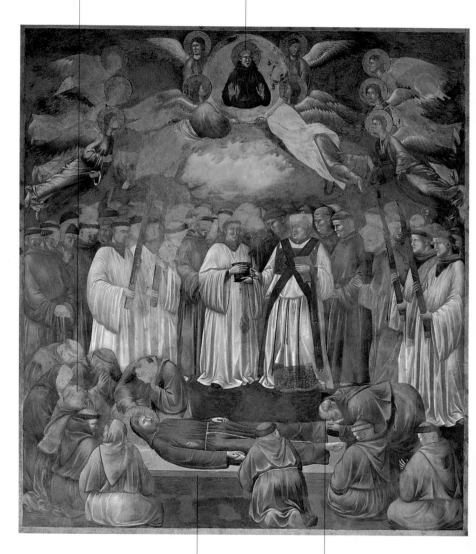

▲ Giotto, *The Death of the Saint,* 1300. Assisi, Upper Basilica of San Francesco.

Francis asked to be buried in the ground without a coffin.

Brother Leo discovers the wounds of the stigmata only at Francis's death.

Francis wears a priest's cassock. His attributes are the crucifix; a bowl he used for baptizing; a heart, which symbolizes his love for God; Indians; the lily of purity; and a pilgrim's hat, which represents his many voyages.

Francis
Xavier

A Spanish priest from a noble family, Francisco Jassu y Xavier was born in 1506 in the castle of Xavier in Navarra. He transferred to Paris in 1525, where he studied at the Sorbonne. Some years later, in 1533, he met Ignatius of Loyola, and their intense friendship and ardent collaboration led to, with the help of other friends, the founding of the Society of Jesus, or Jesuits. Francis was ordained a priest in Venice in 1537. After his ordination, he spent some years in Italy, and then, at the king of Portugal's request, he became inspector of missions in India. His first assignment was at Goa, where he initially dedicated himself to the Europeans who lived there. Soon, however, he began caring for the Indians, moved by a passion for spreading the gospel not just through preaching but also by aiding anyone suffering, sick, poor, or in prison. He eventually reached Japan and tried to enter China, where access was still prohibited to foreigners. Unfortunately, he died before reaching that goal on an island near Canton on December 3, 1552.

Name
Originally a Germanic adjective meaning "Frank," then "French"

Earthly Life
1506–1552; Spain, France, Italy, and the Far East

Characteristics and Activity
With Ignatius of Loyola he founded the Company of Jesus, or Jesuits, and dedicated himself to bringing the gospel message to India and Japan

Patron
Missionaries, sailors, and tourists

Special Devotions
Invoked against the plague

Connections with Other Saints
Ignatius of Loyola

Feast Day
December 3

◀ Francesco Polazzo, *The Death of Francis Xavier on the Shore* (detail), from the first half of the eighteenth century. Bergamo, Duomo.

Francesco del Cairo, ▲ *Francis Xavier Preaches to the Indians* (detail), ca. 1624. Modena, San Bartolomeo.

Here is the bowl Francis used to baptize Indians who converted.

Through his preaching, the Spanish missionary reached many people. They were not only the poor and suffering but also the nobility, such as this Indian princess.

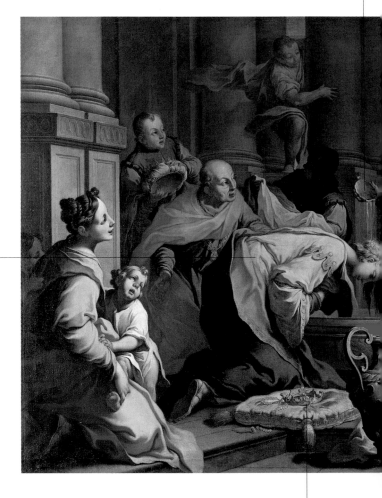

▲ Pietro Ligari, *Saint Francis Xavier Baptizes an Indian Princess*, 1717. From the Banca Popolare di Sondrio collection.

The crown, which shows that this woman being baptized was a member of the nobility, has been placed on a cushion at her feet.

The priest's cassock worn by the Jesuits
can be seen under the surplice, another
liturgical garment worn during baptisms.

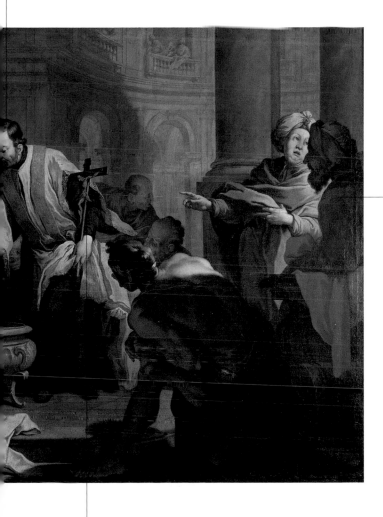

Eastern
peoples are
practically
an attribute
for Francis
Xavier in
art. Nor-
mally they
are Indian,
in memory
of his long
mission to
India.

Another attribute of Francis's is the
crucifix. It is a symbol of his preaching
and his devotion to Christ.

This angel is represented as a young, androgynous figure with wings. Sometimes he wears a crown. His attribute is the lily, which he brings to the Virgin at the Annunciation.

Gabriel
Archangel

Name
Originally Hebrew, meaning "God is my strength," also "man of God"

Characteristics and Activity
Divine messenger of the Bible

Patron
Those who work in communications and telecommunications, radio operators, postal workers, ambassadors, journalists, couriers, and stamp collectors

Connections with Other Saints
The other archangels, Michael and Raphael

Venerated
He was revered beginning around the year 1000

Feast Day
September 29, together with Michael and Raphael

▲ Orazio Gentileschi, *Annunciation* (detail), 1623. Turin, Galleria Sabauda.

Gabriel is an angel sent by God. He appears twice in the Scriptures: first he is sent to the prophet Daniel to help him interpret the meaning of a vision, and then he informs Daniel of the coming Messiah. In the Gospels, he is the bearer of two important birth announcements. He tells Zechariah that John the Baptist will be born, and then—his most important mission—he appears to Mary with news of the Incarnation of Jesus. In Jewish tradition, Gabriel was associated with other interventions in human history, such as the burial of Moses and the destruction of the Assyrian army. In the apocryphal gospels, Gabriel was promoted to archangel, yet this did not make any distinctive difference in his attributes in works of art, which tended to reflect the episode being represented. For this reason, it is quite possible to find the archangel dressed as a court dignitary or with a white tunic covered by a cloak. Nevertheless, Gabriel can hold the long staff of a church doorkeeper or a lily, which he brings to the Virgin Mary.

◀ Lorenzo Lotto, *Annunciation* (detail), ca. 1527. Ponteranica, Parish church.

This image of a prophet, who foretold the coming of the Messiah in the Scriptures, is a sign that God kept his promise, which the angel announces.

The dove is a visible image of the Holy Spirit, which was sent by the Father to incarnate the Son.

The archangel Gabriel carries the staff of church doorkeepers— those who safeguarded the church. It is one of the ancient symbols of angels.

▲ Matthias Grünewald,
Annunciation, 1515.
Colmar, Musée d'Unterlinden.

Luke's Gospel narrates how Mary was troubled by the angel's words. Here this reaction has been represented as reluctance.

Gabriel

The angel Gabriel's greeting to Mary became a
prayer to the Virgin: "Hail Mary, full of grace,
the Lord is with you." Saint Elizabeth's words
to her cousin, "Blessed are you among women,"
were also added.

Huge wings
are a main
attribute for
angels in art;
these origi-
nated from
the Classical
figures of spir-
its and statues
of winged
Victory.

Gabriel seems to
be choosing,
which is an
explicit call to
Mary. Sometimes
he gestures
toward Heaven,
implying the will
of God.

▲ Jan van Eyck, *The Angel Gabriel* (detail),
from the *Annunciation Diptych*, 1435–41.
Madrid, Thyssen-Bornemisza Museum.

After being afraid, surprised, and reluctant at the angel's words at first, Mary surrenders to the will of God.

Gabriel kneels and points toward Heaven, intending to communicate words from God.

The Holy Spirit, in the form of a dove, is often present in representations of the Annunciation.

▲ Orazio Gentileschi, *Annunciation*, 1623. Turin, Galleria Sabauda.

The lily replaces the doorkeeper's staff and becomes Gabriel's emblem. It symbolically refers to Mary's virginity.

George is depicted as a knight slaying a dragon with a sword or lance; sometimes the princess he is saving appears as well. The oldest images of this saint include a palm branch.

George

Proof of the historical existence of Saint George is based on rituals that sprang up at his grave in Lydda (Israel) where he was beheaded at the beginning of the fourth century. Early accounts of his life were already considered apocryphal by the sixth century. The image of the knight battling the dragon spread during the Middle Ages and was narrated in the *Golden Legend* very much like a fable. A horrible dragon was demanding human victims from a city. These were selected by drawing lots, and when the daughter of the king was chosen, she was brought near the lake where the dragon lived. Before the dragon could tear her apart, however, George, a knight from

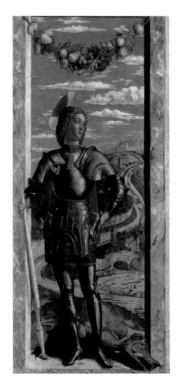

Cappadocia (Turkey), appeared and subdued it with his sword. Bound with the princess's girdle, the creature was led into the city. George reassured the people there, saying that he came to win over the dragon in the name of Christ so that they might convert. After they did, George set out again, but during Diocletian's persecutions he suffered atrocious torture and was beheaded.

Name
A Latin derivative from the Greek, meaning "farmer"

Earthly Life
Third and fourth centuries, Libya

Characteristics and Activity
Knight and martyr

Patron
Archers, knights, knighthood, the military, husbands, scouts, and fencers; patron saint of England

Connections with Other Saints
One of the Fourteen Holy Helpers

Venerated
Pope Gelasius approved George's veneration in A.D. 494; it spread to England in the seventh and eighth centuries and later during the Crusades

Feast Day
April 23

▲ Albrecht Dürer, *Saint George* (detail), from the *Paumgartner Altar*, ca. 1498–1504. Munich, Alte Pinakothek.

◀ Andrea Mantegna, *Saint George*, 1497. Venice, Gallerie dell'Accademia.

This thick forest represents the petrifying, treacherous home of the dragon. It replaced the lake mentioned in the Golden Legend, *which was the monster's traditional location.*

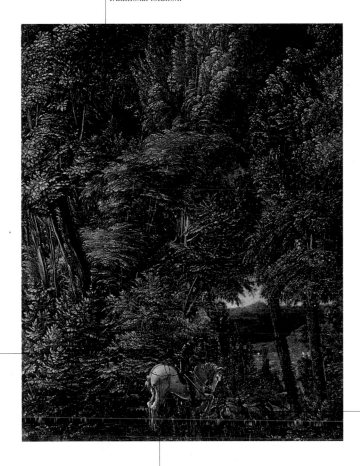

According to tradition, George was a knight from Cappadocia, and artists usually depict him as an armed soldier.

George's horse is often represented as a white steed, alluding to the flawless talents of his rider.

▲ Albrecht Altdorfer, *Saint George in the Forest*, 1510. Munich, Alte Pinakothek.

The dragon that Saint George slew became his main attribute in art. At times it has been interpreted as the Devil.

The princess, who has been interpreted as a metaphor for the church, keeps the dragon tamed and uses her own belt as a leash. This signifies George's power.

George often tames the dragon, his main emblem in art, before slaying him.

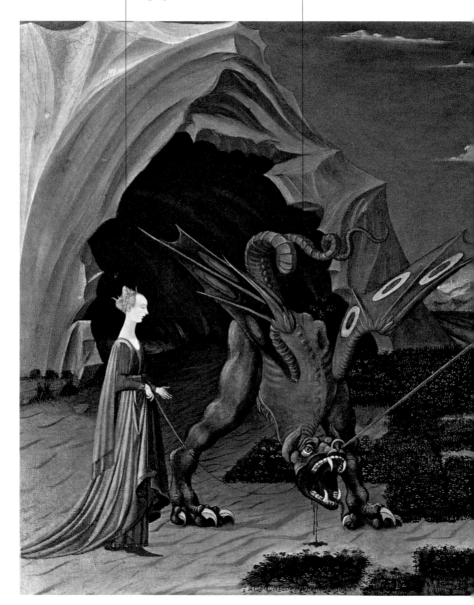

The lance that George uses to kill the dragon, together with the sword, is another one of the saint's attributes.

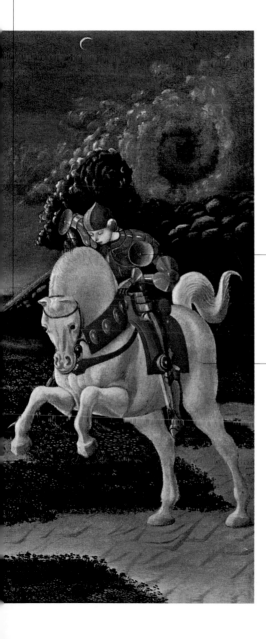

George always appears as a knight.

Here George's horse is shown as a white steed once again, a reflection of its owner.

◄ Paolo Uccello, *Saint George and the Dragon*, about 1460. London, National Gallery.

Giles

Name
From late Latin, *Agid-ium*, which was from the Greek, *aigidio*, which means "goat"

Earthly Life
Seventh and eighth centuries

Characteristics and Activity
Hermit and founder of the Saint-Gilles monastery in Provence

Patron
Protector of the handi-capped, because according to legend, he remained a cripple when he saved the doe; lepers; and nurses, because he cared for the doe

Special Devotions
Invoked against fear

Connections with Other Saints
One of the Fourteen Holy Helpers

Feast Day
September 1

▲ Bartolomeo Frunosino, *Giles Adored by the Angels* (detail), from the fifteenth century. Florence, Museo di San Marco.

Giles typically wears a Benedictine habit. A doe wounded by an arrow appears nearby.

Saint Giles was probably born at the beginning of the seventh century in Athens. He later settled in Provence, France, where he founded a monastery that eventually took his name. He died around A.D. 710. His burial place rose in prominence during the course of the Middle Ages because it was located on pilgrimage roads to Santiago de Compostela in Spain and Jerusalem. For this reason, during that time scarce facts about him were collected, and these eventually found their way into biographies of other saints. The most famous episode of his life, from which his attribute of the wounded doe originated, is the story of the king of the Visigoths, Wamba, who was unknowingly hunting near Giles's hermitage. He was pursuing a doe that had taken shelter in the hermitage cave. The animal had been living with Giles, who drank only its milk and water from a spring. Giles prayed that no one would harm the doe, and as a result, none of the king's company could enter the cave. One of the hunters, however, shot an arrow into it and

wounded Giles. The king then entered with the bishop of Nîmes and discovered the hermit, yet Giles did not accept their help. Later he did consent to being appointed abbot of a monastery that the king had instituted.

◄ Master of Saint Giles, *The Mass of Saint Giles*, ca. 1500. London, National Gallery.

148

The city in the distance must be
St. Gilles-du-Gard.

This hut among the rocks was the
hermitage where Giles retreated to
pray in solitude.

Here the archer
who shoots and
accidentally
wounds Giles
appears.

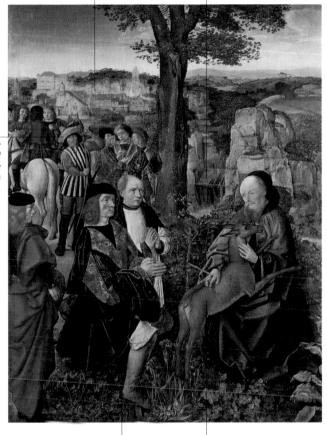

The bishop of Nîmes accompanies
King Wamba as he discovers the hid-
den Giles. The king kneels as a sign of
respect and veneration.

Although a smaller roe deer is
shown here, according to legend
it was a larger doe that nourished
Giles with her milk.

▲ Master of Saint Giles,
Saint Giles and the Hind, ca. 1500.
London, National Gallery.

Gregory is shown in papal vestments; among his attributes are the papal three-tiered crown; the dove of the Holy Spirit that inspires his writings; and the book, which signifies his being a Doctor of the Western Church.

Gregory
the Great

Name
Originally Latin from the Greek, meaning "he who awakens"

Earthly Life
A.D. 540–604, Rome

Characteristics and Activity
A pope and church doctor who first led a monastic life

Patron
Musicians, singers, button makers, teachers, and popes

Special Devotions
Invoked by those struck by the plague and gout

Connections with Other Saints
With Ambrose, Augustine, and Jerome, he is one of the four Doctors of the Western Church

Venerated
His cult spread immediately after his death

Feast Day
September 3

▲ Guercino, *Saint Gregory the Great with Saint Ignatius of Loyola and Saint Francis Xavier* (detail), 1625–26. London, The Denis Mahon Collection.

Gregory was born into a noble Roman family around A.D. 540. He studied law, and in A.D. 572 he became governor of Rome. When his father died in A.D. 573, he sold all his belongings, founded six monasteries in Sicily and seven in Rome on his property, and dedicated himself to helping the poor. Becoming a monk, he entered the monastery of Saint Andrew on Caelian hill and led an austere life according to the Rule of Saint Benedict. He did not stay long, however, since Pope Pelagius II sent him as ambassador to Constantinople. On his return, he was named abbot at Saint Andrew's. A short while later he had to give up the contemplative life once again; he was elected pope by the people and at the insistence of the clergy and the Roman senate. Although Gregory was frail in health, he was quite active in governing the church, charitable work, and missionary action. He especially promoted the Saint Augustine Mission in Canterbury, England. He was author and legislator in the field of liturgy and liturgical song, and he developed a

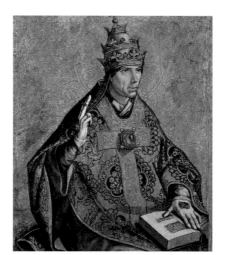

Sacramentary that is still the core of the Roman Missal. Gregory died in Rome on March 12, 604, leaving important pastoral, moral, and spiritual writings.

◄ Pedro Berruguete, *Saint Gregory the Pope*, from the middle of the sixteenth century. Barcelona, Museu Nacional d'Art de Cataluña.

After Gregory prays to convince a monk of the real presence of Jesus in the consecrated host, Christ descends from the cross and pours his blood into the chalice.

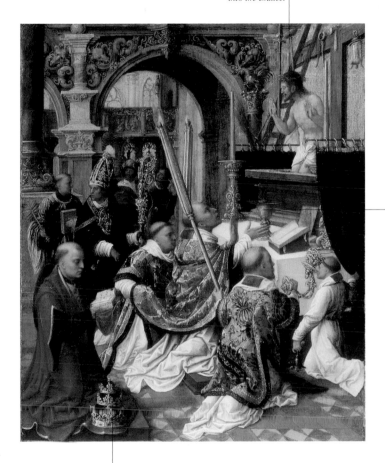

The papal tiara, a three-tiered crown, indicates that the pope is the father of kings and princes, rector of the Catholic world, and vicar of Christ.

The chalice is raised during the Consecration of the Mass.

▲ Adrien Ysenbrandt, *The Mass of Saint Gregory the Great,* from the first half of the sixteenth century. Los Angeles, J. Paul Getty Museum.

The dove of the Holy Spirit is a symbol of divine inspiration in Saint Gregory's writings.

An angel who plays music is a sign of a festive moment. This painting was made to celebrate the canonization of Saint Ignatius of Loyola and Saint Francis Xavier, which occurred on the feast day of Saint Gregory.

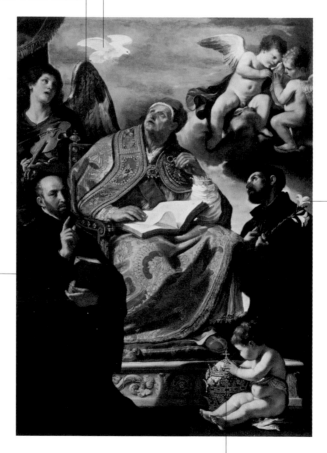

The lily, a symbol of purity and virginity, is one of Saint Francis Xavier's attributes.

The book Spiritual Exercises is one of Saint Ignatius's emblems in art.

▲ Guercino, *Saint Gregory the Great with Saint Ignatius of Loyola and Saint Francis Xavier*, 1625–26. London, The Denis Mahon Collection.

Although it is a sign of the pope's threefold sovereignty, the papal tiara is placed on the ground here as a sign of humility in the presence of the Holy Spirit.

Pax Domini sit semper vobiscum, *or
"May the peace of the Lord be with
you always," is a farewell of peace
that recalls the one Jesus used with his
apostles when he appeared to them in
the cenacle.*

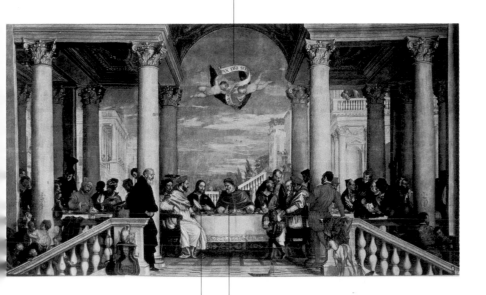

*Jesus, disguised as a pilgrim
(not as the traditional
angel), came to one of the
lunches that Gregory
offered to twelve poor
people each day*

*Gregory offered the meal
to commemorate Christ's
Last Supper.*

▲ Paolo Veronese, *Banquet with
Saint Gregory,* 1572. Vicenza,
Monte Berico Sanctuary.

Here the dove of the Holy Spirit once again symbolizes divine inspiration in Gregory's writings.

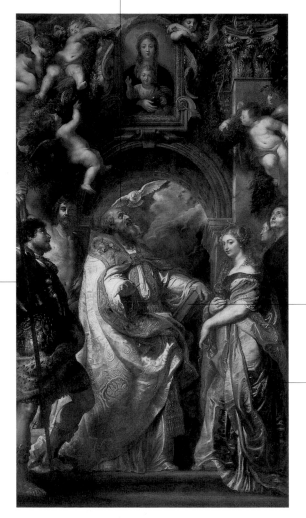

The book is one of Gregory's attributes, showing him to be a Doctor of the Church.

These are saints Maurus and Papias.

This is the Saint Flavia Domitilla, who was martyred together with her servants, Nereus and Achilleus, who appear behind her.

▲ Peter Paul Rubens, *The Madonna of Vallicella Adored by Saints Gregory, Domitilla, Maurus, Papias, Nereus, and Achilleus,* 1507. Grenoble, Musée de Grenoble.

Once again the papal tiara appears, a three-tiered crown signifying that the pope is the father of kings and princes, the rector of the Catholic world, and the vicar of Christ.

The dove of the Holy Spirit signifies divine inspiration.

The book of the Scriptures is an attribute for church fathers.

Emperor Trajan is saved from eternal punishment. Gregory prayed for the soul of the emperor, who had been dead for five centuries and was admired for his righteousness. An angel's voice told Gregory that his prayer had been answered.

▶ Michael Pacher, *Saint Gregory* (detail), from the *Altar of the Fathers of the Church*, 1480. Munich, Alte Pinakothek.

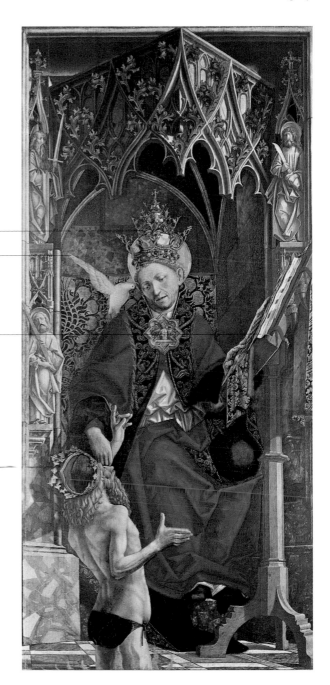

Helen

Helen is typically dressed as an empress. Among her attributes are the cross; the nails of the cross; and a tiny model of a church, reflecting her founding of two churches, the Nativity in Bethlehem and Holy Sepulcher in Jerusalem.

Name
An originally Greek name that spread with the works of Homer, the name can be connected to the gods Helios and Venus

Earthly Life
About A.D. 250–330; Asia Minor, Europe

Characteristics and Activity
This empress was the mother of Constantine, and went on a pilgrimage to the Holy Land and recovered the True Cross of Christ

Patron
Dyers; nail and needle makers

Special Devotions
Invoked against storms and fire, and by those who search for lost belongings

Venerated
She was venerated as a saint immediately after her death

Feast Days
August 18 in the West, May 21 in the East

Helen was born in Bithynia, present-day Turkey. Perhaps she was the daughter of an innkeeper. Around A.D. 270 she became the concubine of a Roman general, Constantius Chlorus, and they had a child together, Constantine, who was born around 285. Constantius disowned her in 292 when he became the Western Roman Emperor and married Theodora, the stepdaughter of Emperor Maximian. When Helen was in her sixties around 312, she converted to Christianity and demonstrated deep devotion. At that time, her son Constantine, after being educated in the East, had taken power at the court of Trier. After he became emperor, Constantine took possession of lands in the Eastern Roman Empire. Helen went on a pilgrimage to the Middle East and had the churches of the Nativity and Holy Sepulcher built there. Saint Ambrose was the first to defend Helen's role in recovering the True Cross of Christ near Mount Calvary, and her emblems in art are typically linked to this event.

This city should have been Jerusalem, but here the painter depicts his own city, Arezzo.

The True Cross was found by Helen and became her symbol in art.

According to legend, the three crosses were buried where a temple dedicated to Venus had been built.

According to Renaissance tradition, a dwarf accompanies the empress and her court.

A dead man rises from his coffin as soon as the True Cross touches it.

The crown is a royal attribute of Helen's. Her gray garments reflect the sobriety of her clothing after she converted to Christianity.

Helen appears twice because there is a second scene shown of the True Cross being tested.

◄ Jacopo Palma il Vecchio, *Saint Helen and Saint Constantine Between Saint Roch and Saint Sebastian* (detail), ca. 1520. Milan, Pinacoteca di Brera.

▲ Piero della Francesca, *The Discovery of the True Cross* (detail), ca. 1452–66. Arezzo, San Francesco.

This saint is dressed as a soldier and holds a horse's harness and bit, symbols of his martyrdom.

Hippolytus
of Rome

Name
From the Greek, meaning "drawn by horses"

Earthly Life
Third century, Rome

Characteristics and Activity
Soldier and martyr

Patron
Horses and wardens

Connections with Other Saints
He was Laurence's jailer

Feast Days
August 13 in the West, August 30 in the East

The character of Hippolytus, the soldier-jailer of Saint Laurence, is often confused with the Saint Hippolytus who was a priest and martyr during the reign of Alexander Severus. The first saint's iconographic traits originated from legendary tales of his martyrdom, which were invented and based on his name's similarity with horses (*hippo* is "horse" in Greek). It was believed that he was not beheaded, the normal capital punishment for Roman citizens, but either dragged to death or quartered by horses. Artists preferred to portray Hippolytus as a soldier and followed the *Golden Legend*. After jailing Laurence, who converted him to Christianity, and after having buried the saint, he in turn was arrested. The legend tells of Hippolytus's faith as he faced the emperor Decius and suffered various forms of torture. These included being shredded by iron combs, which once were among his attributes in art. After watching as his servants were decapitated, he faced martyrdom himself. His hands and feet were tied to horses and dragged over briars—not quartered, as artists preferred to show.

◄ Master of the Altar of San Bartolomeo, *Saint Hippolytus* (detail), from the *Altar of Saint Thomas*, 1490–1500. Cologne, Wallraf-Richartz-Museum.

In images of martyrs, emperors who order their punishment typically watch the torture. According to legend, this is Decius.

After horses were used to execute him, Hippolytus became the protector of this animal, and the harness became his typical emblem.

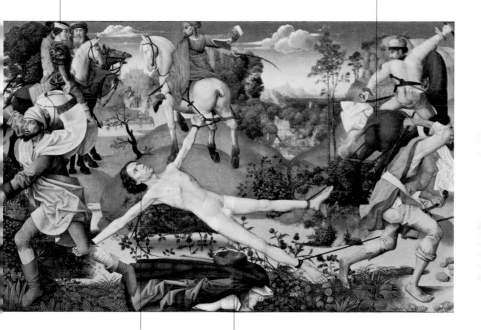

Hippolytus faces martyrdom with a peaceful expression.

Hippolytus's abandoned clothing is that of a soldier, which corresponds to his legend.

▲ Flemish Master, *The Martyrdom of Saint Hippolytus* (detail), ca. 1480. Boston, Museum of Fine Arts.

Ignatius
of Loyola

Ignatius is generally portrayed in a black cassock or with liturgical vestments. His attributes include a heart pierced by thorns, the monogram of Christ (IHS), and the motto Omnia ad maiorem Dei gloriam *(Everything for the greater glory of God).*

Iñigo Lopez de Loyola was born in 1491, the eleventh child of a Basque nobleman. He was educated at the court of King Ferdinand of Spain and had plans for a military career. In May of 1521, however, his leg was wounded as he defended Pamplona from a French siege. During his convalescence, Iñigo, who would later be called Ignatius, had time to read about Christ and the saints, inspiring him to change his life. He began with a long period in a hermitage at Manresa, where he began writing *Spiritual Exercises*, and a pilgrimage to the Middle East. Later he studied philosophy, living in Paris from 1528 to 1535. There, with a number of friends, he took a vow of poverty and chastity and dedicated himself to preaching.

In 1540 Pope Paul III approved the new order, which was named the Society of Jesus. Ignatius was committed to educating young people and to the foreign missions, and the order eventually grew into an extraordinary instrument of the Counter Reformation. He died in Rome on July 31, 1556.

Name
Originally Latin, of unknown meaning

Earthly Life
1491–1556; Spain, France, and Italy

Characteristics and Activity
Founder of the Society of Jesus, or Jesuits

Patron
Jesuits, soldiers

Special Devotions
Invoked against evil spells and wolves

Connections with Other Saints
Francis Xavier

Venerated
Beatified in 1609 and canonized in 1622, his cult initially was defined in the Basque country and in Navarra and then spread to the rest of Europe as the order expanded

Feast Day
July 31

▶ Domenichino, *The Vision of Saint Ignatius of Loyola* (detail), ca. 1622. Los Angeles County Museum of Art.

A possessed woman is struck by convulsions. A prayer from Saint Ignatius saves her.

The whip is a symbol of penitence and mortification.

The crown symbolizes the prize of glory.

▲ Peter Paul Rubens, *The Miracles of Saint Ignatius*, 1622. Genoa, Gesù.

Europe is personified here as a woman on horseback holding a scepter.

Saint Ignatius is brought to Heaven on a cloud held by angels.

A concave mirror captures rays from the saint's glory and reflects the Jesuit symbol.

Fire on the earth—the word of God—is ignited by sunlight reflected in concave mirrors.

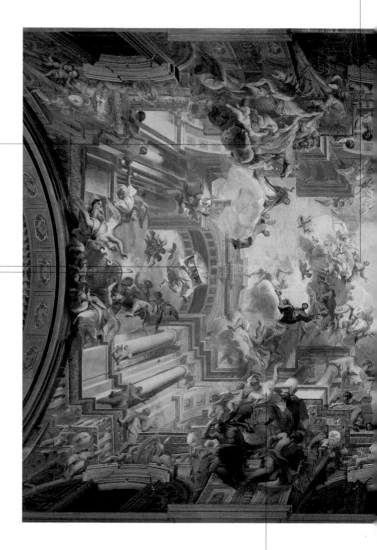

▲ Andrea Pozzo, *The Glory of Saint Ignatius*, 1691–94. Rome, Sant'Ignazio.

A figure with a turban riding a camel represents Asia.

*A Native American
represents America.*

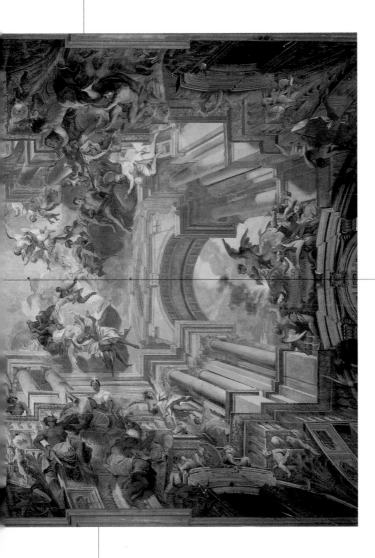

*The risen Christ,
holding the cross,
descends toward
Ignatius.*

*An African figure
represents Africa.*

Ildephonsus

Ildephonsus was born in A.D. 606 in Toledo, Spain, which was then the capital of the Visigoth kingdom. He was a descendant of an influential family that hoped to guide him toward a career that was appropriate to his rank. However, the young man had different aspirations; he escaped from home and took refuge in the nearby Benedictine monastery of Saints Cosmas and Damian in Agli. He became a monk, and although he was only a deacon at the time, he was elected abbot. In 657, at the death of Eugenius II, bishop of Toledo, Ildephonsus was called to fill the vacant position. He was required to give up the monastery, his contemplative life and his writing time. It was the insistence of a Visigoth king that convinced him to leave all these things. He carried out his pastoral activity in a diocese that had its share of difficulties. Ildephonsus nonetheless resumed his studies, producing doctrinal writings, treatises on Mary, and hymns.

Name
Germanic in origin, meaning, "ready for battle"

Earthly Life
A.D. 607–667, Spain

Characteristics and Activity
A Benedictine abbot, he was elected bishop of Toledo; he wrote theological works and treatises on Mary's virginity

Venerated
His cult spread when his relics were transferred in the eighth century

Feast Day
January 23

▲ Master of Saint Ildephonsus, *Presentation of the Chasuble to Saint Ildephonsus* (detail), from the end of the fifteenth century. Paris, Musée du Louvre.

◀ Bartolomé Esteban Murillo, *Presentation of the Chasuble to Saint Ildephonsus*, ca. 1560. Madrid, Prado.

The legend narrates how the chasuble
that was given to Ildephonsus was
white, a symbol of Mary's virginity

Mary appears during
a mass in church

Ildephonsus, who is recognizable from
his shaved head (tonsure) and abbot's
robes, receives a splendid chasuble from
Mary because he had defended her
virginity in his writings.

Ildephonsus

Ildephonsus was not typically depicted at his desk in this way. This image was created by El Greco and influenced the way Spanish saints were portrayed in the seventeenth century.

Our Lady of Charity appears to Ildephonsus as he writes a treatise on Mary's virginity.

The pen, suspended in midair, indicates that he pauses in search of inspiration.

▲ El Greco, *Saint Ildephonsus,* 1600–1603. Llescas, Fundación Hospital de Nuestra Señora de la Caridad Memoria Benéfica de Vega.

The Innocents are baby boys who are seized from their mothers. They often hold palm branches, which are symbols of martyrdom.

Innocents

The children of Bethlehem and the surrounding area who were murdered by Herod the Great were declared martyrs because, even if they were unaware of what was happening, they died for Jesus Christ. Matthew's Gospel (2:16) is the primary source for this story, and the evangelist tells of how King Herod learned from the Magi, three wise men who came from the East, that a star had risen and that the king of the Jews had been born. Herod sent the Magi to Bethlehem and asked that they return to inform him if they found the king. (He was plotting to eliminate a rival.) After their visit to the baby Jesus, however, an angel appeared to the Magi telling them not to return to Jerusalem, which they then avoided. Herod, realizing he had been tricked, ordered all children under two years of age in Bethlehem and the surrounding territory to be slaughtered to make sure that Jesus was eradicated. The number of children slain may have been around twenty, but images of this episode have traditionally been more focused on the atrocious violence and mothers' anguish than the number of casualties.

Name
Their name refers to these innocent children

Earthly Lives
First century, Bethlehem

Characteristics and Activity
They are children under the age of two who were killed in the massacre ordered by King Herod

Patron
Orphans

Venerated
Spread throughout the West in the fourth century

Feast Days
December 28 in the West, December 29 in the East

Guido Reni, *The Massacre* ▲ *of the Innocents* (detail), 1611. Bologna, Pinacoteca Nazionale.

Mattia Preti, *The Massacre* ◄ *of the Innocents* (detail), from the second half of the seventeenth century. From a private collection.

The soldiers execute their orders of a merciless bloodbath.

King Herod the Great, with a crown on his head, orders and watches the butchery.

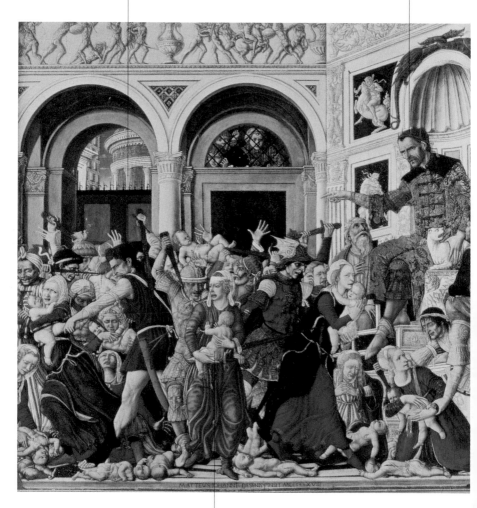

In the scene of the massacre, the Innocents are always portrayed as much younger than two years old, which was their maximum age as ordered by Herod.

▲ Matteo di Giovanni di Bartolo,
The Massacre of the Innocents,
ca. 1480–90. Naples, Capodimonte.

This saint is shown in farmers' clothing with agricultural tools.

Isidore was born in Madrid around 1080 into a very poor family. He lost his parents at a young age and eventually became a day laborer. He was quite devout in his faith, and each day he attended a mass before going out to work in the fields. His first employer, Vera, held him in high regard because of his righteousness and honesty. This caused his workmates to be envious. They accused Isidore of neglecting his work because he was too busy praying. As a result, his employer took back the share of the harvest that Isidore should have received and prohibited him from praying on workdays. God

then multiplied the small amount of grain that Isidore had in his storehouse. After a forced exile from the Madrid area because of the invading Almoravids, he was finally able to return and was hired by a landowner, Juan de Vargas, who was more understanding. Nevertheless, Isidore was again persecuted by the jealousy of the other day laborers. De Vargas, however, became suspicious and hid near the field where Isidore was working. He was astonished to find Isidore kneeling in prayer while two angels tilled the land. Isidore died around 1130.

Isidore
Farmer

Name
Latin name derived from the Greek, meaning, "gift of Isis"

Earthly Life
About 1080–about 1130, Spain

Characteristics and Activity
A poor, very devout day laborer who constantly tolerated the jealousy and envy of his coworkers with patience

Patron
Day laborers, farmers

Venerated
Canonized on March 12, 1622, by Pope Gregory XV

Feast Day
August 15

Giuseppe Antonio Petrini, ▲ *Saint Isidore the Farmer* (detail), 1703. Dublin, Church of Saints Peter and Andrew.

Master of San Giovanni ◄ alla Guilla, *The Miracle of Saint Isidore* (detail), from the seventeenth century. Palermo, Sant'Ignazio all'Olivella.

Ivo
of Kermartin

Name
Originally French,
meaning a yew tree

Earthly Life
1253–1303, Brittany

**Characteristics
and Activity**
A priest who was quite
active in the ecclesial
courts; considered an
advocate for the poor

Patron
Lawyers, judges,
jurists, magistrates,
notaries, attorneys,
bailiffs, and the poor

Special Devotions
The Pardon of Saint
Yves is celebrated each
year on May 19 at the
cathedral of Tréguier

Venerated
Canonized in 1347 by
Pope Clement VI

Feast Day
May 19

*Ivo is dressed as a scholar or cleric, and he holds a scroll or
a book.*

Ivo, or Yves Hélory, was born on October 17, 1253, in
Kermartin, which is in the region of Brittany in France. There
he began his first studies in theology and canon law, which he
then continued at the universities of Paris and Orléans. After
completing his education, he became an official at the ecclesial
courts of Rennes and Tréguier as a representative of an
archdeacon. He was quite talented and was called to the priest-
hood; although Ivo felt unworthy, the bishop of Tréguier
ordained him in 1284. Ivo was then named pastor of Trédrez,
although he remained active in the courts as an ecclesiastical
judge. In 1297 he decided to entirely renounce his position in
the courts in order to dedicate himself to preaching in the vil-
lages. A year later he donated to the poor all his belongings
and the castle at Kermartin that he had inherited from his
father. He continued his ascetic lifestyle there until he died on
May 19, 1303. In art, the image of Saint Ivo sitting between a
poor and a rich person was quite popular. It is considered a
variation on the theme of The Judgment of Solomon, a symbol

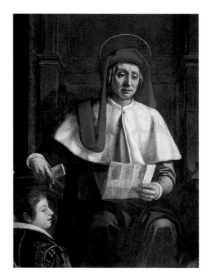

of Christian justice.
Ivo typically wears
the robe of a scholar
and a judge's hat,
although he can also
have clerical vest-
ments. His attribute is
a scroll of petitions or
a book. Sometimes he
displays a scourge as
an instrument of
penance.

◄ Jacopo da Empoli, *Saint Ivo,
Protector of Widows and
Orphans* (detail), 1617.
Florence, Palazzo Pitti.

Widows, together with orphans and the poor, are among those who benefit from Ivo's generosity.

A jurist's beret is one of Ivo's emblems as lawyer.

The book, or scroll of poor people's requests, is another of Ivo's attributes.

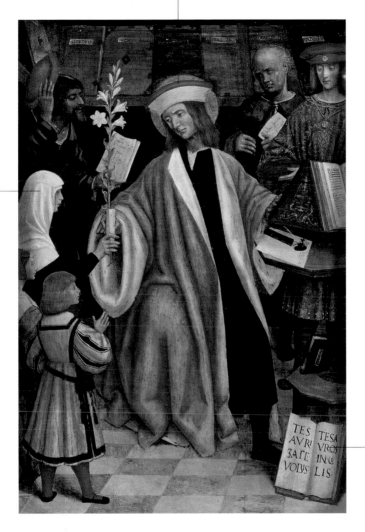

▲ Defendente Ferrari, *Saint Ivo Collects the Needs of the Poor,* 1520. Turin, Galleria Sabauda.

James
the Greater

James is dressed as a pilgrim with a staff, sack, cap, cloak, and seashell. Sometimes he appears with a book or sword. The image of this saint on horseback defeating the Moors was widespread after the saint appeared during the Battle of Clavijo in A.D. 844.

The Gospels mention James, son of Zebedee and older brother of Saint John the Evangelist, a number of times. Jesus called him the "son of thunder," which leads one to think he had a fiery character. James was present, together with Peter and John, at the Transfiguration on Mount Tabor and the Agony in the Garden at Gethsemane. According to the *Golden Legend*, James preached in Judea and Samaria after Jesus ascended to Heaven and then brought the gospel message to Spain. After disappointing results, he later returned to Jerusalem, where he was the first apostle to be martyred.

He was beheaded around A.D. 42. His legend tells of how his disciples placed James's body in a boat and brought it to Galicia, Spain, where they buried it in a forest. In the ninth century his tomb was discovered under miraculous circumstances, and around it rose Santiago de Compostela, a site of intense devotion that is still vibrant today.

Name
Perhaps originally Hebrew; one of its roots can mean "protect" or "follow"

Earthly Life
First century; Palestine and Spain

Characteristics and Activity
An apostle who witnessed the Transfiguration

Patron
Milliners, pharmacists, grocers, hosiery manufacturers, and pilgrims; patron of Spain and Guatemala

Special Devotions
Invoked against rheumatism and to obtain good weather

Connections with Other Saints
The Twelve Apostles, especially Peter and James's brother, John

Venerated
His cult spread in Spain beginning in the ninth century, when his relics were found in Santiago de Compostela

Feast Day
July 25

▲ A shell-shaped insignia from the fourteenth century. Museum of London.

▶ *Saint James*, a Flemish sculpture, 1500–1525. From a private collection.

A pilgrim's staff and a gourd used as a water container are James's main emblems since he became a pilgrim.

A shell identifies pilgrims who travel to Santiago di Compostela, perhaps because originally they would push on to the sea at Finisterre to collect a shell as proof of their completed pilgrimage.

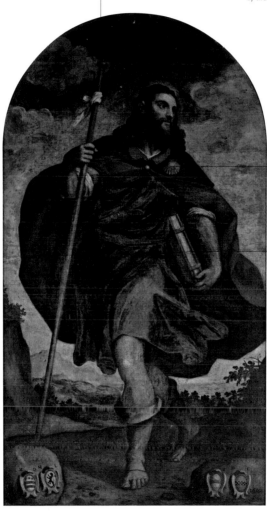

The book is one of the apostle's emblems, for he witnessed the events written inside.

▲ Palma Il Giovane, *James the Greater,* from the end of the sixteenth century. Airuno, Rocchetta Sanctuary.

This image shows James as the slayer of Moors (matamoros) and a defender of Christianity in Spain. Mounted on a horse, he brandishes a sword against these Arab and Berber conquerors.

There are a number of legendary episodes in which James appeared. The most famous was at the Battle of Clavijo in A.D. 844.

The Moors were defeated thanks to James's miraculous appearance on horseback.

The Christians were retreating to the Castle of Clavijo during the battle.

▲ Giovanni Battista Tiepolo,
Saint James the Greater, 1749.
Budapest, Szépmuvészeti Muzeum.

The blindfolded James waits to be beheaded. The scribe Josiah was also executed with him; he converted after seeing James cure a paralytic and was at the saint's side throughout his punishment.

James is beheaded outside of Jerusalem.

The staff is a pilgrim's faithful companion.

A shell has been placed on his hat—signifying a pilgrim of Santiago.

James is decapitated with a sword, which later becomes his attribute in art.

▲ Jean Fouquet, *The Martyrdom of Saint James the Greater,* from the illuminated manuscript *The Book of Hours* by Étienne Chevalier, 1450. Chantilly, Musée Condé.

The legend of the miracle at Santo Domingo della Calzada is shown here. This was a town on the way to Santiago de Compostela where a young pilgrim was unjustly accused and hanged. Afterward his parents, who were also on the pilgrimage, continued on their way. When they returned, they found that their son was still alive. They announced this fact to the bishop, who incredulously responded, "Your son is about as alive as the chickens I am eating." Suddenly the chickens flew off his plate.

Januarius is shown in a bishop's attire. His attributes are the palm of martyrdom, ampoules containing his blood, and lions that refuse to devour him.

Januarius
of Benevento

Name
Originally Latin, from the name of the Roman god Janus

Earthly Life
Third and fourth centuries; Benevento, Naples

Characteristics and Activity
Bishop of Benevento who was martyred in Naples

Patron
Blood donors, goldsmiths

Special Devotions
Celebrated in Naples three times a year: September 19; the first Sunday of May, in memory of the transfer of his relics; and December 16, the feast of the patron of the city and the day of a terrible eruption of Mount Vesuvius; since 1398, his blood, which is kept in two ampoules in the cathedral, continues to miraculously liquefy

Venerated
Since the fifth century in the West and East

Feast Day
September 19

Januarius was born in the second half of the third century, either in Benevento or Naples (there is some disagreement among the early sources). He later became bishop at Benevento at the beginning of the fourth century, during Diocletian's reign. In the course of persecutions that the emperor ordered in A.D. 303, Januarius was captured and imprisoned because of industriously aiding prisoners, particularly a deacon named Sossus. As a result, Januarius was prosecuted, condemned to death, and led to the Pozzuoli amphitheater with the deacon. However, the lions there refused to devour them and even lay down at Januarius's feet. He was then thrown into a burning furnace, where he should have died from horrific torment, yet he miraculously emerged unscathed. In the end he was beheaded near the sulfur mine of Pozzuoli. A Christian woman gathered his blood and saved it in two vials; these eventually became Januarius's symbols in art. His remains were brought to the catacombs of Capodimonte, which have been called the Catacombs of Saint Januarius ever since.

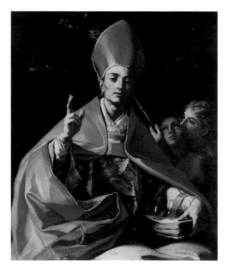

◀ Francesco Solimena, *Saint Januarius*, from the beginning of the eighteenth century. Naples, Tesoro di San Gennaro Chapel.

Among the Christians brought to the amphitheater with Januarius was the deacon Sossus (shown here wearing a deacon's dalmatic). He had been imprisoned before Januarius and was helped by the bishop.

Januarius wears a bishop's vestments, including the miter and pastoral staff. He blesses the lions.

Christians were executed in an arena of wild beasts during the persecutions of Diocletian. The bishop of Benevento was brought to the Pozzuoli amphitheater.

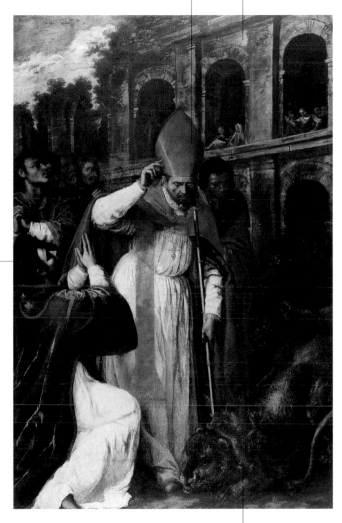

▲ Artemesia Gentileschi, *Saint Januarius in the Arena*, 1635–38. Pozzuoli, Duomo.

The lions of the arena refuse to tear into the bishop. They even become tame and lie at his feet.

The angels bring a palm
branch, an award for martyrs,
and a crown of glory.

In the background, the Christian
woman who saved a small amount
of the martyr's blood can be seen.
She holds the two tiny vials.

Januarius wears a bishop's
miter on his head. His cope is
taken from him as he raises his
eyes to Heaven and offers his
life in martyrdom.

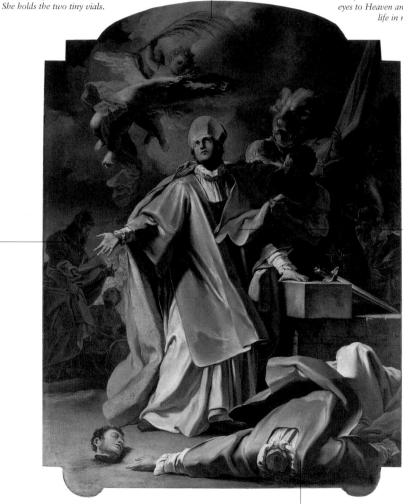

▲ Domenico Antonio Vaccaro,
The Beheading of Saint Januarius,
from after 1725. Naples, Concezione a
Montecalvario.

The bishop is shown a second time
in this sequence. His decapitated
body lies lifeless.

As a hermit, Jerome typically wears a beard and is partly nude. At times he beats himself on the chest with a rock as he faces a crucifix. His emblems are a lion, a skull, a cardinal's hat, and a book, since he revised a translation of the Bible.

Jerome

Jerome was born in Stridon (in the present-day Balkans), into a noble Christian family. He was taught by his father and then moved to Rome to further his literary education under the grammarian Donatus. He then dedicated himself to studies of rhetoric in Gaul and Trier, where he transcribed works for a library. He was baptized in A.D. 366 and traveled widely for a number of years in order to network with scholars, theologians, and biblical experts. Desiring to be a monk, he lived as a hermit in the desert in Chalcis for four years, from 375 to 378. Then, after studying in Constantinople with Saint Gregory Nazianzen, he moved to Rome to be special secretary to Pope Damasus, who assigned him the task of revising an ancient translation of the Bible from the Greek texts. According to a medieval interpretation that was repeated in the *Golden Legend,* Jerome must have been cardinal to be the pope's secretary, and therefore he wears a cardinal's vestments and red hat in art. When he eventually left Rome, Jerome retired to a monastery in Bethlehem, where he died when he was almost eighty years old in A.D. 420.

Name
Latin derivative of the Greek *Hieronymos,* which means "sacred name"

Earthly Life
About A.D. 341–420; Palestine, Rome, and Constantinople

Characteristics and Activity
Church doctor, monk, and hermit; author of the Vulgate translation of the Bible

Patron
Scholars, students, archaeologists, booksellers, pilgrims, librarians, and translators

Special Devotions
Invoked by those with difficulties seeing

Feast Day
September 30

Georges de La Tour, ▲
The Penitent Saint Jerome (detail), ca. 1530. Stockholm, Nationalmuseum.

Domenico Ghirlandaio, ◄
Saint Jerome in His Study (detail), ca. 1470–80. Florence, Ognisanti.

This cardinal's hat is the result of a mistaken interpretation of Jerome's life in the Middle Ages. He was never a cardinal, and the hat he wears is anachronistic, since this type of hat only began to be worn by cardinals around 1252.

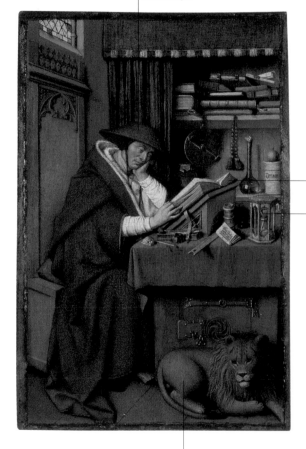

The book is a scholar's emblem. In Jerome's case, it refers to his numerous exegetical writings and Vulgate edition of the Bible.

The hourglass is among the symbols of a penitent hermit. This instrument for measuring time is a call to meditate on the transience of earthly things.

The Golden Legend *narrates how Jerome, in a monastery in Bethlehem, healed a wounded lion that had a thorn in its paw. It remained with him and is considered a symbol of compassion conquering brute force.*

▲ Jan van Eyck, *Jerome in His Study,* 1430–31. Detroit, Institute of Arts.

Here once again is the lion that—according to the Golden Legend—Jerome healed after it had wounded its paw. The animal was considered a symbol of the victory of compassion over brute force.

Rome can be seen in the distance. The outline of Castel Sant'Angelo has been included in order to emphasize the hermit's detachment from the earthly city.

The crucifix is among the hermit's symbols. It is an object of meditation. Here the penitent saint kneels in front of it.

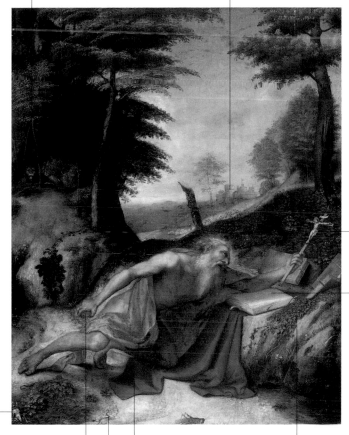

A bird's skull alludes to the vanity of all things (vanitas).

Jerome struck himself on the chest with a rock as atonement and in order to overcome the temptations of the flesh.

Here a cardinal's cloak helps identify Jerome. In the Middle Ages he was mistakenly thought to have been a cardinal.

The climbing plant symbolizes loyalty and steadfast faith.

▲ Lorenzo Lotto, *The Penitent Saint Jerome*, ca. 1520. Bucharest, Muzeul Național de Artă al României.

The serpent symbolizes a treacherous demon that is waiting to tempt the hermit in the desert.

The book is a scholar's symbol. In Jerome's case, it refers to his numerous writings and his work on the Vulgate.

The image of the angel of the Apocalypse blowing a trumpet to announce the Last Judgment stimulates a reflection on death and reuniting with God. It became widespread during the Counter Reformation.

This skull, one of Jerome's attributes, symbolizes vanity (vanitas) *and invites meditation on death.*

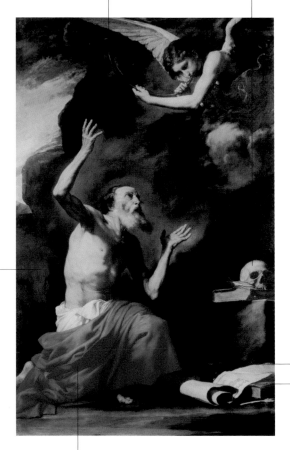

The lion is typically present in images of Saint Jerome in the desert. According to the Golden Legend, *the saint healed the lion and it stayed by his side.*

Along with the crucifix and skull, *the hourglass also* identifies a penitent hermit, who meditates on the transience of earthly things.

The scroll refers to Jerome's revision of the Vulgate and his numerous biblical writings.

A cardinal's red cloak, which sometimes appears with a cardinal's hat, helps to identify Jerome. In the Middle Ages he was erroneously thought to have been a cardinal.

▲ Jusepe de Ribera, *Saint Jerome and the Judgment Angel,* 1626. Naples, Capodimonte.

Domenichino, ▶
The Communion of Saint Jerome, 1614. Vatican City Pinacoteca Vaticana

These angels descend from Heaven to show the solemnity of the moment, or perhaps they refer to the vision that Sulpicius Severus, a disciple of Saint Martin of Tours, had when Jerome died.

Despite his living an ascetic life that made him quite weak physically, Jerome was almost eighty when he died.

Since he felt he was dying, Jerome called his disciples, hoping to receive Communion with them for the last time.

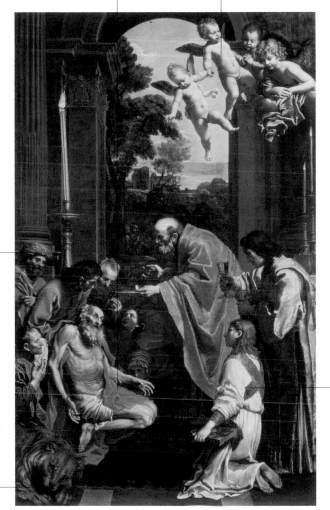

Paula was a widow who founded a convent near Jerome's monastery. She was present at the saint's final Communion.

The lion that Jerome healed, which according to tradition never left his side, licked his feet as he was dying.

One of Jerome's attributes is the skull, a sign of the vanity of things (vanitas). It is usually included in depictions of funeral rites.

Jerome healed the wounded lion, which had entered the monastery and frightened the monks. After his death it stayed at the monastery and had the task of guarding the donkey.

The palm tree is not intended to be symbolic here, yet it recalls that Jerome historically died in a monastery near Bethlehem.

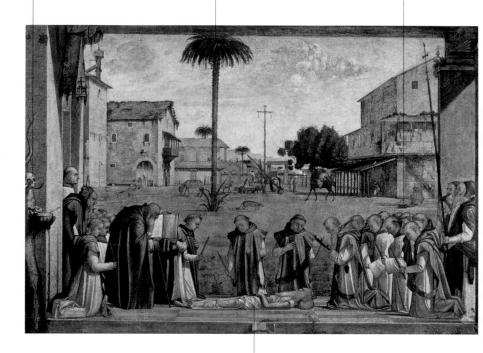

Jerome died when he was almost eighty and was buried at the church of the Nativity in Bethlehem.

▲ Vittore Carpaccio, *The Funeral of Saint Jerome*, 1502. Venice, San Giorgio degli Schiavoni.

This saint appears in full armor. She is often on horseback with a standard in hand.

Joan was an illiterate farm girl, yet at the age of thirteen she was already hearing the voices of saints urging her to free France. The English, who had already taken possession of the north of France and Paris, were besieging Orléans. She managed to obtain an audience with Charles VII and explain her precise plans to strengthen the army and free the city. Although some people—above all her parents—thought she was crazy, Joan knew how to dominate and persuade the generals. She led the French troops and freed Orléans from the siege. She followed this important military victory with a political one: she brought the reluctant and fearful Charles VII to Reims for his crowning on July 17, 1429. Now France had a true king who was recognized and indisputable. Unfortunately, Joan never saw Charles VII's triumphal entrance into Paris in 1437 because she was wounded in 1429, after being betrayed and captured by the Burgundians at Compiègne in September that year. She was then sold to the English and prosecuted as an excommunicate and heretic at Rouen. Although she was not

yet twenty years old, Joan was burned alive in Rouen's market square in 1431. She kept her eyes fixed on the cross that her confessor held for her.

◄ Jean-Auguste-Dominique Ingres, *Joan of Arc at the Coronation of Charles VII* (detail), 1851. Paris, Musée du Louvre.

Joan
of Arc

Name
From Hebrew, meaning "the Lord has been merciful" or "gift of the Lord"

Earthly Life
1412–1431, France

Characteristics and Activity
Inspired by mysterious voices, she fought for France against the English and brought King Charles VII to the throne

Patron
Telegraph and radio, patron saint of France

Venerated
In 1455 Pope Callistus II ordered her canonization process revived, and in 1909 Pope Pius X beatified her; she was canonized by Pope Benedict XV in 1920

Feast Day
May 30

Joan of Arc in Arms, ▲ from an illuminated manuscript of poems by Carlo d'Orléans from the fifteenth century. Paris, Musée de l'histoire de France.

Job

Name
From Hebrew,
meaning "someone
persecuted who bears
hardships"

Earthly Life
1500 B.C., the Middle
East

**Characteristics
and Activity**
Biblical figure who
was quite prosperous
and then was struck
by unthinkable
misfortunes, which he
managed to bear as if
they had been decreed
by God's will

Patron
Silkworm breeders

Special Devotions
Invoked by lepers and
hypochondriacs

Venerated
Already widespread
in the first century;
promoted by Saint
Clement

Feast Days
Roman Martyrology
and the Latin liturgy
remembers him on
May 10; Eastern litur-
gies, instead, have
other rites dedicated to
him on other days

Job is portrayed as an old man who is covered with sores.

Job is a character from the Bible who stands out as a model of
sanctity and patience. He lived in the land of Uz between the
regions of Idumea and Arabia. He was a wealthy man who
possessed a large number of animals and slaves. He had seven
sons and three daughters and was a pious and proper man. At
the height of his well-being and prosperity, however, he was
suddenly hit by a long series of misfortunes that deprived him
of all his belongings and even his children. In the end, even
though a disease struck him and covered his body with sores,
he never lost hope or reproached God, not even when his wife
derided him and instigated him to oppose the Lord. Ejected
from his house, he was forced to spend his days on a dung
heap. Here three friends of his came to comfort him, and they
began a long dialogue to probe the causes of humanity's suffer-
ing. They concluded that Job must have sinned to deserve all
that he had endured. God, however, who had allowed the Devil
to put Job to the test,
proclaimed Job inno-
cent, restored all his
previous happiness,
and enriched him with
twice as much wealth.

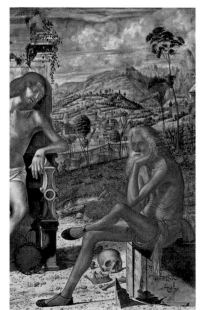

▲ Albrecht Dürer,
Job and His Wife (detail),
1503–4. Frankfurt,
Städelsches Kunstinstitut.

◄ Vittore Carpaccio,
Meditation on the Passion
(detail), ca. 1510.
New York, The Metropolitan
Museum of Art.

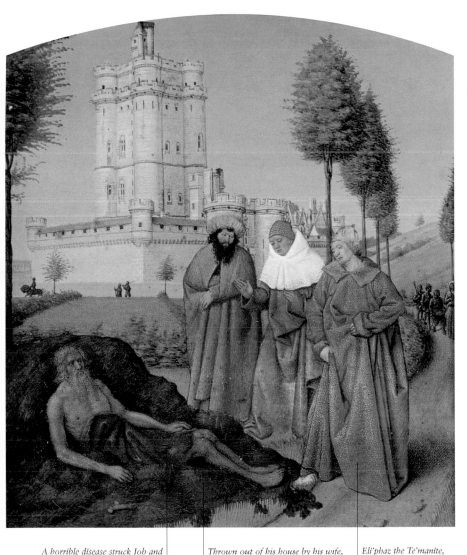

A horrible disease struck Job and covered his body with sores.

Thrown out of his house by his wife, Job went to live on a dung heap. He sat on ashes and used a pottery fragment to scrape himself.

Eli'phaz the Te'manite, Bildad the Shuhite, and Zophar the Na'amathite are three friends of Job's who accuse him of being such a sinner that he deserves misfortunes sent by God.

▲ Jean Fouquet, *Job on the Dunghill*, from the illuminated manuscript *The Book of Hours* by Étienne Chevalier, 1450. Chantilly, Musée Condé.

John is typically a hermit dressed in animal skins. His attributes are the lamb, because of the phrase he spoke upon seeing Jesus ("Behold, the Lamb of God"); a cross; and a scroll.

John
the Baptist

Name
Derives from Hebrew, meaning "the Lord has been merciful" or "gift of the Lord"

Earthly Life
First century, Palestine

Characteristics and Activity
Preached repentance by baptizing with water; baptized Christ

Patron
Hoteliers, cutlers, bird watchers, tailors, and leather workers

Connections with Other Saints
Elizabeth, his mother

Venerated
The veneration of John the Baptist had already spread by the fourth century around his grave, which according to tradition was at Sebastea in Armenia

Feast Days
June 24, his birth; August 29, his martyrdom; and September 23, his conception

The Gospels narrate that John was the son of Zechariah and Elizabeth and that he was born about six months before Jesus. According to an apocryphal tradition, Mary visited Elizabeth, who was her elderly cousin, and carried John in her arms when he was born. The Gospels do not refer to John's childhood, but apocryphal sources proposed that John left his parents at an early age in order to live a life of atonement in the desert. He was Jesus' predecessor and lived as a hermit, preaching conversion and baptizing people in the Jordan River. One day Christ came to John to be baptized. A short while later, Herod Antipas imprisoned John because the prophet had reproached him for his behavior (Herod was living with Herodias, his brother's wife). Then, during a banquet, Heriodias's daughter Salome danced so well that Herod promised her anything she asked. Influenced by her mother, Salome requested John's head on a silver platter. Too proud to retract his promise, the king ceded to her wishes and had John beheaded.

▲ Raphael, *The Holy Family with Saint John the Baptist and Saint Elizabeth* (detail), 1505–6. Munich, Alte Pinakothek.

◄ Francesco del Cossa, *Saint John the Baptist* (detail), 1473. Milan, Pinacoteca di Brera.

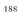

The vine branches are a symbol of eucharistic wine and the Passion.

A thorny briar branch refers to Christ's crown of thorns at the Passion.

The image of the young Saint John in the wilderness became widespread after the Council of Trent (1563). It derives from the Italian Renaissance artists' invention of portraying John and Jesus playing together as children.

John is normally dressed in poor hermit clothes made of animal skins. According to the Gospels, these were camel hides.

▲ Caravaggio, *Saint John the Baptist*, 1597–98. Toledo, Cathedral Museum.

The lamb is a main attribute of John's in art, because when he saw Jesus he said, "Behold, the Lamb of God" (John 1:29).

When Jesus is baptized, the Holy Spirit descends on Jesus in the form of a dove.

God the Father, who at the Baptism of Christ is present as a voice that comes from Heaven, is shown here as the traditional old man with a long beard.

In imagery featuring John the Baptist, the traditional hermit's staff is replaced by a cross made of reeds or pieces of wood.

Three angels, who are normally depicted holding Jesus' clothes, watch the extraordinary event of God the Father formally recognizing Jesus.

▲ Giovanni Bellini, *The Baptism of Christ*, 1500–1502. Vicenza, Santa Corona.

Jesus comes before John to be baptized and then begins preaching.

The eucharistic chalice that receives blood from this lamb enhances the theological meaning of this work.

John gestures toward whom to follow: Christ. Similar to that of the archangel Gabriel, John's mission is to announce Jesus.

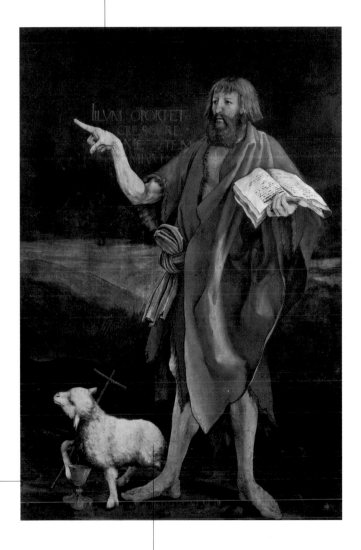

▲ Matthias Grünewald, *Crucifixion* (detail), 1515. Colmar, Musée d'Unterlinden.

The lamb is John's main attribute in art. When he saw Jesus he said, "Behold, the Lamb of God" (John 1:29).

The Baptist's head is held up before being brought to Salome.

John's decapitated body lies upside down.

Following Salome's request, the silver platter is waiting for the Baptist's head.

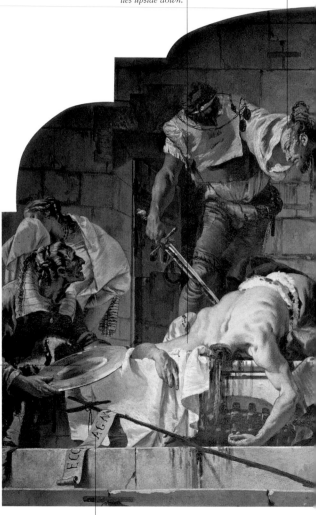

▲ Giovanni Battista Tiepolo,
The Beheading of John the Baptist,
1732. Bergamo, Colleoni Chapel.

The long cross holds a banner that reads, "Behold, the Lamb of God" (Ecce agnus Dei).

The weak King Herod listens to Herodias. She had persuaded Salome to ask him for the Baptist's head.

Herodias watches the Baptist's execution. His guilt was having condemned her for disobeying God's law.

*John's head is placed on
a silver platter.*

*Salome
is shown in
festive garments.*

*In the background of the
composition, the kneeling
Salome presents John's
head to her mother on the
platter.*

▲ Rogier van der Weyden, *Saint
John the Baptist Triptych* (detail),
ca. 1450–55. Berlin, Gemäldegalerie.

The silver platter becomes a precious cake stand in images of John's head being presented as a relic.

John's head symbolically represents a saint's martyrdom, and this image was widespread by the end of the Middle Ages.

▲ Andrea Solario, *The Head of John the Baptist*, 1507. Paris. Musée du Louvre.

John the Baptist

John's disciples buried his
body at Sebastea, in Palestine,
according to tradition.

The Johannites were
able to save a small
amount of the Baptist's
ashes.

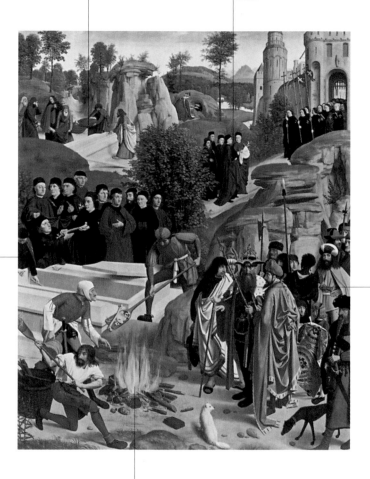

Julian the Apostate ordered
that John the Baptist's tomb
be desecrated.

In order to erase
any relics, John's
bones were burned
on a pyre.

Julian also commanded that
John's bones be destroyed in
order to destroy the veneration
of this forerunner of Christ.

▲ Geertgen tot Sint Jans, *The Story
of the Bones of Saint John the
Baptist,* ca. 1480–90. Vienna,
Kunsthistorisches Museum.

John is portrayed as a young, beardless man with an eagle and book. The chalice and serpent, his symbols, derive from an apocryphal source that narrated how John was forced to drink poison after refusing to offer sacrifices to pagan gods. Before doing so, he blessed the chalice and a snake emerged.

John
Evangelist

John, Zebedee's son, was one of the first apostles, together with his brother, James. He is considered Jesus' favorite disciple and was present at some of the most important moments in Christ's life. He witnessed the Miraculous Draught of Fishes and the Multiplication of Loaves and Fishes. Together with Peter and James, he experienced the Transfiguration on Mount Tabor and the Agony in the Garden of Gethsemane. John was the only disciple not to desert Jesus at the Crucifixion; he remained beneath the cross until the very end. After Jesus ascended to Heaven, it seems that John settled at Ephesus and remained quite active in the community there, organizing and preaching with Peter. According to the *Golden Legend,* he was exiled to Patmos after being immersed in a pot of boiling oil but emerging unharmed. During his banishment to the island, he wrote the Book of Revelation. According to tradition, he died when he was quite old, between A.D. 93 and 117, during Emperor Trajan's reign.

▲ Giovanni da Liegi (attributed), *Saint John the Evangelist* (detail), from the end of the fifteenth century. Paris, Musée de Cluny.

▶ Domenico Fetti, *Saint John the Evangelist,* ca. 1614. Mantua, Palazzo Ducale.

Name
From the Hebrew, meaning "the Lord has been merciful" or "gift of the Lord"

Earthly Life
First century B.C. and first century A.D., Palestine

Characteristics and Activity
One of the Twelve Apostles, probably the youngest; after the Resurrection, he took care of the Virgin Mary; toward the end of his life he wrote his Gospel, narrating the facts he had witnessed

Patron
Booksellers, writers, theologians, artists, knights, stationers, and typesetters

Connections with Other Saints
The Twelve Apostles, especially Peter and James, his brother; Matthew, Mark, and Luke, the other evangelists

Feast Days
December 27 in the West, September 26 in the East

John the Evangelist

According to the Gospel
(John 13:25, 21:20), John lays his
head on Jesus' chest and asks Jesus
who will betray him.

The connection
between these
two men, shown
for the first time
through this
image, is a sym-
bol of a disciple's
mystical union
with God.

The united hands
express deep affec-
tion, which is
characteristic of
statues of Jesus
and Saint John
from fourteenth-
century Germany.

▲ *Christ and Saint John*, ca. 1330.
Berlin, Skulpturensammlung,
Staatliche Museen.

Moses has rays of light on his head that resemble horns. This was due to a conflicted translation of the Bible that read that Moses' head was "horned" instead of "radiant" when he received the tablets of the Law.

Christ, shown here with a cruciform nimbus (halo), is flooded with light. Wearing white, he is transfigured before the apostles on Mount Tabor, revealing that he is the Son of God.

The image of Elijah is a typical representation of a prophet: thinning hair and a long beard. Only his head appears in order to indicate that he is an apparition.

Mary was not at the Transfiguration, yet she was inserted in this work because of the Dominican friars' great devotion to Mary.

This is the apostle Peter.

This is the apostle James.

The apostle John raises his hands to his face.

Saint Dominic appears at the Transfiguration because the Dominicans commissioned this fresco. He has a star above his forehead, a symbol of wisdom.

▲ Fra Angelico, *Transfiguration*, ca. 1440–46. Florence, San Marco.

This vision of a shining figure with "hair like wool" appears to Saint John as he is in exile on Patmos. She orders him to write the Book of Revelation.

The pen is also an attribute of John's, since he is a writer. It recalls that he is an evangelist.

The eagle is one of John's attributes in art. It is one of the animals in Ezekiel's vision (1:5, 10), and was given to John because he wrote the most spiritual and contemplative Gospel.

▲ Hans Burgkmair the elder, *Saint John at Patmos*, 1518. Munich, Alte Pinakothek.

These two men were
thieves condemned to be
crucified with Jesus, one
on his right and the other
on his left.

Mary, Jesus' mother, stayed at the
foot of the cross with John. Jesus
entrusted her to John's care just
before he died.

The three crosses are arranged
in an unusual manner. Typically,
Christ's cross is situated between
the other two.

John was the only disciple not
to desert Jesus when he was
crucified. He remained near
the cross.

According to the
tradition of the Gospels,
the sky darkened when
Christ died.

▲ Lucas Cranach the Elder,
Crucifixion, 1503.
Munich, Alte Pinakothek.

Mary of Cleophas also went to the tomb.

Joseph of Arimathea was a disciple of Jesus. He was the one who asked Pilate's permission to bury Jesus. Normally his attributes are pliers and nails.

Mary Magdalene, with the other women, watched where Jesus had been laid from afar.

▲ Niccolò dell'Arca, *Mourning for the Dead Christ,* 1485. Bologna, Santa Maria della Vita.

John, who is always shown as a
young man, weeps for Jesus yet
remains composed.

According to Mark's Gospel (16:1),
a woman named Salome came to the
tomb with the others on the morning
after the Sabbath.

Mary, Jesus' mother, stayed next to
her son until he was buried.

Jesus, who has been taken down
from the cross, is laid out and
mourned before being buried.

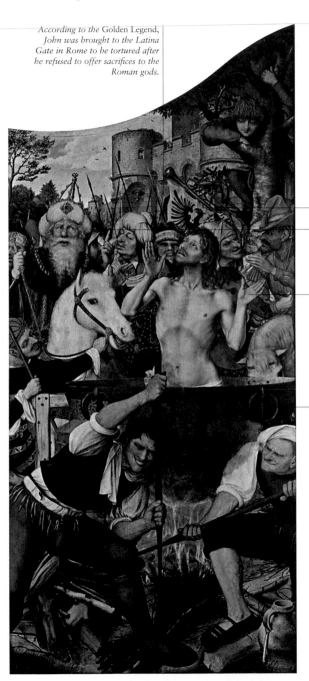

According to the Golden Legend, John was brought to the Latina Gate in Rome to be tortured after he refused to offer sacrifices to the Roman gods.

The eagle on this flag is an imperial symbol of the emperor Domitian.

Emperor Domitian, who had ordered the persecution of Christians, condemned John to a martyr's death.

John is shown in a martyr's stance, offering his life to God. Here the artist has ignored the fact that John's head was shaved to ridicule him.

John's punishment was to be immersed in a cauldron of boiling oil. He emerged unscathed, however.

▲ Quentin Massys, *The Martyrdom of Saint John* (detail), from the *Triptych of Saint John,* 1511. Antwerp, Koninklijk Museum voor Schone Kunsten.

Jesus' adoptive father is generally depicted as a mature or elderly man. Among his emblems are a flowering branch and carpentry tools.

Joseph

The evangelists Matthew and Luke reported the few facts known about Saint Joseph. Mary's husband and Jesus' adoptive father was a righteous man, a descendant of King David who lived in Nazareth and worked as a carpenter. He was betrothed to Mary when he learned that she was pregnant by someone else, but after an angel appeared to him in a dream and explained that it was divine intervention, he decided not to leave her. After Jesus was born, another angel urged him in a dream to flee to Egypt to save his child from Herod's rampage. He did this, and after Herod died, he brought Mary and the child back to Nazareth thanks to more advice from an angel. Joseph is featured again in the Gospels when he and Mary lose the twelve-year-old Jesus and find the boy discussing issues with the learned doctors of the temple. There is nothing else really known about Saint Joseph, except other episodes that originate from apocryphal writings and popular beliefs and devotions. Many of these determined his attributes in imagery. His characteristic traits of a mature man who is much older than Mary emerged from a need to emphasize Jesus' divinity. The apocryphal gospels state that Joseph was an elderly widower.

▲ Caravaggio, *Rest During the Flight to Egypt* (detail), 1595–96. Rome, Galleria Doria Pamphilj.

▶ Guido Reni, *Saint Joseph with the Child* (detail), 1638. From a private collection.

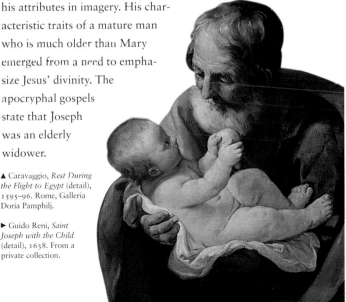

Name
From Hebrew, meaning "God adds," to be understood as joined by "other children"

Earthly Life
First century, Palestine

Characteristics and Activity
Marries Mary and is chosen by God to be Jesus' adoptive father

Patron
Artisans, carpenters, cabinetmakers, economists, laborers, fathers, and attorneys

Special Devotions
Invoked for a good death, by the homeless, and by those in exile

Venerated
Probably originally venerated in the East, his cult spread to the West in the ninth century, yet only entered into the liturgy in the fifteenth century; in 1870 he was declared patron of the universal Church

Feast Days
March 19 and May 1, the feast day of Saint Joseph the Worker

Mary is dressed in red to indicate her humanity. Her blue cloak emphasizes her divine role as Mother of God.

Joseph gives Mary a ring, a symbol of their marriage vows.

According to apocryphal tradition, Joseph is shown as a older man. Here Raphael paints him with a beard, a sign of maturity and wisdom.

According to apocryphal texts, the young women who were presented at the temple were given the task of weaving. Here the young woman accompanying Mary holds a piece of linen.

The flowering branch is an emblem of Joseph's because God indicated that he was the chosen one for Mary by making his dried branch bud and flower.

Bare feet are a sign of humility.

A disappointed suitor breaks his stick because he was not chosen.

▲ Raphael, *The Marriage of the Virgin*, 1504. Milan, Pinacoteca di Brera.

An angel in the sky announces Jesus' birth to the shepherds and encourages them to go and adore him.

A kneeling Virgin Mary at the Nativity was a theme that spread during the Renaissance.

Martin Paumgartner is shown here with his sons, Lucas and Stephan, and an elderly devout man who has not been identified.

Joseph is shown as an elderly man in order to emphasize Jesus' divine Father.

The ox and ass originated from a tradition in the apocryphal gospels. The ass symbolizes humility and the ox sacrifice.

▲ Albrecht Dürer, *Nativity* (detail), from the *Paumgartner Altar*, ca. 1498–1504. Munich, Alte Pinakothek.

The Paumgartner women have been included here. Here are Martin's wife and his daughters, Mary and Barbara.

The cherubs around Mary and her
child help to fill an everyday scene
with solemnity.

The kneeling Mary was defined
during the Renaissance, when
the theme of adoring the child
became a dominant motif in
images of the Nativity.

Joseph sleeps away from Mary
and the child to underline
once again his exclusive task
to safeguard them both.

The shepherds who heard
the angel's proclamation
are the first to give homage
to the child.

The child Jesus lying naked on
Mary's cloak emphasizes
Christ's absolute poverty.

▲ Andrea Mantegna, *The Adoration of the
Shepherds*, shortly after 1450. New York,
The Metropolitan Museum of Art.

The angel's hand stretches up to show that its message comes from God.

Sleep refers not only to the angel's visit to Joseph in a dream but also to the carnal burden that people experience without the Holy Spirit's revelation.

The angel shown here does not have wings, although its body is extraordinary. Since it is a spirit, its body does not cast a shadow over Joseph.

The pages that Joseph holds could be from the Bible. Perhaps this just man consulted it in order to find answers to his uncertainties.

▲ Georges de La Tour,
Joseph's Dream, ca. 1640.
Nantes, Musée des beaux-arts.

Joseph keeps watch and holds music for the angel to play. His role as guardian over Mary and the child is clear.

The music emphasizes the idyllic aspect of their resting. The scene does not originate from a specific source, but the piece of music linked to the Song of Songs is a key to reading this piece.

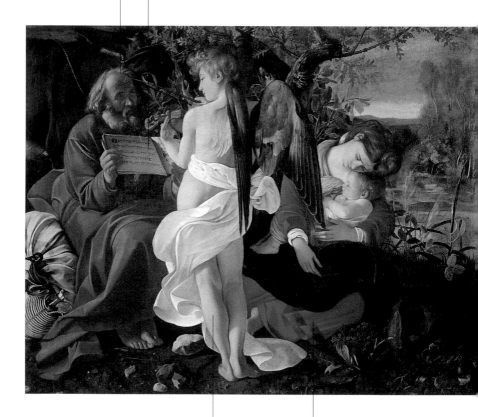

The angel, in the form of a winged young boy, derives from the winged spirits of Classical imagery.

Mary is weary from the journey. Her red hair comes from the biblical figure of the woman in the Song of Songs, which seems to have inspired Caravaggio in this work.

▲ Caravaggio, *Rest During the Flight to Egypt* (detail), 1595–96. Rome, Galleria Doria Pamphilj.

Elizabeth, Mary's cousin and John the Baptist's mother, is shown as an elderly woman. She conceived John when she was already advanced in years.

The staff is an attribute of Joseph's in art. Here the traveler's staff refers to the journey to Bethlehem, the flight to Egypt, and the return to Nazareth.

John the Baptist's symbol is a paper banner with the words "Behold, the Lamb of God."

The book is an emblem of Mary's. One of her titles in prayer is Seat of Wisdom (Sedes sapientiae).

▲ Raphael, *The Holy Family with Saint John the Baptist and Saint Elizabeth*, 1505–6. Munich, Alte Pinakothek.

*A red flower foreshadows
the Passion.*

▲ John Everett Millais, *Christ at the
House of His Parents (The Carpenter's
Shop),* 1849–50. London, Tate Gallery.

*Mary is kneeling next to Jesus
in Joseph's workshop.*

The artist has portrayed the dove of
the Holy Spirit somewhat irreverently,
with an exaggeratedly simple form
and position.

This child, who is
the same age as
Jesus and holds a
bowl, is John the
Baptist, following
typical Renaissance
works that
portrayed the two
cousins together as
children.

Jesus' hands already carry the
wounds of the stigmata, hinting at
his future death on the cross.

Joseph is typically portrayed as an elderly man because artists needed to emphasize Jesus' divine Father.

A carpenter's tools are Joseph's most common emblems.

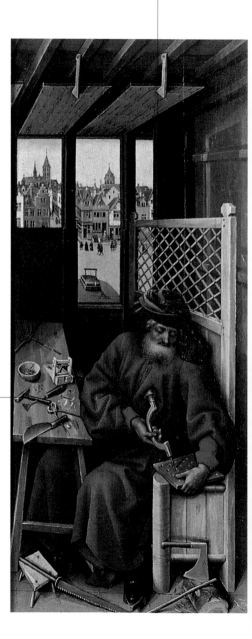

▶ Robert Campin, *Saint Joseph* (detail), from *The Annunciation Triptych*, ca. 1425. New York, The Metropolitan Museum of Art.

This saw is an emblem of Joseph's, since he was a carpenter.

Mary is at Joseph's side, praying as he dies.

Jesus, now an adult, blesses Joseph on his deathbed.

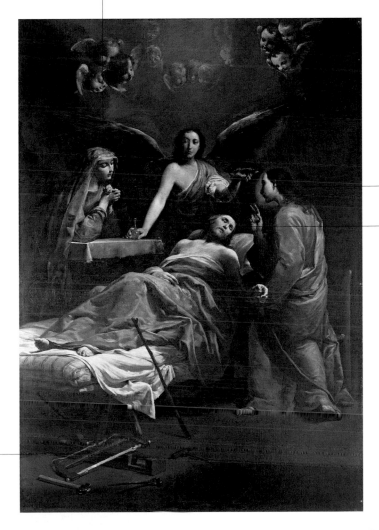

▲ Giuseppe Maria Crespi,
The Passing of Joseph, 1715–20.
Stuffione, Parish church.

Other than traditions from early Christian apocrypha, nothing is known about Saint Joseph's death, which probably occurred before Jesus' public life.

Julian
Hospitaller

Name
From Latin, meaning a member of the Julian family (*gens Julia*)

Earthly Life
Unknown

Characteristics and Activity
Nobleman who mistakenly slew his parents and then dedicated his life to sheltering and aiding the poor and pilgrims in order to atone for his sin

Patron
Hoteliers, travelers

Venerated
Scarcely venerated because of the uncertainty of his legend

Feast Day
January 9

This saint appears in a knight's armor. He has a falcon, a stag, or a sword—symbol of his patricide—as an attribute.

Dating perhaps to the fourth century A.D., the story of Julian is a legendary retelling of the myth of Oedipus the king. Even during the Middle Ages this character was confused with other saints who had the same name. The beginning of Julian's story resembles the legend of Saint Eustace: a young man hunts down a stag. However, the beast suddenly turns on him and demands, "How dare you hunt me, when you will kill your own parents!" Fearing the prophecy will come true, Julian flees as far as possible from his parents. He eventually marries and lives happily with his wife. One day, however, as he is away from home, two pilgrims arrive at his house. They tell Julian's wife that they are his parents and have been searching for their son for years. His wife gives them shelter, offering them the room where she and Julian usually sleep. Upon his return, Julian finds a man and woman in his bed and slays them, believing that his wife has been sleeping with a lover. Only after the wrongful act does he discover that he actually massacred his own parents. In order to atone for the horrible offense, Julian dedicates his life to aiding wayfarers with the help of his wife. Years later, during the night, he helps a leper; it is Jesus, who forgives his wrongdoing.

▲ Lorenzo di Credi, *Virgin with Child, Saint Julian, and Saint Nicholas of Myra* (detail), 1494. Paris, Musée du Louvre.

◄ Andrea del Castagno, *Christ and Saint Julian* (detail), ca. 1451. Florence, Santissima Annunziata.

Julian helps these two
blind boys.

Julian's wife shares her
husband's fate and helps
him give aid to pilgrims
and the poor.

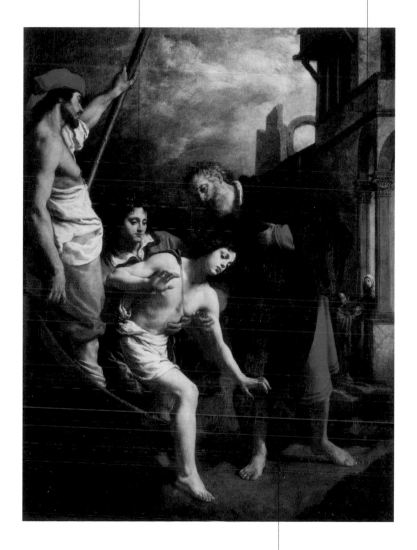

▲ Cristofano Allori, *The Hospitality
of Saint Julian,* from the beginning
of the seventeenth century. Florence,
Palazzo Pitti.

The saint is depicted as an
elderly man to emphasize his
long years of reparation for
having horrendously murdered
his parents.

Justina
of Padua

Name
From Latin, meaning "equal" and "just"

Earthly Life
Fourth century, Padua

Characteristics and Activity
Virgin and martyr

Patron
The Benedictine communities

Connections with Other Saints
Prosdocimus, who baptized her

Venerated
There are records of basilicas dedicated to her that date to the sixth century

Feast Day
October 7

▲ Guariento, *Saint Justina* (detail), from the *Coronation of the Virgin Altarpiece*, 1344. Pasadena, Norton Simon Museum.

▶ School of Andrea Mantegna, *Saint Justina*, 1432–1507. Milan, Museo Bagatti Valsecchi.

Justina is typically depicted as a young woman with a palm branch and a dagger in her heart; among her attributes are the dragon and unicorn.

Facts about Justina, virgin and martyr, have been muddled. She was baptized by Saint Prosdocimus, the first bishop of Padua, Italy, and perhaps was martyred during the persecutions of Maximian. However, no one is sure who she was, what she did during her life, or even how she died. Her character became legendary—based on a biography written during the twelfth century—around the time her relics were being transferred.

The image of this saint and her emblems derive from details in the *Golden Legend* and from confusion with other saints. The dragon, which represents evil, recalls the traps set by demons that Cyprian the magician unleashed against her after vainly attempting to possess her. The unicorn, a symbol of virginity, is attributed to Justina just as it was to Justina of Antioch. Finally, the dagger is a variation of the sword that, according to tradition, Justina was beheaded with around A.D. 304.

S. GVSTINA DE BOROMEIS

Laurence is shown wearing a dalmatic (a deacon's vestment) and holds the book of the Psalms and alms for the poor. He also appears as a martyr with a gridiron and a palm branch.

Laurence

Laurence was one of the seven Roman deacons of Pope Sixtus II and was martyred during Emperor Valerian's persecutions in A.D. 258. Details about his life before his martyrdom come from early biographies that also illustrate the life of another saint, Vincent of Saragossa. Prudentius, Saint Ambrose, and Saint Augustine also wrote about him. According to the *Golden Legend*, Laurence was from Spain and was called to Italy by the pope to become a deacon in Rome. Among his tasks was distributing goods to the poor, and although the prefect Cornelius Secolarius coveted them for himself, Laurence continued giving away the church's possessions. After the prefect demanded the church's treasure, Laurence gathered a group of poor people and came before the prefect, telling him that they were the church's treasure. He was arrested and tortured on a burning gridiron. According to the *Golden Legend*, Laurence said to the emperor, who was observing his punishment, "Behold, wretch, thou hast well cooked one side! Turn the other and eat!"

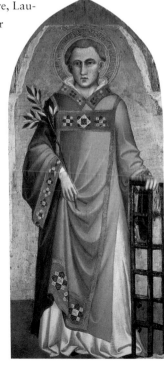

Name
From Latin, meaning "native of the city of Laurentum"

Earthly Life
Third century; Aragon, Rome

Characteristics and Activity
Deacon and martyr

Patron
Rotisserie owners, hosts, cooks, librarians, pastry chefs, firemen, window cleaners, and the poor

Special Devotions
Invoked against fires and backaches

Connections with Other Saints
Hippolytus, his jailer

Venerated
At first locally in Aragon and Italy; since the tenth century, in Germany and the rest of Europe

Feast Day
August 10

Francisco de Zurbarán, ▲ *Saint Laurence* (detail), 1636. Saint Petersburg, Hermitage.

➤ Spinello Aretino, *Saint Laurence*, ca. 1390. From a private collection.

Laurence was charged with distributing the church's gold furnishings and treasure to the poor.

The dalmatic is a deacon's vestment and shows Laurence's position.

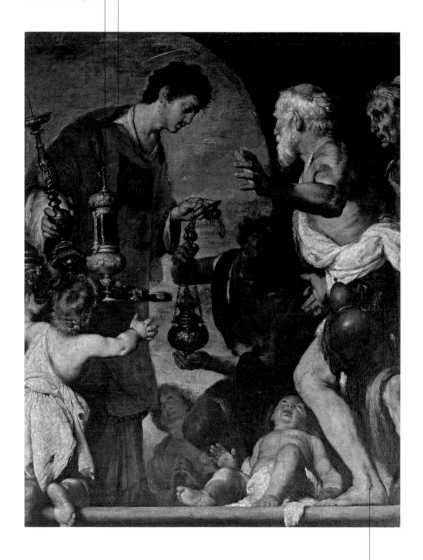

▲ Bernardo Strozzi, *The Almsgiving of Saint Laurence*, ca. 1638–40. Venice, San Nicola da Tolentino.

The poor were the recipients of aid from deacons. As he stood before the emperor, Laurence defined them as the real treasure of the church.

Emperor Valerian watches the torture inflicted on Laurence.

An angel brings a palm branch, a prize of martyrdom.

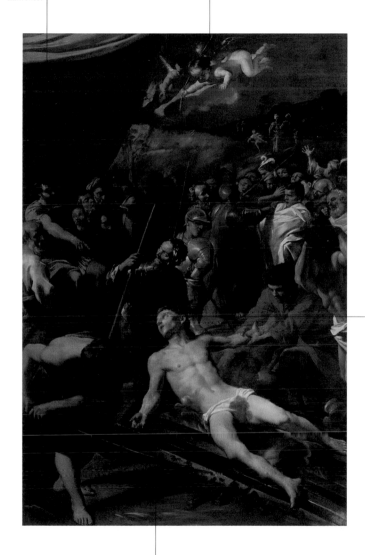

▲ Giovanni Lanfranco, *The Martyrdom of Saint Laurence*, 1635. Lucca, Museo Nazionale di Villa Guinigi.

Apocryphal tradition holds that Laurence was martyred with a burning gridiron.

Laurence gazes toward the emperor. Before dying, he tells him, "Thou hast well cooked one side! Turn the other and eat!"

Once again the dalmatic, a
deacon's garment, indicates
Laurence's position.

The deacon is typically
portrayed as a young
man.

Laurence holds a
gridiron, which is
his main attribute
in art.

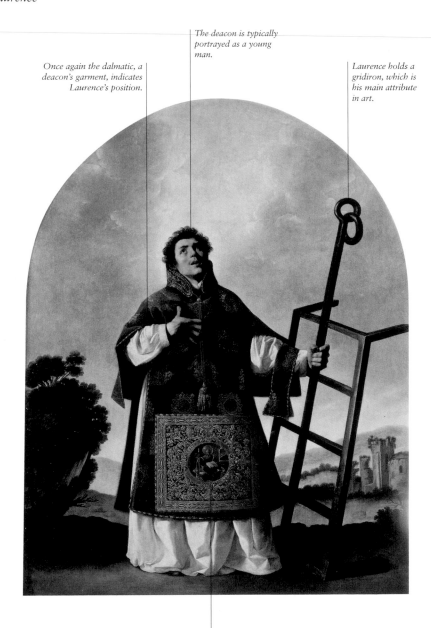

▲ Francisco de Zurbarán,
Saint Laurence, 1636.
Saint Petersburg, Hermitage.

Portrayed in the rich embroidery of
Laurence's dalmatic is Saint Paul and his
emblems in art: the book and the sword
with which he was martyred.

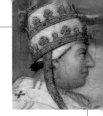

Leo is portrayed in papal attire and wears a papal tiara, a three-tiered crown.

Nothing is known of Leo's life during his early years as deacon except that he was sent to Gaul to mediate between two feuding generals. He was elected pope in A.D. 441, and throughout the twenty years of his pontificate, he intervened in theological and political disputes and demonstrated a decisive and unyielding character that was capable of action. His most famous achievement in the theological field occurred when the Council of Chalcedon endorsed his doctrine on the Incarnation of Christ in 451. Traditionally he has been attributed with legendarily stopping Attila the Hun, who, after having sacked Milan in 452, was advancing on Rome. It seems that Leo persuaded Attila to not invade the city in return for an annual tribute. Three years later, unfortunately, Leo was not able to stop Genseric, who besieged Rome for forty days. Leo died on November 10, 461, and was buried in Saint Peter's Basilica. In 1754 he was declared a Doctor of the Church. The episode of his life that is most often depicted in art is his halting Attila at the gates of Rome. According to a tradition alluded to in the *Golden Legend*, Attila decided to stop his siege because he saw the saints Peter and Paul beside the pope's company with their swords drawn.

Leo
the Great

Name
"Lion"

Earthly Life
Fifth century, Rome

**Characteristics
and Activity**
Pope; during his pontificate he saved Rome from Attila and the Huns

Patron
Musicians and cantors; patron of sacred music

Feast Days
November 10 in the West, February 18 in the East

► Raphael, *The Meeting Between Attila and Leo the Great*, 1513. Vatican City, Palazzi Vaticani, Stanza di Eliodoro.

223

Leonard typically appears dressed as a monk or in a deacon's dalmatic (outer garment). Sometimes he holds fleur-de-lis as a souvenir of his days at court. His emblem is a chain, since he petitioned the king for prisoners' freedom.

Leonard
of Noblac

Name
Originally Germanic, meaning "strong as a lion"

Earthly Life
Sixth century, France

Characteristics and Activity
Hermit and abbot

Patron
Farmers, blacksmiths, fruit vendors, prisoners, and the mentally ill (since they were tied down)

Special Devotions
Invoked against birth pains and by barren women

Connections with Other Saints
One of the Fourteen Holy Helpers

Venerated
Beginning in the eleventh century

Feast Day
November 6

Devotion to Saint Leonard especially flourished from the eleventh century on, when his first legendary biography was written. Jacobus de Voragine later took up his story again in the *Golden Legend*. According to these sources, Leonard was a French nobleman who lived in the sixth century. He was converted to Christianity by the bishop of Reims, Saint Remigius, who baptized him. Inspired by Christian love, he visited prisoners every day and obtained their freedom from King Clovis I. After this, Leonard decided to retire to an eremitic life. One day, however, Clovis's pregnant wife, the queen, was in the forest near his hut and unexpectedly went into labor. Thanks to Leonard's prayers, she peacefully gave birth to a baby boy. Leonard refused the money that the king then offered him, but he accepted a stretch of forest, as much land as he could ride around in a night on his donkey. There Leonard founded his monastery, where according to legend he was abbot.

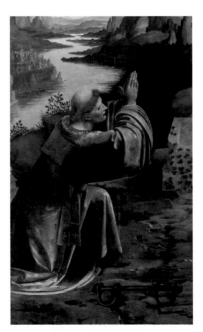

▲ Pietro Lorenzetti, *Saint Leonard* (detail), 1320. Riggisberg, Abegg-Stiftung.

◄ Giovanni Antonio Boltraffio e Marco d'Oggiono, *The Resurrection of Christ Between Saints Leonard and Lucy* (detail) ca. 1500. Berlin, Gemäldegalerie.

Louis appears as a young man wearing a bishop's vestments over a Franciscan habit. His attributes are those of royalty: the scepter, crown, and cloak decorated with fleur-de-lis.

Louis
of Anjou

The son of Charles II, king of Naples and Sicily, Louis was born in Salerno in 1274. When he was ten years old, he and his two brothers were handed over to the king of Aragon as ransom for their father's freedom. During his imprisonment near Barcelona, Louis began to hope for a religious life. When he was finally freed, he renounced his hereditary right to become king, transferring it to his brother in order to enter the Franciscan order and follow a life of penance and prayer. After being ordained a priest in 1296, he was appointed bishop of Toulouse, France, where he excelled at aiding the needy. Despite his ailing health, in 1297 he set out for Rome to attend the canonization of the French king Louis IX, his granduncle. (See next entry.) After just a few weeks of travel, however, he died from a fever at Brignoles, in Provence, and never reached Rome. Veneration of Saint Louis, bishop of Toulouse, spread rapidly, as did his image in art, which joined Franciscan traits with those of bishops and royalty.

Name
From French, meaning, "famous in battle"

Earthly Life
1274–1297; Spain, France

Characteristics and Activity
Successor to the king of Naples, he renounced the throne to his brother in order to embrace a religious life

Patron
The Franciscan order

Connections with Other Saints
Louis IX, his granduncle

Venerated
His cult spread after his death; he was canonized in 1317 and immediately popular in southern France and Italy

Feast Day
August 19

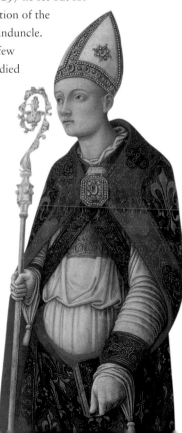

▶ Antonio Vivarini, *Saints John the Baptist and Louis* (detail), from the fifteenth century. Avignon, Musée du Petit Palais.

Simone Martini, ▲ *Saint Louis of Anjou* (detail), 1317. Naples, Capodimonte.

225

Angels hold a heavenly crown over
Louis's head, even though he already is
wearing a bishop's miter.

The symbol of Aragon on Louis's cope
recalls his time in that kingdom, where
he was held hostage and decided to
devote himself to a religious life.

A rope used as
a belt around
a habit is char-
acteristically
Franciscan. The
three knots recall
the three vows of
poverty, chastity,
and obedience.

The crown that
Louis is placing
on his brother
Robert's head
symbolizes
earthly power
which he
renounces in
order to embrace
a religious life

Fleur-de-lis are
a symbol of the
French royal
family.

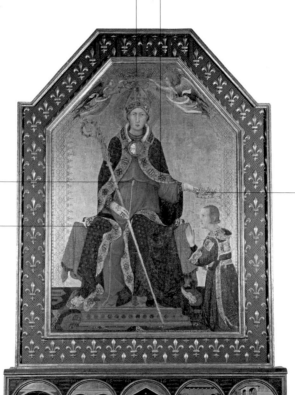

The main episodes of Louis's life are
pictured in five compartments of the
base. Here he accepts his position as
bishop, professes his Franciscan vows,
is ordained bishop, serves the poor,
and dies. Miracles after his death are
also shown.

▲ Simone Martini,
Saint Louis of Anjou, 1317.
Naples, Capodimonte.

Louis is typically shown in king's attire with all the attributes of a king: a scepter, crown, and the fleur-de-lis, an emblem of the French monarchy. He also wears a crown of thorns, a relic from the Holy Land for which he had Sainte Chapelle built.

Louis
of France

Louis IX was the son of King Louis VIII of France and Blanche of Castile. He was born in Poissy in 1214 and inherited the kingdom when his father died in 1226. Given that he was only twelve, he remained under his mother's guardianship until he reached the age of an adult. In 1234 he married Margaret of Provence, King Henry II of England's sister-in-law. Louis was a pious man, educated in his mother's faith. When Frederick II died, he became the most powerful sovereign in the West. This did not impede him from governing with wisdom and integrity in particularly bloody times. He led two crusades; during his first expedition, to Egypt, he and his army were imprisoned and had to pay a significant ransom to return to France. He then had to face a feudal revolt, yet he also dedicated himself to instituting important reforms and helping the weakest in society. In 1270 he set out on a crusade in Tunisia. Struck by the plague during a fatal epidemic, he never returned.

▲ Claudio Coello, *Madonna and Child Adored by Louis, King of France* (detail), from the second half of the seventeenth century. Madrid, Prado.

▶ Bartolomeo Vivarini, *Polyptych with Saint Ambrose Blessing a Number of the Faithful with Saints Louis, Peter, Paul, and Sebastian* (detail), 1477. Venice, Gallerie dell'Accademia.

Name
Originally French, meaning "famous in battle"

Earthly Life
1214–1270; Italy, France, the Middle East, and Tunisia

Characteristics and Activity
King of France

Patron
Carpenters, barbers, distillers, sculptors, haberdashers, hairdressers, and weavers; patron of the third order of Franciscans, the military order of Saint Louis, the French Academy, and France

Special Devotions
Invoked against blindness and deafness

Connections with Other Saints
Louis of Anjou; Thomas Aquinas

Venerated
From the moment of his death

Feast Day
August 25

227

A scepter is often the royal symbol that distinguishes Louis, king of France.

The fleur-de-lis at the head of this scepter—here given to a royal page—emphasizes that Louis was from French lineage.

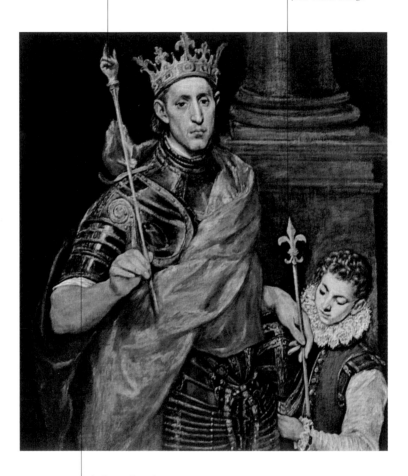

The king is dressed in armor in memory of the two crusades that he led in order to free Christian holy places.

▲ El Greco, *Saint Louis King of France with a Page*, ca. 1586. Paris, Musée du Louvre.

According to popular tradition, the child Jesus appeared to Louis IX.

Saint Joseph appears with the Virgin and Child.

Saint Anne is Mary's mother.

Saint Elizabeth is Mary's cousin and Saint John the Baptist's mother.

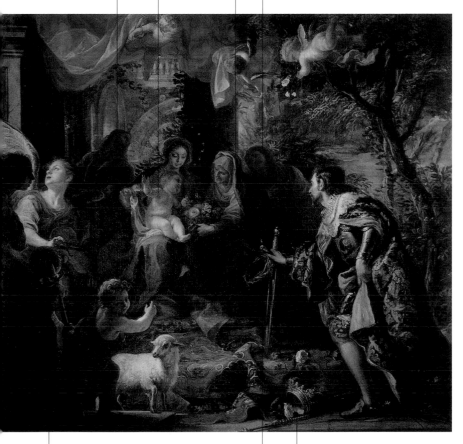

The child John the Baptist wears goatskins and holds a cross. He stands next to a lamb.

The crown of thorns is one of Saint Louis's attributes in art. He brought the relic from the Middle East and had Sainte Chapelle built to house it.

The scepter and crown are royal emblems that identify King Louis of France.

▲ Claudio Coello, *Madonna and Child Adored by Louis, King of France,* from the second half of the seventeenth century. Madrid, Prado.

Lucy

Name
Originally Latin,
linked to "light"

Earthly Life
Fourth century, Sicily

**Characteristics
and Activity**
This virgin died a
martyr during the per-
secutions of Diocletian

Patron
Electricians and
ophthalmologists

Special Devotions
Invoked for inflam-
mations of the eye

Venerated
Immediately after
her death

Feast Day
December 13

Lucy is typically shown holding her eyes on a plate. She can also display either the palm of martyrdom or the sword or dagger that she was martyred with. The scene in which teams of oxen fail to budge her is often depicted.

Lucy died a martyr in Syracuse (Sicily) around A.D. 304 during persecutions by the emperor Diocletian. The accounts of her martyrdom tell of a young noblewoman from Sicily who was consecrated to Christ. Although she was betrothed, she decided to give all her belongings to the poor and never marry. As a result she was denounced by her fiancé to the consul of Syracuse. She was then imprisoned and beheaded, after every attempt had been made in vain to dissuade her, including bringing her to a brothel, threatening to rape her, and trying to burn her at the stake. Lucy's legend derives from her connection with light ("lucidity"), which stimulated popular imagination to invent a form of torture with her eyes. This provided her attribute in art. It was said that her eyes were pulled out, and that she herself had to reinsert them. This belief, which was not included in the *Golden Legend,* has influenced depictions of

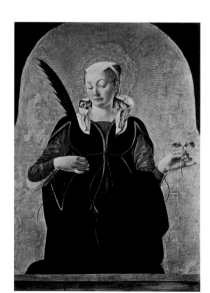

Saint Lucy ever since the Middle Ages, together with a tale by Jacobus de Voragine of how the Holy Spirit made Lucy so heavy as she argued with the consul that no one, not even teams of oxen, could move her.

► Francesco del Cossa,
Saint Lucy, after 1470.
Washington, D.C.,
National Gallery.

The consul Paschasius orders Lucy brought to a brothel and abused until she dies.

The presence of the Holy Spirit is made visible through the traditional image of a white dove.

Lucy's fiancé was disappointed and rejected by the young woman, who had consecrated herself to God, so he denounced her to the consul.

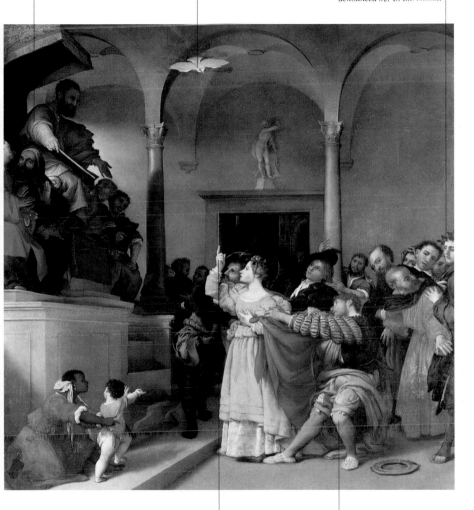

▲ Lorenzo Lotto, *Saint Lucy Before the Judge*, 1532. Jesi, Pinacoteca Comunale.

Lucy points above her to the Holy Spirit in the form of a dove, the origin of her faith and strength.

Paschasius summons a group of men to carry Lucy off, but they are not able to move her after the Holy Spirit makes her extremely heavy.

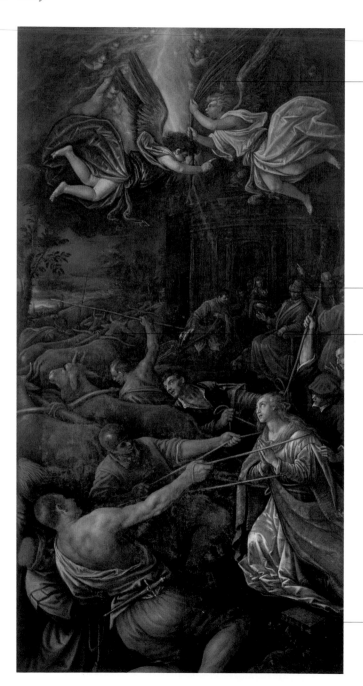

Angels bring a palm branch, the prize for martyrdom.

Paschasius, a consul of Syracuse, watches the futile attempts to move Lucy.

A number of oxen teams were tied to Lucy in an effort to move her, but the Holy Spirit made her so heavy that any attempt was in vain.

The Scriptures appear at Lucy's feet. She studied them and became wise.

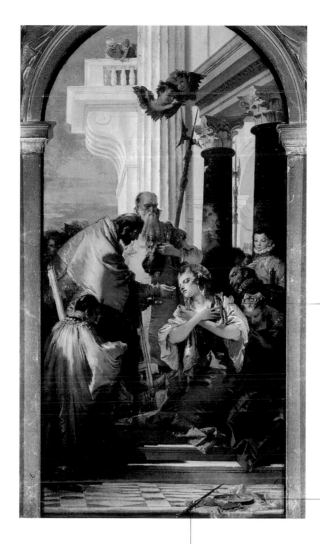

After she was
stabbed in the
throat, tradi-
tion holds
that Lucy
received Com-
munion and
then died.

Lucy's eyes are
on a plate. They
are her main
attributes in art.

The dagger with which she was
stabbed in the throat and martyred
is also Lucy's emblem.

◀ Leandro Bassano, *The Martyrdom of
Saint Lucy,* 1590–1600. Venice, Chiesa di
San Giorgio Maggiore.

▲ Giovanni Battista Tiepolo, *The Last
Communion of Saint Lucy,* 1748–50.
Venice, Santi Apostoli.

Luke
Evangelist

*Luke is shown either writing his Gospel or painting a portrait of
Mary. Among his attributes are the book and the ox, a symbol
of a sacrificial animal that scholars gave him in the third century
because his Gospel begins with Zechariah's sacrifice.*

Name
From Lucanus

Earthly Life
First century, Antioch

**Characteristics
and Activity**
One of the first disci-
ples of Antioch

Patron
Surgeons, gilders,
doctors, manuscript
illuminators, notaries,
writers, glass artists,
glass manufacturers

**Connections with
Other Saints**
Matthew, Mark, and
John, the other evange-
lists; Paul, with whom
he collaborated

Venerated
Even before his relics
were transferred to
Constantinople

Feast Day
October 18

▲ Gabriel Mälesskircher, *Saint
Luke Paints the Madonna*
(detail), 1478. Madrid,
Thyssen-Bornemisza Museum.

▶ Benedetto Bonfigli,
Annunciation and Saint Luke
(detail), from the second half
of the fifteenth century.
Perugia, Galleria Nazionale
dell'Umbria.

Luke is the author of the Third Gospel, written around A.D. 70,
and the Acts of the Apostles. Details about him can be found in
the letters of Saint Paul, since Luke was Paul's disciple and col-
laborator, and the two traveled together on a number of voy-
ages. According to Paul, Luke was probably a physician, a
Syrian who converted to Christianity. According to tradition, he
was one of the first members of the community in Antioch,
where he practiced his profession. His Gospel is addressed to the
Gentiles, Christians who had converted from Hellenism. In it he
emphasizes Jesus as someone who saves, as shown in the parable
of mercy and the large amount of attention he gives to stories of
Christ's birth and childhood. Tradition holds that he knew Mary
personally. His sharp observations particularly emerge in the
Acts of the Apostles, and news of his talents probably furthered
the legend that he was also an artist and painted the first portrait
of Mary. This episode became a recurring theme in art and was
especially widespread in fifteenth- and
sixteenth-century Flemish art. There
are even a number of portraits of
Mary in Rome at the church of
Saint Augustine that are attributed
to this evangelist.

The kneeling Saint Luke traces a sketch on a piece of paper for Mary's first portrait.

An open book on a stand symbolizes the Gospel Luke wrote.

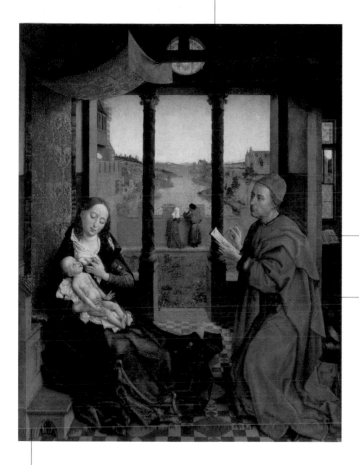

The fact that the Virgin is seated on a low step emphasizes her humility.

The ox is a symbol connected with this saint because it is a sacrificial animal, and his Gospel begins with Zechariah's sacrifice.

▲ Rogier van der Weyden, *Saint Luke Paints the Madonna*, ca. 1435–38. Boston, Museum of Fine Arts.

Margaret is typically portrayed as a young woman tending sheep. Among her attributes are the dragon that appeared to her after her torture—when she prayed to God to see her enemy—and the crucifix with which she defeated it.

Margaret
of Antioch

Facts about Margaret of Antioch, or Marina, derive from legends of the Middle Ages. It was thought that historically she was a young woman from Antioch (present-day Turkey) who lived during either the third or fourth century. Probably during Diocletian's reign, at the beginning of the fourth century, she suffered martyrdom. In the fifth century Pope Gelasius declared her legend apocryphal, although she reemerged during the ninth century in a martyrology by Rabanus Maurus, and her fame continued. According to the *Golden Legend,* Margaret was a girl from a noble family, the daughter of Theodosius, patriarch of the Gentiles. She was taught about Christianity and baptized. When she was fourteen, the prefect Olybrius saw her tending sheep and was so struck by her beauty that he immediately wanted her for himself— Margaret would be his wife if she was free or his mistress if a

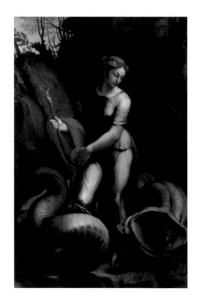

slave. In response, the girl declared her nobility and her Christian faith to him. As a result, she was tortured with every kind of punishment, and in jail she conquered a demon that appeared in the form of a dragon. She was eventually beheaded.

▲ Pellegrino Tibaldi, *Saint Margaret* (detail), 1556–61. Milan, Pinacoteca del Castello Sforzesco.

◄ Raphael, *Saint Margaret,* from the beginning of the sixteenth century. Vienna, Kunsthistorisches Museum.

Margaret's main attribute is the dragon, since she fought and defeated a demon that was shaped like one.

The shepherd's staff recalls how Margaret tended sheep.

A hat, which often replaces a crown, also indicates that Margaret was a shepherd.

▲ Francisco de Zurbarán, *Saint Margaret of Antioch*, 1630–34. London, National Gallery.

A book of prayer or the Scriptures indicates her Christian faith.

After having overcome all kinds of torture, Margaret was beheaded.

An angel brings the palm branch—the prize for martyrdom—from Heaven.

▲ Lodovico Carracci, *The Martyrdom of Saint Margaret*, 1616. Mantua, Chiesa di San Maurizio.

Margaret was executed with a sword, yet it did not become a symbol for this saint in art.

Since she was a lay member of the Franciscans, Margaret wears the habit of that order. Her emblems are a dog and the cross and skull of a penitent hermit.

Margaret
of Cortona

Margaret was born in Laviano, Italy, around 1247 into a modest family of farmers. She had a difficult childhood after losing her mother at an early age and enduring harsh treatment from her stepmother. She soon left her father's house to go live in the castle of a nobleman from Montepulciano, Arsenio, who had seduced her. Margaret lived for around nine years with Arsenio and their son, until her lover was killed under mysterious circumstances and found dead. Margaret tried returning to her father, but he shunned her, so she found shelter in the house of two noble ladies, to whom Franciscan friars referred her. She lived through a difficult time, mortifying herself and mistreating her son, whom she considered an offspring of sin. She was admitted into the third order of Franciscans, and Margaret dedicated herself to curing the sick poor. She continued her life of sacrifice, eating and sleeping very little and wearing sackcloth. After she received a revelation from God, she became committed to redeeming sinners. She died in 1297 and was already considered a saint.

Name
Latin name derived from Greek, meaning "pearl"

Earthly Life
1247–1297, Cortona, Italy

Characteristics and Activity
Penitent Franciscan tertiary

Patron
Repentant sinners

Venerated
She was widely considered a saint when she died, and her cult was authorized by the diocese of Cortona in 1515; her canonization only came in 1728

Feast Day
February 22

Unknown Tuscan artist, ▲ *Margaret of Cortona and Stories of Her Life* (detail), from the beginning of the fourteenth century. Cortona, Museo Diocesano.

Giovanni Lanfranco, ◄ *Ecstasy of Saint Margaret of Cortona* (detail), 1622. Florence, Palazzo Pitti.

239

A dog leads Margaret to the forest, where she discovers Arsenio's body. It eventually became her attribute in art.

Arsenio was found dead under mysterious circumstances.

▲ Marco Benefial, *Margaret Discovers Arsenio's Body*, 1729–32. Rome, Santa Maria in Aracoeli.

The painters who had recently traveled
to Constantinople, relied on what they
saw to depict these veiled women.

Turks are among those who
listen to Mark's preaching.
The painters came across
them during a trip through
the Ottoman Empire.

243

The turban on Annianus's head indicates he is a representative of the pagan culture and religion.

A gesture of blessing accompanies Mark's healing of the cobbler's hand, which occurred when he dressed the wound with clay made from his own saliva.

Cobblers' tools became emblems of Annianus's in art.

Annianus's hand was wounded as he repaired Mark's boot.

▲ Giovanni Battista Cima da Conegliano, *The Healing of Annianus*, 1497–99. Berlin, Nationalgalerie.

When Saint Mark's body was discovered, the saint appeared holding a book and stopped anyone from desecrating the other tombs.

A demon leaves the body of a possessed man.

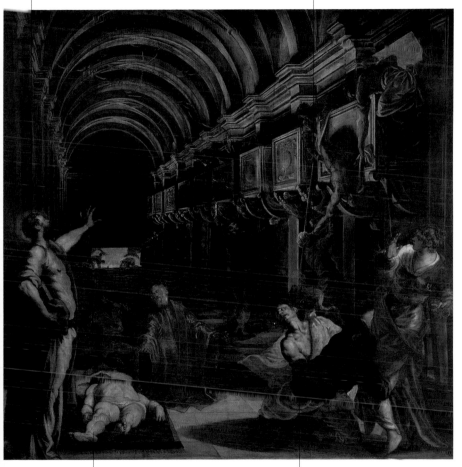

According to tradition, the body of Saint Mark was found during the ninth century in a church in Alexandria. Venetian merchants stole it and brought it back to Venice.

When the possessed man was freed from the demon inside him, this was proof that the true body of Saint Mark had been found.

▲ Tintoretto, *The Discovery of Saint Mark's Body*, 1562–66. Milan, Pinacoteca di Brera.

Martha

Martha is shown with a container and an aspergillum, a device used for sprinkling holy water, which she used to chase away a dragon that infested the forests of Tarascon. These emblems were mistakenly interpreted and later transformed into everyday utensils such as wooden spoons or a bunch of keys.

Name
Originally Aramaic, meaning "madam" or "mistress"

Earthly Life
First century, Palestine

Characteristics and Activity
Sister of Lazarus and Mary Magdalene; Jesus was a guest at her house a number of times

Patron
Homemakers, maids, servants, cooks, and nutritionists

Connections with Other Saints
Her sister, Mary Magdalene

Venerated
First locally in Provence, when her presumed relics were found in the twelfth century

Feast Day
July 29

▲ *Saint Martha,*
The Grimani Breviary
(detail), ca. 1500. Venice,
Biblioteca Marciana.

Martha appears three times in the Gospels. The first is when Jesus resurrects her brother, Lazarus, an event that allows her to know Jesus and become friends with him. Jesus is subsequently invited to their house, and her sister, Mary, remains with Jesus to listen to his words. At one point Martha asks Jesus to scold Mary for not helping her in the kitchen. Finally, Martha is in Bethany when Mary honors Jesus, six days before his Passion, by breaking open a jar of perfume and anointing his head. Other sources regarding Martha's life are apocryphal and originated much later. According to one medieval tradition, Martha, Mary, and Lazarus brought the gospel to Provence in France. Martha's characteristics in art often revolve around the gospel episode of hospitality toward Jesus, but in choosing her attributes artists tended to prefer the apocryphal legends.

◄ Giuseppe Cesari, *Saint Martha*,
ca. 1610. Rome, Santa Maria in
Vallicella.

Martha asks Mary why she isn't
helping her prepare the meal for
Jesus. This does not exactly follow
Luke's Gospel, in which Martha
asks Jesus to make Mary help her.

Listing or counting on
fingers is an image that
comes from medieval art
and signifies teaching
with authority.

Mary is seated lower than
Jesus with the humble
attitude of a disciple.

► Tintoretto,
*Christ in the
House of
Martha and
Mary,* 1570–75.
Munich, Alte
Pinakothek.

247

A sculptural relief of Moses with
tablets of the Law emphasizes t
continuity between the Old Testame
and the New Testament and the ne
covenant brought by Jes

▲ Pieter Aertsen, *Christ in the House of
Martha and Mary,* 1533. Rotterdam,
Museum Boymans-van Beuningen.

With one hand toward Mary and another toward Martha, Jesus reaffirms the separation between active and contemplative life, a theme that will be extensively discussed during the Protestant Reformation.

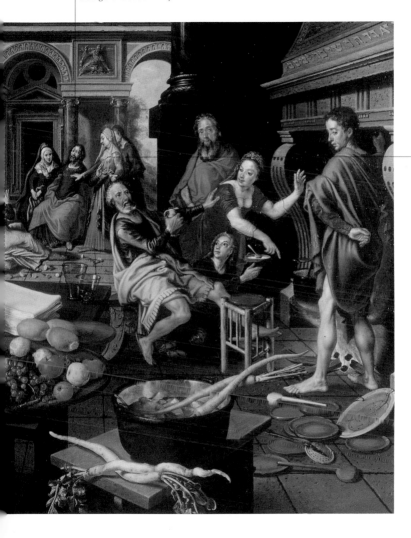

Hands clasped in prayer are a sign of recognition of Jesus' teaching authority and divinity.

Martha asks Jesus to intervene, pointing toward the foreground, an extremely rich scene with still lifes.

Martha

Mary, who symbolizes contemplation,
is portrayed sitting humbly on the
ground.

Jesus' emphatic gesture evokes his
response to the complaining Martha:
"Martha, Martha, you are worried and
distracted by many things; there is need
of only one thing. Mary has chosen the
better part, which will not be taken
from her."

Martha brings bread to the table, which
alludes to eucharistic bread. Here the
painter hopes to bring the character of
Martha, a symbol of busyness, toward
what is essential in life: contemplation.

▲ Jan Vermeer, *Christ in the House of
Martha and Mary*, ca. 1655. Edinburgh,
National Gallery of Scotland.

Martin is typically depicted as a soldier on horseback. He cuts his cloak in half with his sword to clothe a poor man.

Martin
of Tours

Martin was born in Pannonia (modern-day Hungary) around A.D. 315. He was the son of an official in the Roman army and enrolled in the military at an early age. Soon he converted to Christianity, however, and found great difficulty reconciling his faith with his military service. When he was stationed near Amiens, he happened to give half of his cloak to a poor man. That very night he dreamed that Jesus was wearing that same half. He interpreted the dream as a calling, decided to get baptized, and asked to be relieved of his military duties. Saint Hilary baptized him at Poitiers, and Martin became his disciple. They traveled together throughout Europe. In 360 Martin founded a monastery in present-day Ligugé—the first in Gaul—where he lived for twelve years. The clergy and people eventually elected him bishop of Tours. He preached Christianity through-out this diocese while living in a monastery at Marmoutier that he had founded at the gates of the city. After twenty-five years as bishop, ceaseless preaching, and many miracles, he died at Candes in 397.

▶ Bartolomeo Vivarini, *Saint Martin and the Poor Man* detail), 1491. Bergamo, Accademia Carrara.

Name
Originally Latin, meaning "dedicated to Mars"

Earthly Life
Fourth century; Pannonia, Italy, and France

Characteristics and Activity
Roman soldier who became bishop

Patron
Soldiers, tailors, hoteliers, and merchants

Connections with Other Saints
Martin followed Hilary of Poitiers

Venerated
His cult was especially popular during the Middle Ages, thanks to a biography written by Sulpicius Severus, where he is called the thirteenth apostle

Feast Days
November 11 in the West, November 12 in the East

El Greco, *Saint Martin ▲ and the Beggar* (detail), 1597–99. Washington, D.C., National Gallery.

A laurel crown adorns the emperor Julian's head. The painter was probably inspired by some ancient model, perhaps a coin or precious stone.

Martin's folded hands make the ceremony of his investiture as a knight more solemn.

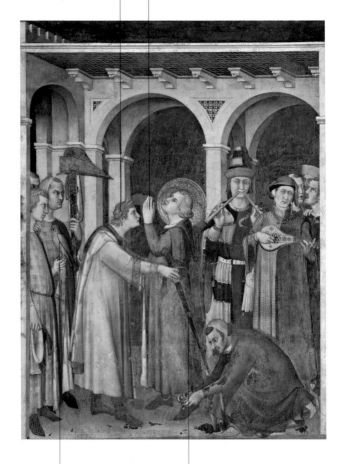

The falcon and helmet are a knight's emblems. Squires bring them for Martin.

The emperor attaches the sword to Martin's belt. This is the decisive act of a knight's investiture.

▲ Simone Martini, *Saint Martin of Tours Ordained a Knight by Emperor Julian,* ca. 1315–16. Assisi, Lower Basilica of San Francesco, San Martino Chapel.

A soldier's armor is one of Martin's
attributes in art. Here the painter
portrays him in his own era.

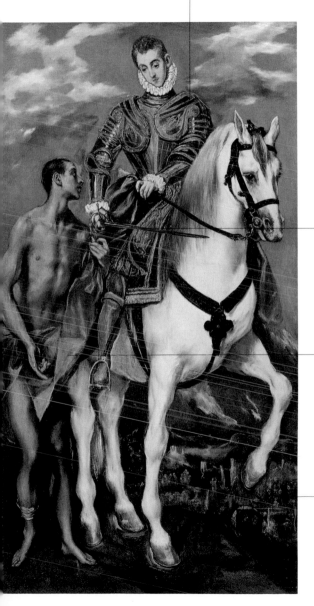

The sword, which
Martin uses to cut his
cloak in half, refers
to a decisive moment
in Martin's life,
which became a
renowned episode in
popular devotion and
the history of art.

Later in a
dream, Martin
will see the
divided cloak
that he gives to
the half-naked
man once
again—this time
worn by Jesus.

The city in the
background is
not the town
of Amiens,
where Martin
met the poor
man, but the
city of Toledo,
the artist's
adoptive city.

◀ El Greco, *Saint Martin and the
Beggar*, 1597–99. Washington, D.C.,
National Gallery.

According to the Golden
Legend, *soldiers who fought
the barbarians in Gaul were
given money beforehand.*

Spears, helmets, and
shields with savage
insignia distinguish
the enemy.

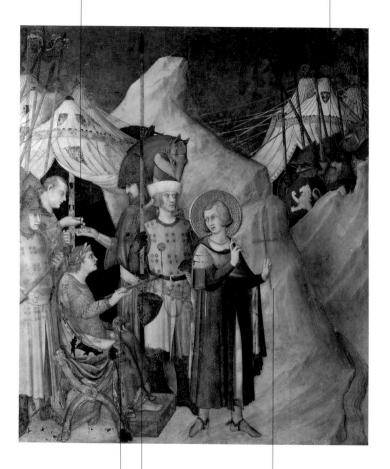

The globe is a
sign of dominion
over the earth.

The scepter is a symbol
of power in the hands
of the emperor.

Martin holds the cross, a symbol of
Christians. He declares that he
renounces all arms for Christ, and in
order to not appear a coward, he
offers to continue fighting, but armed
only with the cross.

▲ Simone Martini, *Saint Martin
Lays Down His Arms*, ca. 1315–16.
Assisi, Lower Basilica of San
Francesco, San Martino Chapel.

A priest who was celebrating Mass realized that there was a globe of fire over Martin's head.

The globe of fire miraculously appeared as Martin was celebrating Mass.

According to Martin's biography, the miracle of the globe of fire happened during Advent. By depicting green curtains, the artist has not respected the colors of the liturgical calendar. They should have been violet.

A monk who had raised his head was able to see the globe of fire appear.

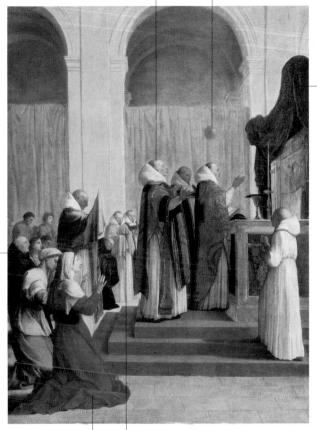

Among the faithful who attended were a woman, a monk, and a priest who noticed the globe of fire.

The miter, a bishop's hat, defines Martin's position as bishop of Tours.

▲ Eustache Le Sueur, *The Mass of Martin of Tours*, 1654. Paris, Musée du Louvre.

Mary
of Egypt

Name
Hebrew, probably
Egyptian in origin,
linked to the verb
"love"

Earthly Life
Fifth century; Egypt
and Palestine

**Characteristics
and Activity**
Penitent hermit in the
desert of Palestine

Patron
Repentant sinners

**Connections with
Other Saints**
Mary Magdalene

Venerated
Particularly wide-
spread in the Middle
Ages, often together
with Mary Magdalene

Feast Day
April 2

*Mary is a convert to Christianity who is generally portrayed
near a desert cavern with hair long enough to cover her body.
She often carries three loaves of bread. In art she typically
receives Communion from angels or the abbot Zosimus; some-
times, the lion that helped him bury her body appears.*

According to a tradition narrated in the *Golden Legend,* Mary
of Egypt lived for a number of years in Alexandria as a prosti-
tute after having run away from home when she was twelve.
When she was about to turn thirty, a caravan of pilgrims that
was heading toward Jerusalem sparked her curiosity. There,
after a number of miraculous events—a mysterious force
blocked her from entering Holy Sepulcher Church with the
other pilgrims—she was inspired to retreat to the desert and
lead a life of penance to atone for her sins. Setting out, she
bought three loaves and headed toward the desert. Miracu-
lously, she nourished herself with the loaves, together with
dates and edible plants, for many years. Her clothes were even-
tually worn out, and all that covered her body was her
extremely long hair. Only the abbot Zosimus visited her during
the remainder of her life there. According to her wishes, he

brought her Commu-
nion near the Jordan
River, where Jesus had
been baptized. The
next year in that same
place, Zosimus found
Mary's body and
buried it with the help
of a lion.

▲ Jusepe de Ribera, *Mary
of Egypt* (detail), 1651.
Naples, Museo Civico
Gaetano Filangieri.

◀ Anonymous, *Saint Mary of
Egypt* (detail), from the base of
*The Meeting Between Saint
Francis and Saint Dominic,* from
the end of the fourteenth century.
Siena, Pinacoteca Nazionale.

Mary Magdalene is either elegantly dressed, partly dressed, or nude and covered only with her long hair, depending on whether the artist wished to emphasize her immoral lifestyle before her conversion or her penitent life afterward. Her attributes are a jar of ointment and a hermit's belongings.

Mary Magdalene

Mary Magdalene's image in art follows a tradition that originated from Saint Gregory the Great. According to Gregory, the name "Magdalene" refers to two women in the Gospels: the first anoints Jesus' feet at the house of Simon the Pharisee, the second is Martha's sister in Bethany. Mary Magdalene the prostitute presented herself before Jesus, who was a guest at Simon's house, to ask forgiveness for her sins. She washed his feet with her tears, dried them with her hair, and anointed them with precious ointment. This incident foreshadowed and announced Jesus' death, as did another in Bethany, when Mary opened a jar of ointment to honor Jesus by anointing his head. She is also one of the three women who went to Jesus' tomb the morning after the Sabbath to anoint Christ's body, and she met the risen Jesus even before the apostles did. Medieval imagery depicted her as the anointer of myrrh, but her image as a repentant sinner took precedence after the Counter Reformation.

▲ Caravaggio, *Mary Magdalene* (detail), ca. 1596–97. Rome, Galleria Doria Pamphilj.

▶ Jan van Scorel, *Mary Magdalene* (detail), 1528. Amsterdam, Rijksmuseum.

Name
Hebrew, probably Egyptian in origin, linked to the verb "love"; her last name means "native of Magdala"

Earthly Life
First century, Palestine

Characteristics and Activity
A sinner, she asked Jesus' forgiveness and was the first witness of the Resurrection

Patron
Gardeners, hairdressers, perfume makers, glove makers, repentant sinners

Connections with Other Saints
Martha, her sister; Lazarus, her brother

Venerated
Considered a model of repentance; her cult spread in Europe from Provence, believed to be her resting place

Feast Day
July 22

The demon is a personification of sin, which Mary renounces through her conversion.

The angel expels the demon. Here this figure seems more Classical than ever, more similar to Cupid than a biblical messenger.

Here are rich and attractive garments that Mary abandons in order to start a new life.

Mary Magdalene's nudity signifies her wish to strip herself of everything that belonged to her previous life.

The abandoned jewelry shows disdain for wealth.

▲ Guido Cagnacci, *The Conversion of Mary Magdalene,* ca. 1660–61. Pasadena, Norton Simon Museum.

Simon the Pharisee had invited
Jesus to his house and cannot
understand why Jesus accepts a
sinner's interruption during lunch.

With his gesture, Jesus invites Simon
to understand and accept the woman's
sincere change of heart.

Mary dries Jesus' feet with
her extremely long hair. She
had wet them with her
repentant tears.

Here is Mary Magdalene's main attribute
in art, a jar of precious ointment that she
breaks open to bathe Jesus' feet.

▲ Simon Vouet, *Mary Magdalene in the
House of Simon*, from the first half of
the seventeenth century. From a private
collection in the United States.

Long, loosened hair is an attribute of Mary Magdalene's. It refers to the episode when she bathed Jesus' feet with her tears and dried them with her hair.

The mirror is a symbol of vanity (vanitas) *and inspires meditation on the transience of earthly things, according to the Book of Ecclesiastes.*

The burning candle invites reflection on life's brevity.

These jewels, which have been abandoned here with disdain, are a memory of Mary's previous life.

The skull is a hermit's emblem and invites contemplation of death.

▲ Georges de La Tour, *The Penitent Magdalen*, 1638–43. New York, The Metropolitan Museum of Art.

Once again, Mary Magdalene is
shown with her hair down, in
memory of the gospel story of her
bathing Jesus' feet with her tears
and drying them with her hair.

The discarded jewels show
contempt for riches.

A jar containing precious
ointment is Mary's main
attribute in art. She used it
to anoint Jesus' feet.

▲ Caravaggio, *Mary Magdalene*,
ca. 1596–97. Rome, Galleria
Doria Pamphilj.

Here, too, at the foot of the cross, Mary Magdalene's hair is long and free.

The tree that sprouts from the cross where Jesus dies symbolizes new life and his death's redemption of humanity.

Mary, Jesus' mother, is at the foot of the cross as her son dies.

John is the only apostle who stays close to Jesus as he dies on the cross.

Mary Magdalene's red clothes are an expression of her fragile humanity, which led her to sin, repent, and deserve forgiveness.

Mary Magdalene's raised arms express her loss. John's Gospel narrates how she was present when Jesus died.

Jesus stops Mary Magdalene from touch-ing him, since he had to rise to his Father first. This image of his fingers touching her forehead originated when the relic of the skin of Mary Magdalene's forehead was discovered.

Mary Magdalene was crying over Jesus' disappeared body when she heard her name called and recognized Jesus.

The angel sitting on the empty tomb announced the Resurrection to the women.

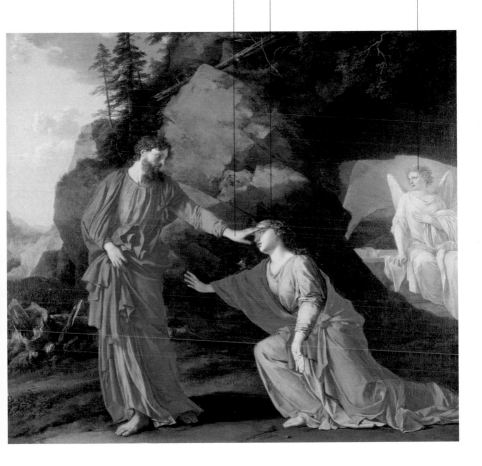

◀ Masaccio, *Polyptych of Pisa* (detail), ca. 1426. Naples, Capodimonte.

▲ Laurent de La Hyre, *Christ Appears to Mary Magdalene*, 1656. Grenoble, Musée de Grenoble.

Mary Magdalene

Artists often emphasize the jar of precious ointment that Mary Magdalene used to anoint Jesus' feet.

The penitent Mary Magdalene appears with her long hair down, just as she typically does at the foot of the cross or when she uses her hair to dry Jesus' feet, which she had bathed with her tears.

▲ Titian, *The Penitent Mary Magdalene*, 1523. Florence, Palazzo Pitti.

According to the Golden Legend, *Mary Magdalene was brought to Heaven seven times each day during the last years that she lived as a hermit.*

Here Mary Magdalene's long, flowing hair is once again shown in memory of her bathing Jesus' feet with her tears and drying them with her hair.

Lucas Cranach the Elder, *Mary Magdalene,* 1525. Cologne, Wallraf-Richartz-Museum.

The jar is a symbol of Mary Magdalene the "anointer," the "perfume bearer," since she anointed Christ's feet and brought ointment to Jesus' tomb after the Crucifixion.

The scourge identifies repentant sinners and is included in images of the penitent Mary Magdalene.

The angel holds the jar of precious ointment—Mary Magdalene's main emblem—which she used to anoint Jesus' feet.

Following the legend, Mary Magdalene is dressed as a hermit, which was how she spent the final years of her life.

According to the Golden Legend, angels brought Mary Magdalene to Heaven seven times each day while she lived as a hermit.

▲ Domenichino, *Saint Mary Magdalene in Glory,* ca. 1620. Saint Petersburg, Hermitage.

Her white and gold clothing probably matches the liturgical colors of her feast day.

Matthew is shown being inspired by an angel as he writes the Gospel. In Ezekiel's vision (1:10) the angel was originally the figure of a man, to whom artists added wings. This symbol of a man was associated with Matthew because his Gospel begins with the genealogy of Jesus. His attributes as an apostle are the book and the halberd with which he was martyred.

Matthew
Evangelist

Matthew, who is also called Levi in the Gospels of Mark and Luke, was Jewish and worked for the Romans as a tax collector. Because of his profession, most of the population looked upon him with contempt. Jesus called Matthew to follow him—as Matthew himself narrates (Matt. 9:9)—as he was carrying out his job collecting taxes. The Gospel he wrote during the second half of the first century centered on Jesus' character and the attitude needed for those who chose to be his disciples. He probably wrote it in Syria, where he had traveled to preach and evangelize. There are no certain facts about the place and circumstances of his martyrdom. According to apocryphal texts, it occurred in Ethiopia. Matthew was killed near an altar because of being opposed to the marriage of King Egippus's daughter, who had converted to Christianity and become an abbess.

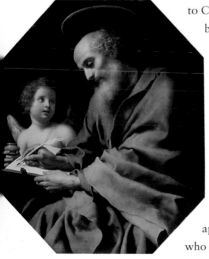

Among the many images that include him, the most common shows Jesus calling Matthew as the future apostle avidly counts money. When shown as an evangelist, Matthew appears with the angel who inspired him.

Name
Originally Hebrew, meaning "gift of God"

Earthly Life
First century; Palestine, Syria

Characteristics and Activity
Apostle and evangelist

Patron
Bankers, tellers, accountants, tax collectors, bookkeepers

Connections with Other Saints
The evangelists Mark, Luke, and John

Feast Days
September 21 in the West, November 16 in the East

Rembrandt, ▲
Matthew the Evangelist (detail), 1661. Paris, Musée du Louvre.

Carlo Dolci, *St. Matthew* ◄
Writing His Gospel, ca. 1670. Los Angeles, J. Paul Getty Museum.

*Despite his being
dressed in clothes
from the painter's
era, Matthew is
shown here with an
apostle's traditional
look: a bearded,
mature man.*

*Matthew's gesture
seems to indicate
his surprise at
being singled out.*

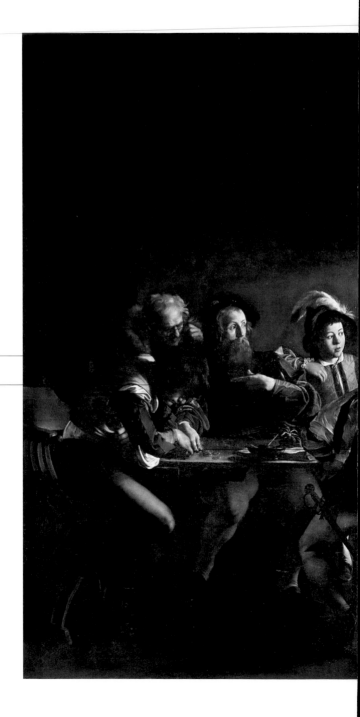

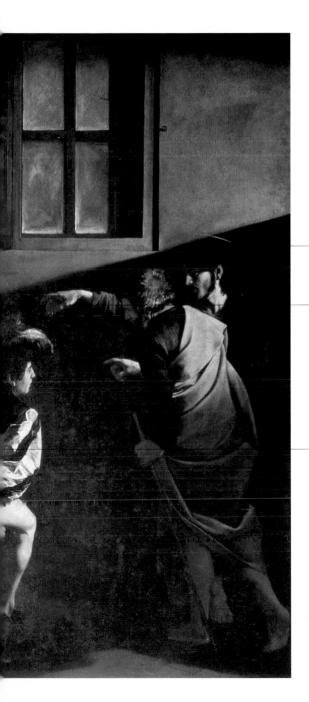

This halo shows Jesus to be the only holy person present. Neither Matthew, who has just been called as a disciple, nor Peter, wears one.

Jesus motions unmistakably toward Matthew, calling him to follow him.

Two hands count money. One belongs to Matthew and the other to another figure, who is also perhaps a tax collector.

◄ Caravaggio, *The Calling of Saint Matthew*, 1590–1600. Rome, San Luigi dei Francesi.

Maurice
of Agaunum

Name
Originally Latin, meaning "native of Mauritania"

Earthly Life
Third and fourth centuries; Egypt, Switzerland

Characteristics and Activity
Commander of the Theban Legion, he was martyred with his soldiers after refusing to offer sacrifices to the Roman gods

Patron
Mountain climbers, soldiers, the Swiss Guards, dyers

Connections with Other Saints
Alexander, standard-bearer of the Theban Legion

Venerated
His cult was initially widespread in Switzerland and Valais

Feast Day
September 22

▲ Matthias Grünewald, *Saint Maurice* (detail), from *Saints Erasmus and Maurice,* ca. 1523. Munich, Alte Pinakothek.

Maurice is shown fully armed as a soldier, often with a banner. Sometimes, especially in German art, he is dark-skinned, which derives from the etymology of his name ("from Mauritania"). The sword that he was martyred with is his attribute, as is the palm branch.

Based on historical foundations, the legend of Saint Maurice and his six thousand fellow soldiers was written by Theodore, bishop of Octodurum in the fourth century A.D. The story itself dates to the beginning of that century, when the emperor Diocletian recruited troops to persecute Christians. The Theban Legion, which Maurice commanded, was normally deployed in the East and did not usually involve itself in persecutions. Around A.D. 286, however, it seems that the legion was sent to the West to quell the insurrections of the Bagaudae. As it crossed Valais (Switzerland), the order was given to persecute Christians, which Maurice's legionnaires refused to obey. They deserted the camp and took shelter near Agaunum. The emperor responded to their refusal by decimating their ranks, although the surviving soldiers did not allow themselves to be intimidated. They sent word that they had not renounced their Christian faith, although they remained loyal to the emperor. In response, they were still hunted down and executed.

◀ *Saint Maurice,* ca. 1250. Magdelburg, Cathedral.

The palm branch is a prize for martyrdom.

An angel brings a crown of glory to the martyrs.

Saint Maurice points toward Heaven, the promised reward for Christians who bear witness to their faith by laying down their lives.

The souls of the martyrs are brought directly to Heaven in a beam of light.

This sword, which is used to behead Saint Maurice and his companions, became his emblem in art.

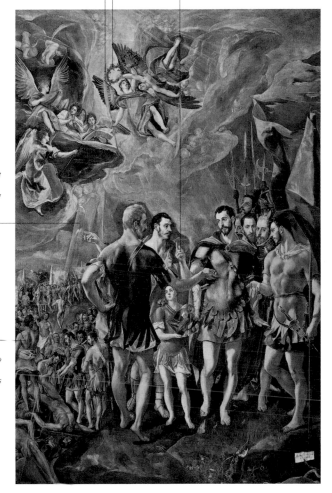

▲ El Greco, *The Martyrdom of Saint Maurice*, 1580–82. Madrid, El Escorial.

Maurus

Maurus is generally shown as a young man and appears dressed as a monk. Among his attributes are the abbot's cross; a spade, which alludes to the monastery of Saint-Maur-des-Fossés; a crutch, since he is patron of cripples and those who suffer from rheumatism; and a scale that was used to measure out food to the monks according to the Rule of Saint Benedict, which Maurus brought to France.

Name
Originally Latin, meaning "native of Mauritania"

Earthly Life
Sixth century; Italy, France

Characteristics and Activity
Benedictine abbot and disciple of Saint Benedict; considered a model of obedience

Patron
Boilermakers, coal workers, gardeners, the handicapped

Special Devotions
Invoked against rheumatism and, at one time, against gout

Connections with Other Saints
Benedict, Placidus

Feast Day
January 15

Maurus was the son of a Roman aristocrat named Equitius, who placed his son in Saint Benedict's care so that he would be educated and become a monk. We know little of his life, but he must have been a model disciple in terms of goodness and obedience. Pope Gregory the Great praises him in his writings and narrates extraordinary episodes that happened during Maurus's life in the monastery, which emphasize his obedience to Benedict, his spiritual guide. The most renowned incident (which can also be found in the *Golden Legend*) occurred when Placidus the monk fell into a nearby stream and was saved by Maurus, who with Benedict's blessing saved him by walking on water. When Benedict left Sublacum for Monte Cassino around A.D. 529, Maurus probably remained there as abbot. According to a widespread tradition from the ninth century that was based on a biography written by Odo of Glanfeuil, Maurus founded a monastery in Glanfeuil and brought the Rule of Saint Benedict with him.

◄ Consolo Master, *Saint Benedict Gives Bread to the Raven* (detail), from the thirteenth century. Subiaco, Sacro Speco.

Saint Benedict was in his cell when he had a vision of what happened to Placidus. He blessed Maurus and sent him to save the drowning monk.

The legend states that Maurus saved Placidus by drawing him up by the hair. Here Dürer prefers to show him being pulled out by the arm.

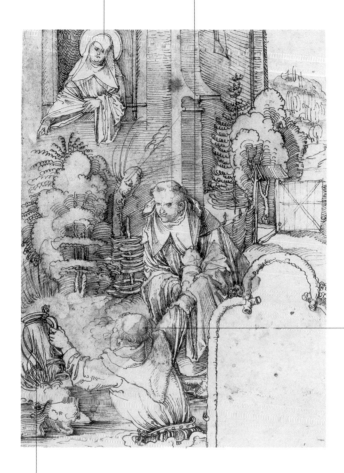

Placidus holds a pitcher for drawing water. Sources say that he had gone to a stream to do this.

A monk's tonsure, or shaved head, is his distinctive sign in art.

▲ Albrecht Dürer, *Maurus Saves Placidus from Drowning with the Help of Saint Benedict*, ca. 1500. London, British Museum.

The winged Michael is typically shown in full armor with a sword or spear. He often defeats the Devil in the form of a dragon. Sometimes he has a scale in hand, with which he measures the weight of souls.

Michael
Archangel

Name
Originally Hebrew, meaning "who is like God"

Characteristics and Activity
Archangel

Patron
Businessmen, weapons instructors, police, merchants, haberdashers, spice sellers, makers of scales, fencers

Special Devotions
Invoked for a good death

Connections with Other Saints
The archangels Raphael and Gabriel

Venerated
Initially in the East; spread throughout Europe at the end of the fifth century, when he appeared on Mount Gargano

Feast Day
September 29, together with Gabriel and Raphael

▲ Master of Castelsardo, *The Archangel Michael* (detail), from the *Retablo di Tuili*, 1498–1500. Tuili, Parrocchia di San Pietro.

Michael is cited in the Bible's Book of Daniel as the first of chief princes and guardians of the people of Israel. The New Testament's Letter of Jude defines him as an archangel, and in the Book of Revelation Michael leads other angels into battle to defeat the dragon, which represents the Devil. In iconography and in popular devotion, which rapidly developed, the archangel Michael's image has generally been based on the passages of Revelation. Other writings about Michael were also created based on Revelation, which defined him as a majestic being who had the power to weigh souls at the Last Judgment. Byzantine iconography preferred to represent the archangel as a court dignitary instead of a warrior battling the Devil or weighing souls, which was adopted in Western art.

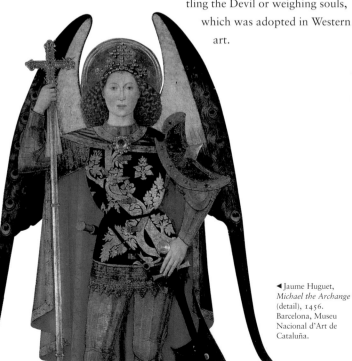

◀ Jaume Huguet, *Michael the Archange* (detail), 1456. Barcelona, Museu Nacional d'Art de Cataluña.

Wings are the angel's main attribute. They were derived from Classical images of winged Victory and widely adopted throughout Christian iconography.

This staff is a long rod that was held by gatekeepers, those who had the task of safeguarding sacred sites.

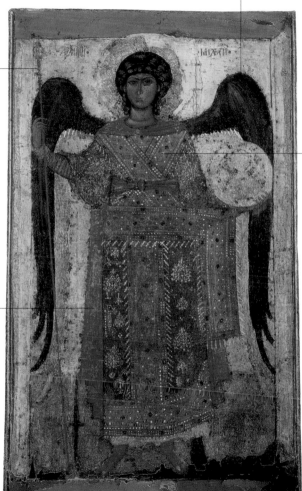

One characteristic example of noble vestments from the court of Byzantium, the loron, *is part of Michael's costume. He is part of Heaven's army.*

In the Byzantine world, Michael was represented in a dignitary's clothes instead of human

▲ Anonymous, *The Archangel Michael,* ca. 1299. Moscow, Tret'jakov Gallery.

Michael

Once again, the angels are shown with wings, their attribute that originated with Classical images of winged Victory.

Michael is frequently dressed in armor, since he heads Heaven's army to battle the Devil.

The monstrous traits of these rebellious angels, who have become horrendous creatures, are a visible sign of their choice of evil.

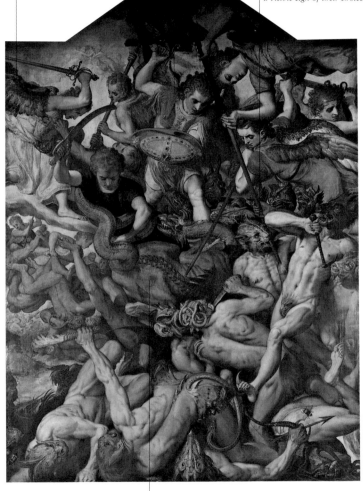

▲ Frans Floris the elder, *The Fall of the Angels*, 1544. Antwerp, Musées royaux des beaux-arts.

The dragon of the Book of Revelation, which Michael and his angels battle and defeat, represents the Devil.

Wings are an angel's
main attribute.

Once again Michael is shown
with his emblematic armor,
since he heads Heaven's army
to fight the Devil.

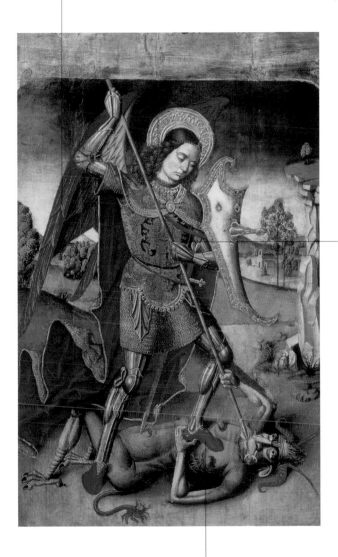

▲ Master of Castelsardo, *The Archangel
Michael* (detail), from the *Retablo di
Tuili*, 1498–1500. Tuili, San Pietro.

Michael stands on the Devil as
a sign of his victory over him.

Here Michael's wings are splendidly
decorated with peacock's eyes.

According to the Book of Revelation,
seven angels sound seven trumpets for
the Last Judgment.

The lighter soul
has been purified
and can rise to
face God.

The scale is one of
Michael's symbols
at the Last Judg-
ment, when he
weighs souls.

This soul, which is
burdened by sin,
will be rejected and
sent to Hell.

The diagonal stole that
Michael wears emphasizes
his service for God, as it
does for deacons who
wear it.

▲ Rogier van der Weyden, *Polyptych of
the Last Judgment* (detail), 1445–50.
Beaune, Hôtel-Dieu.

Monica is typically portrayed in the black habit of the Augustinian sisters. Among her attributes are a book containing the Rule of Saint Augustine and the cross.

Monica

Most of the facts about Saint Monica come from Saint Augustine's *Confessions*. As described by her son, Monica was a model Christian mother who suffered greatly because of her husband Patricius's immoral and violent behavior and her mother-in-law, who lived with the family and was prone to drinking. With Christian patience and dedication, Monica managed to convince her husband to be baptized. She also had constant anxiety about her son Augustine. Despite the fact that Augustine had prepared for baptism, he was leading a life that was inappropriate for a catechumen. This went on so much that at a certain point his mother resigned herself to the fact that the time was simply not right for his conversion. When Augustine ran away from home—first to Rome and then to Milan—Monica followed him and was present when her son converted, which occurred thanks to his meeting Saint Ambrose, bishop of Milan. As she was returning to Tagaste in North Africa after her son's baptism, Monica died in A.D. 397 at Ostia, Italy, before she was able to board a ship for Africa.

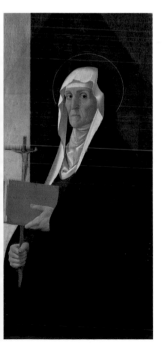

Name
Perhaps a Latin derivative, meaning "mother" or "wife"

Earthly Life
A.D. 331–397; Africa, Italy

Characteristics and Activity
Mother of Saint Augustine

Patron
Women, mothers

Special Devotions
Popularly considered the benevolent saint of childbirth

Connections with Other Saints
Augustine

Venerated
Since the tenth century, through the Augustinian order

Feast Day
August 27

◀ Alvise Vivarini, *Saint Monica* (detail), 1485–90. Venice, Gallerie dell'Accademia.

Luis Tristán de Escamilla, ▲ *Saint Monica* (detail), 1616. Madrid, Prado.

A row of saints contemplate God the Father in the glory of Paradise.

The figure of God the Father is traditionally an elderly man with a white beard who appears among the clouds. His welcoming gesture of mercy is significant here.

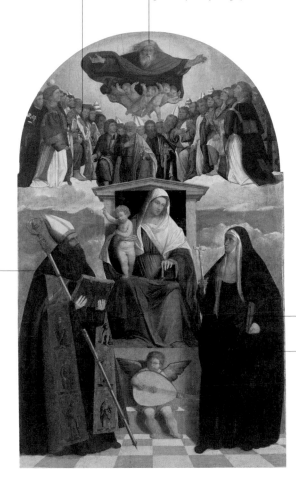

Saint Augustine, Monica's son, is depicted in bishop's attire and holds a pastoral staff. A book indicates that he is a Doctor of the Church.

The book of the Rule of Saint Augustine is a sign that Monica belongs to the Augustinians.

The black habit of the Augustinian nuns became Monica's attribute in art.

▲ Unknown Venetian artist, *Madonna and Child, Saint Augustine, and Saint Monica*, from the sixteenth century. Feltre, Ognissanti.

▶ Benozzo Gozzoli, *Stories of Saint Augustine: The Death of Saint Monica*, 1465. San Gimignano, Sant'Agostino.

Augustine tells of how, the day before his
mother's death, they had a spiritual dia-
logue that brought him to the point of
having an ecstatic vision of God's glory.

This small figure of Saint Monica
represents her soul, which rose to
Heaven after her death.

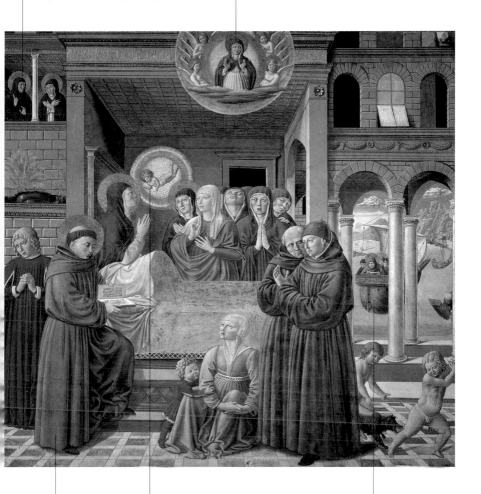

Saint Monica had a vision of the
child Jesus that comforted her on
her deathbed.

Saint Augustine is depicted next to his dying
mother's bed. He wears the Augustinian
order's habit and a monk's shaved head.

Saint Monica was buried
near Ostia, and Augustine
continued the trip toward
Tagaste.

Nicholas

This saint is dressed as a bishop and wears a miter, although he is also shown without any head covering. He typically holds a bishop's staff and a book. His main attributes are three gold spheres, three children in a washtub, bread, an anchor, and a ship.

Nicholas was born during the second half of the third century in Patara, Lycia (present-day Turkey). As a layperson, he was widely esteemed by both the people and clergy and was soon elected bishop of Myra, a small seaboard city in Lycia. Nicholas was subsequently ordained a priest and guided his diocese with charity, dedication, and severe orthodoxy. It seems that he was present at the Council of Nicaea in A.D. 325 and condemned the Arian heresy. Saint Nicholas died some years later on December 6. Beginning in the sixth century, a number of legends about his life were added to enrich his story. These, in turn, shaped his image in rituals and his characteristics in art, where narratives of his life often portray his charitable acts and childhood. His attitude, for example, led him to give money to three poor girls in order to save them from a life of prostitution that their desperate father was about to force them into. Other stories include his interventions and miracles after his death.

This saint was widely venerated in Northern Europe and was the original Santa Claus.

▲ Fra Angelico, *Stories of Saint Nicholas of Bari* (detail), ca. 1437. Vatican City, Pinacoteca Vaticana.

◀ Antonello da Messina, *Madonna Enthroned with the Child and Saints Nicholas of Bari, Mary Magdalene, Ursula, and Dominic* (detail), 1475–76. Vienna, Kunsthistorisches Museum.

Saint Nicholas's position
as bishop of Myra is
signified by this miter.

The pastoral staff is also
emblematic of his position as
bishop, as he is the spiritual
pastor of a diocese.

These three sacks
of gold are emblems
of Saint Nicholas's,
in memory of the
episode when he
saved three poor
girls from prostitu-
tion by giving them
their dowries.

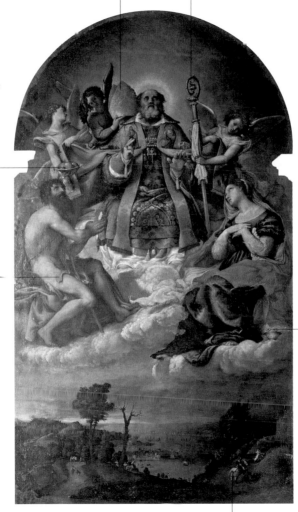

Lambskin
identifies Saint
John the Baptist,
hermit and ascetic.

These eyes
identify
Saint Lucy.

▲ Lorenzo Lotto, *The Glory of
Saint Nicholas*, 1529. Venice,
Santa Maria dei Carmini.

The depiction of Saint
George was included only
at the request of a buyer.

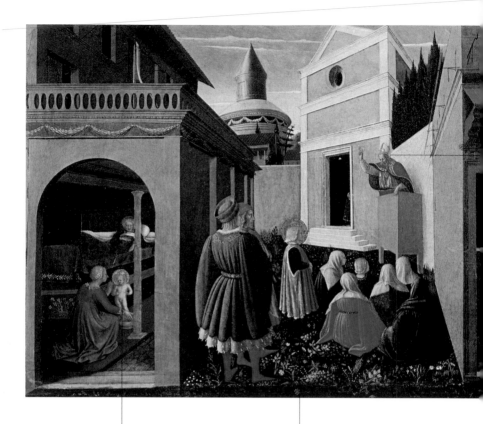

Nicholas listens among the crowd during
a bishop's passionate sermon. According
to the legend, he began his path toward
the priesthood at a very early age.

According to legendary biographies of Saint
Nicholas, as soon as he was born he was so
precocious that during his first bath he
jumped to his feet in the washtub.

During a serious
famine, sacks of
grain were brought
to the city of Myra.

Nicholas the bishop
speaks with an imper-
ial official and
requests some grain,
assuring him that he
will not notice any
difference in weight.
In fact, the weight of
the grain remained the
same.

▲▶ Fra Angelico, *Stories of Saint
Nicholas of Bari*, ca. 1437.
Vatican City, Pinacoteca Vaticana.

The preaching bishop who influenced the tiny Nicholas was perhaps his uncle.

Nicholas throws a sack of gold into the window of his poor neighbor, who had decided in desperation to send his three daughters into prostitution.

Three young girls sleep, not imagining that they will receive their dowries thanks to Nicholas's charitable action.

The sailors invoke Saint Nicholas, who comes to their aid and calms the storm.

Nicholas was considered protector of navigators, which influenced his characteristics in art.

Nicholas raises two fingers, his pointer and middle finger, for a special blessing.

The characteristics of his face—high cheekbones, sunken cheeks, and clenched mouth—are typical of Byzantine imagery, and indicate courage and fortitude.

▲ *Saint Nicholas of Myra*, from the middle of the thirteenth century. Saint Petersburg, Russian State Museum.

Hands must be covered before touching this holy book.

Sweets are the first gifts that
Saint Nicholas gives to children
on his feast day.

A shoe, or sometimes a sock, soon
became a container in which Nicholas
secretly left gifts at night. Here a naughty
boy has been given a stick.

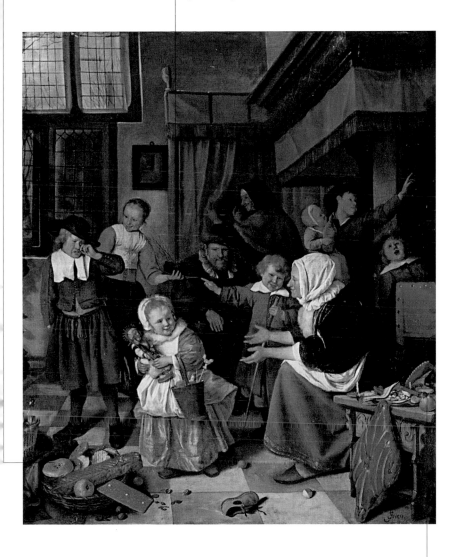

▲ Jan Steen, *The Celebration of Saint
Nicholas,* from the seventeenth century.
Amsterdam, Rijksmuseum.

The tradition of giving a piece of
fruit with a coin may come from
the story of Saint Nicholas and
the three girls.

Nicholas is often portrayed as a beardless young man who wears the black robes of the Augustinians. His attributes are a flowering lily branch, a star on his chest, a book of the Rule of Saint Augustine, and sometimes a crucifix.

Nicholas
of Tolentino

Name
Originally Greek, meaning "victorious among the people"

Earthly Life
1245–1305; Italy

Characteristics and Activity
An Augustinian friar and preacher, he aided the sick and marginalized

Patron
Souls in Purgatory, Augustinians, childhood, motherhood, and sailors

Special Devotions
Invoked against disease and fever; he is a defender from injustice

Venerated
Only canonized in 1446; the process was interrupted by church schism

Feast Day
September 10

▲ Francesco Bissolo, *Saint Stephen with Saints Augustine and Nicholas of Tolentino* (detail), from the end of the fifteenth or the beginning of the sixteenth century. Milan, Pinacoteca di Brera.

Nicholas was born in 1245 in Sant'Angelo along the border of Ancona, Italy. When he was eighteen he became a brother in the Augustinian order and was ordained a priest in 1270. For a number of years he did not settle down and moved between the order's monasteries, working as a preacher and spiritual director. He also healed a number of people and began to be considered a miracle worker. When he finally settled at the monastery of Tolentino, the city was in the process of developing and was the site of intensifying political disagreements. Nicholas's presence and his position as a capable preacher played a fundamental role in mediating the ongoing conflict between the Guelf and Ghibelline families. According to tradition, the entire city attended his sermons, and Nicholas brought many people to conversion. At the same time, he continued to dedicate himself to the sick and needy with his continuous and tireless aid. After thirty years in Tolentino, he became ill and died on September 10, 1305.

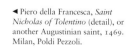

◄ Piero della Francesca, *Saint Nicholas of Tolentino* (detail), or another Augustinian saint, 1469. Milan, Poldi Pezzoli.

288

Paul is typically portrayed dressed as an apostle in a tunic and pallium (cloak). His characteristics were defined in the fifth century and have been constant ever since, thanks to Eusebius of Caesarea's description of him in the third or fourth century. He had a noble face and was a balding man with a long, black beard. His attributes are a book of the letters that he wrote to the first Christian communities and the sword with which he was martyred.

Paul

Paul of Tarsus, who was originally named Saul, was a Jewish tent maker. After Christ's death, he actively persecuted Christians. The Acts of the Apostles narrates how he was among those who watched Saint Stephen being stoned to death. He had enough influence and authority to obtain permission to arrest and imprison those belonging to the new religion of Christ. While traveling toward Damascus, however, on his way to implement persecutions, he had a blinding vision that led him to convert. After being cured of his blindness, he was baptized by Ananias and set out to preach the Christian faith. Understandably, he encountered many problems at first because Christians mistrusted him and a number of Jews tried to assassinate him. He eventually founded a variety of Christian communities in Asia Minor and lived in Rome for three years, where the emperor Nero executed him around A.D. 65.

Name
Originally Latin, meaning "small of stature"

Earthly Life
First century; Palestine, Asia Minor, and Rome

Characteristics and Activity
A Jewish persecutor of Christianity, he converted and became an apostle whose letters are in the New Testament

Patron
Rope makers, basket makers, theologians, Catholic printers

Special Devotions
Invoked against storms and snake bites

Connections with Other Saints
Peter

Venerated
Universally venerated, yet much later than the cult of Saint Peter

Feast Day
June 29, together with Saint Peter

▲ Domenico Fetti, *Saint Paul* (detail), ca. 1614. Mantua, Palazzo Ducale.

▶ Master of the Getty Epistles, *Saint Paul* (detail), ca. 1520–30. Los Angeles, J. Paul Getty Museum.

Christ appears to Saint Paul on the way to Damascus and says, "I am Jesus, whom you are persecuting."

The sword, with which Saint Paul is beheaded, becomes his attribute in art.

After his vision, Saint Paul falls and loses his sight.

The book is also an emblem of Paul's and refers to a number of letters that he wrote to Christian communities.

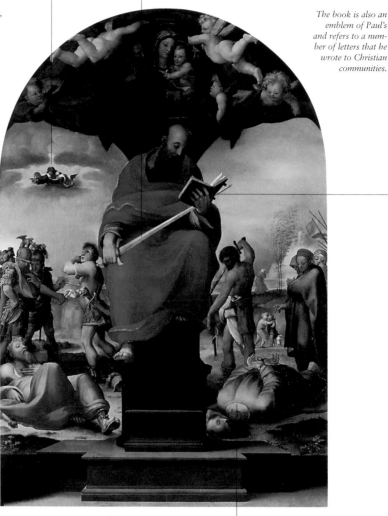

▲ Domenico Beccafumi, *Saint Paul Enthroned*, 1516–17. Siena, Museo dell'Opera del Duomo.

Since he was a Roman citizen, he was condemned to be beheaded, not crucified like Saint Peter.

Artists invented the horse that Saint Paul was supposed to have fallen from during his vision of Jesus. The sources themselves (Acts of the Apostles) give no indication as to how he was traveling.

Caravaggio added this angel to accompany Jesus during Saint Paul's vision. The work was criticized because the angel seemed to be carrying the figure of Jesus.

After his vision of Jesus, Saint Paul falls and loses his sight

The apparition that appeared to Saint Paul on the way to Damascus identified itself by saying, "I am Jesus, whom you are persecuting."

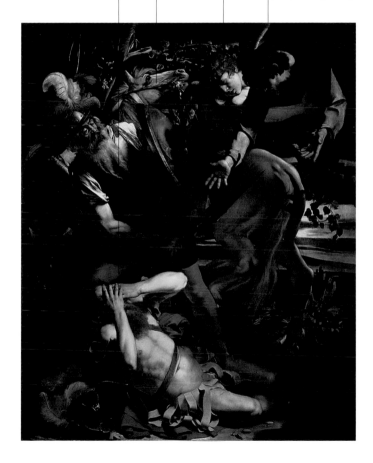

▲ Caravaggio, *The Conversion of Saint Paul*, 1600–1601. Rome, Collezione Odescalchi.

Paul's enemies had the city gates of Damascus watched day and night in order to keep the apostle from escaping.

Saint Paul narrates how he was helped to flee by being lowered from the walls in a basket.

Paul's disciples help him to leave Damascus and reach safety.

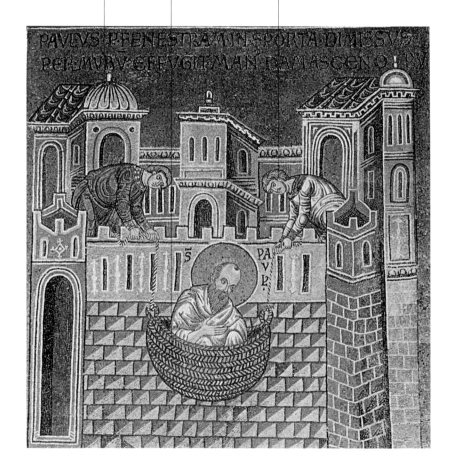

▲ *Saint Paul Lowered from the Walls of Damascus,* about the twelfth or thirteenth century. Montreal, Cathedral.

Saint Peter has coarse features;
short, curly hair; and a short,
frizzy beard.

The gaze between Saint Paul
and Saint Peter shows their
intense relationship as they are
led to be martyred.

Their handshake was their
farewell; the tale of saints
Peter and Paul being executed
on the same day is legendary.

Saint Paul has noble
features, thinning hair,
and a dark beard.

▲ Giovanni Serodine, *The Meeting
Between Peter and Paul on Their Way
to Martyrdom* (detail), 1624–25. Rome,
Galleria Nazionale d'Arte Antica.

Saint Paul was martyred
outside the walls of Rome.

The sword that was used to
behead Saint Paul according to the
law for Roman citizens became his
attribute in art.

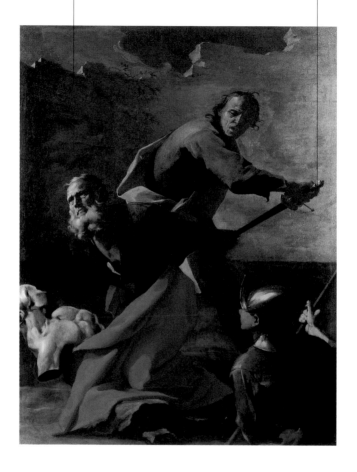

▲ Giuseppe Antonio Petrini, *The
Beheading of Saint Paul*, ca. 1710.
Altavilla Monferrato, San Giulio.

Paul is shown with a long, wild beard and long hair. He is either partially nude or covered with woven palm leaves. Among his attributes are the raven, lions, and a skull.

Facts about Paul of Thebaid (upper Nile Valley), who is considered the first hermit, are quite scarce. He was Egyptian and from a noble family. In the middle of the third century, he left Thebaid in order to flee the emperor Decius's persecutions. The solitude of the desert captured Paul's soul, and although the persecutions died with Decius in A.D. 251, he never returned to Thebaid. Only Saint Anthony the Hermit (also called Anthony Abbot) was able to visit Paul a short time before he died, after being told in a dream of another hermit in the desert like himself who was even older than he was. According to tradition, especially that of Saint Jerome, Paul remained in the desert for close to ninety years, wearing only a garment of woven palm leaves and eating only fruit he found with bread that a raven brought him each day. He died alone and was buried by Anthony, who had seen his soul fly to Heaven in a vision. Since Anthony did not have any tools with him to dig the grave, two lions helped him, and they became Paul's emblems in art.

Paul
Hermit

Name
Originally Latin, meaning "small of stature"

Earthly Life
Third and fourth centuries, Egypt

Characteristics and Activity
Considered the first hermit, he lived in the desert of Thebaid

Patron
Straw-mat makers

Connections with Other Saints
Anthony Abbot

Venerated
In Egypt since the fourth century, in all of Europe since the thirteenth

Feast Day
January 15

▶ Jusepe de Ribera, *Saint Paul the Hermit* (detail), 1647. Cologne, Wallraf-Richartz-Museum.

Salvator Rosa, *Saint* ▲ *Paul the Hermit* (detail), from the seventeenth century. Milan, Pinacoteca di Brera.

A raven nourished Saint Paul by bringing him a loaf of bread each day. When Saint Anthony went to visit Paul, the bird brought two.

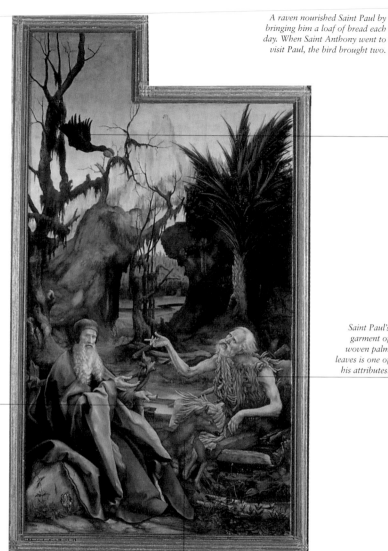

Saint Paul's garment of woven palm leaves is one of his attributes.

The T-shaped cane is an emblem of Saint Anthony Abbot.

▲ Matthias Grünewald, *Conversation Between Saints Anthony the Hermit and Paul of Thebes* (detail), 1515. Colmar, Musée d'Unterlinden.

This faun, together with a centaur and a wolf, led Saint Anthony to Saint Paul's hermitage.

Peter is depicted with all the usual characteristics of an apostle and is dressed in a tunic and pallium (cloak). He can also be shown in papal attire. His physical traits were defined in art from the fifth century on, based on a description by Eusebius of Caesarea during the third or fourth century: short, curly hair; a short beard; and wrinkled features. Among his attributes are keys, a book, a rooster, and sometimes a boat.

Peter
Apostle

Peter, who was originally named Simon, was a fisherman from Bethsaida of Galilee and met Jesus through his brother, Andrew. Jesus called him to be his follower, promising to make him a "fisher of men," and Peter was always at Jesus' side from that time on. He witnessed the Transfiguration, the Agony in the Garden of Gethsemane, and tried to use violence to stop Christ from being captured. Simon declared that Jesus was the Messiah, yet also denied him and bitterly regretted it. Jesus changed Peter's name from Simon to Kephas, the Aramaic equivalent of Peter (i.e., "rock"), to signify that he was founding the church and beginning with Peter. The other apostles recognized Peter's primacy and authority; he was considered the first to work miracles, baptize, and organize the church after Jesus. His preaching brought him to Rome, where he died during Nero's reign between A.D. 64 and 67. According to tradition, he was crucified upside down because he considered himself unworthy of dying in the same manner as Jesus.

Name
Originally Latin, meaning, "rock" or "stone"

Earthly Life
First century; Palestine, Rome

Characteristics and Activity
An apostle whom Jesus chose to be the foundation of the church; the first pope

Patron
Cobblers, key makers, harvesters, builders, watchmakers, fishermen, fish vendors, doorkeepers

Connections with Other Saints
The Twelve Apostles, especially James, John, and Paul

Venerated
Universally

Feast Day
June 29, together with Saint Paul

Albrecht Dürer, *Four ▲ Apostles* (detail), 1526. Munich, Alte Pinakothek.

Francesco del Cossa, *Saint ◄ Peter* (detail), 1470–73. Milan, Pinacoteca di Brera.

297

Jesus motions for the
apostles to throw out
their nets and fish.

Peter responds to Jesus' invitation
with doubts, since they had already
fished for the whole night without
success.

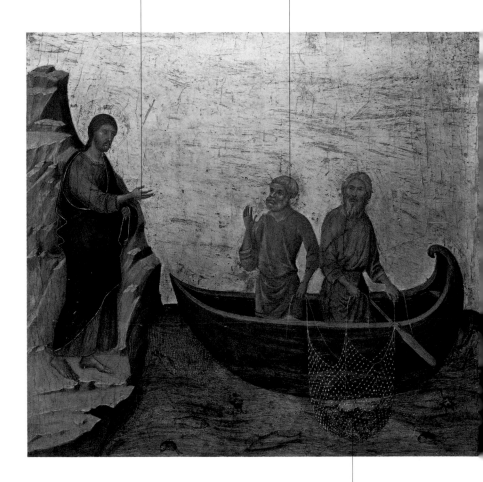

The net is filled with fish—
a miracle by Jesus.

▲ Duccio di Buoninsegna, *The
Calling of the Apostles Peter and
Andrew,* 1308–11. Washington,
D.C., National Gallery

► Bernardo Strozzi, *Christ Gives the
Keys to Saint Peter,* ca. 1635. Madison,
Elvehjem Museum of Art.

The key that Jesus gives
to Peter is an image, the
so-called Traditio clavum,
of his mandate to him. He
founds the church upon
Peter and promises him
the keys to Heaven.

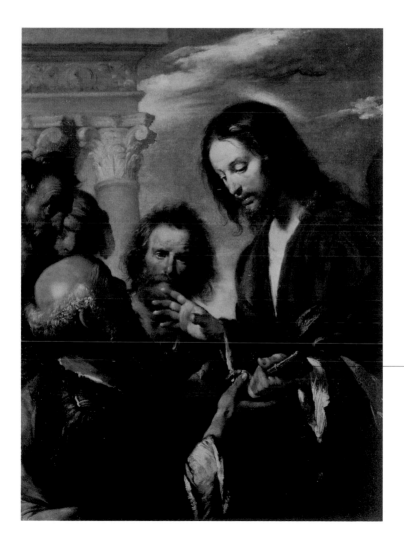

Peter catches a fish with a coin inside it, just as Jesus told him he would.

Jesus sends Peter fishing in the lake. He tells him that the first fish that bites will have a coin to pay the tax.

▲ Masaccio, *The Tribute*, 1425.
Florence, Chiesa di Santa Maria
del Carmine, Brancacci Chapel.

The tax collector is the only figure in the painting who wears clothing from the painter's era.

A building shows that the scene unfolds within a city. This episode occurred as Jesus and his disciples were entering Capharnum.

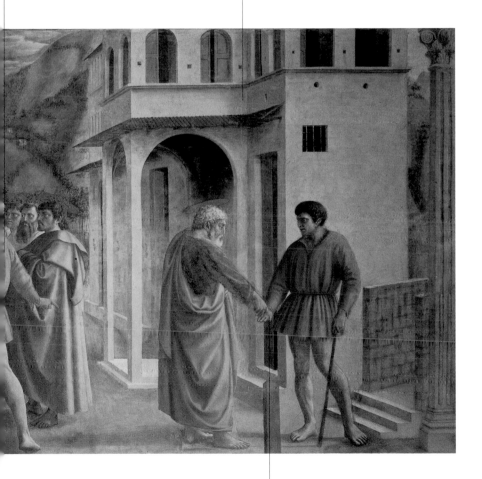

Peter pays the temple tax.

301

Peter holds a key, a symbol of
the key to Heaven, which Jesus
promised him when he founded
the church.

The apostles only
number eleven,
since the artist
bases this scene
on John's Gospel,
which placed this
episode after the
Resurrection.

The sheep correspond
to Jesus' command to
Peter, "Feed my lambs."

Saint John is recognizable
among the apostles because
he is the youngest.

The risen Jesus wears a white mantle.
He appeared a number of times to the
apostles before ascending to Heaven.

The apostles got out of their boat
when they recognized Jesus on
the shore after the Resurrection.
The boat is an emblem of Peter's
and a symbol of the Church.

▲ Raphael, *Pasce Ovea Meas*, 1514–15.
London, Victoria and Albert Museum.

▶ Master of the Housebook,
The Washing of the Feet, 1475.
Berlin, Gemäldegalerie.

Judas does not have a halo.
Since he betrayed Jesus, he is
missing this sign of holiness.

Jesus' halo is different from those
of the apostles. Ever since the
sixth century A.D., this "cruciform
nimbus" has included the sign of
the cross inside.

At first, Peter
does not under-
stand Jesus' ges-
ture and refuses
to let himself be
served by Jesus.

Jesus uses a
towel tied around
his waist to wash
his disciples' feet,
in accordance
with the Gospel
of John.

Hands raised in surprise show the more reserved character of the apostle Andrew, Peter's brother.

Peter's hand quickly reaches for John to ask about what Jesus said.

The complicated twisting of Peter's wrist and the knife he holds seem to foreshadow his impulsive action of wounding a servant of the high priest who attempts to arrest Jesus in the garden of Gethsemane.

A moneybag is one of Judas's symbols in art. He had the task of holding the money for the apostles and sold Jesus for thirty pieces of silver.

▲ Leonardo da Vinci, *The Last Supper* (detail), ca. 1495–98. Milan, Santa Maria delle Grazie.

Peter severs the right ear of
the high priest's servant.
Jesus reproaches him.

Peter uses a sword to wound
the high priest's servant.

Judas betrays Jesus with a kiss and
shows the soldiers whom to arrest.

▲ *The Capture of Christ,* from
the *Rheinau Psalter,* ca. 1260.
Zurich, Zentralbibliothek.

Ivy is a symbol of loyalty. Since it is dangling in this way, it is probably a sign of betrayal.

The rooster became an emblem of Peter's. Jesus predicted that after he was arrested, Peter would deny him three times before the rooster crowed, which he did.

This lantern could allude to the fact that Jesus was captured. This follows medieval imagery, in which Judas normally carried a lantern.

▲ Georges de La Tour, *The Tears of Saint Peter*, 1645. Cleveland, Museum of Art, Hanna Foundation.

▶ Masaccio, *Saint Peter Heals the Sick with His Shadow*, 1425. Florence, Santa Maria del Carmine, Brancacci Chapel.

A sick man who had been brought to the street where Peter was to pass waits faithfully to be healed.

Peter miraculously healed a number of people when his shadow passed over the crippled and possessed. According to the Acts of the Apostles, this signified his faith in Christ.

A young, beardless John follows Peter.

An angel leads Peter past the guards and out of prison, then disappears.

Peter sleeps chained in prison the night before his trial. Herod Agrippa arrested him.

An angel suddenly appears to free Peter from his chains. According to the Acts of the Apostles, the chains fell from Peter's hands.

▲ Konrad Witz, *Saint Peter Is Freed from Prison*, 1444. Geneva, Musée d'art et d'histoire.

Here the artist respects traditional medieval images of Peter's crucifixion, which showed two nails for his feet.

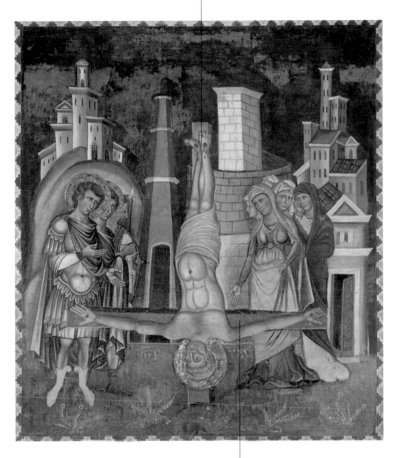

The upside-down cross originated from apocryphal tradition. Peter is said to have asked to be crucified this way because he felt unworthy of dying in the same manner as Jesus. However, according to Origen (second and third centuries A.D.), this was Emperor Nero's way of crucifying leaders.

▲ Master of the Sancta Sanctorum, *The Crucifixion of Saint Peter,* from the thirteenth century, Rome, Lateran Basilica, Sancta Sanctorum Chapel.

Christ the Judge is
sculpted in the
lunette over the
door of Paradise.

Once again the key
is shown as Saint
Peter's symbol. Jesus
promised him the
key to Heaven.

Saint Peter welcomes
the souls of those
who have been
saved as they enter
into Heaven.

► Hans Memling, *The Last Judgment:
The Gate of Paradise*, ca. 1472. Danzig,
Muzeum Narodowe.

Peter wears the white robes and black cloak of the Dominican order. Among his attributes are the symbols of his martyrdom: a billhook driven through his head or some sign of that wound, a dagger in his chest, and a palm branch.

Peter
Martyr

Peter was born in Verona, Italy, at the end of the twelfth century into a heretical family. He studied law in Bologna and, fascinated by the preaching of Saint Dominic, he decided to enter the Order of Preachers, or Dominicans, in 1221. He soon excelled in his enthusiasm and preaching ability and was named prior and teacher. In 1232 Pope Gregory IX named him general inquisitor for northern Italy. The church was going through difficult times because of struggles against the Valdese, Albigensian, Patari, and Cathari heresies, which often led to terrible, politically motivated violence. Peter was called in to combat the Cathari sect. In the end it was the Catharis, who were allied with the Ghibelline family, who arranged for Peter to be ambushed on April 6, 1252. As he was returning from Como to Milan with another brother, Peter—the first Dominican martyr—was struck on the head with a billhook. According to tradition, he died writing *Credo in Deum* (I believe in God) with his own blood.

Name
Originally Latin, meaning "rock" or "stone"

Earthly Life
From the end of the twelfth century to 1252, northern Italy

Characteristics and Activity
Dominican friar, inquisitor for northern Italy, martyred by heretics

Patron
Dominicans, investigators

Special Devotions
Invoked against headaches

Connections with Other Saints
Dominic

Venerated
Proclaimed a saint a year after his death

Feast Day
April 29

Fra Angelico, *The Death of* ▲ *Saint Peter Martyr* (detail), 1435. Zagreb, Gallerija Strossmayer.

Giovanni Bellini, *The Assassination* ◀ *of Saint Peter Martyr* (detail), 1509. London, Courtauld Institute Gallery.

Peter Martyr

Peter was martyred with a billhook. It became his main attribute in art.

Angels bring the crown of glory for Peter.

God the Father sends an angel with the palm of martyrdom.

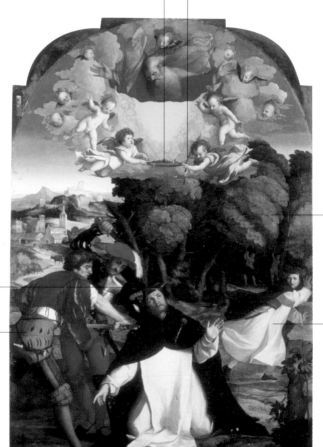

The forest recalls how this episode occurred on the road from Como to Milan near the forests of Barlassina.

An attacker, probably a hired assassin, strikes at Peter. He later renounces his heresy after Peter dies.

A friar who was traveling with Peter was also beheaded.

▲ Jacopo Palma Il Vecchio, *The Assassination of Saint Peter Martyr*, ca. 1520. Alzano Lombardo, Museo della Basilica di San Martino Vescovo.

She is portrayed as a young girl with keys, similar to those of Saint Peter. It was once thought that she was his daughter.

Petronilla

The only certain facts about Petronilla come from a number of inscriptions that were uncovered at the catacombs of Domitilla, where it is written she was a martyr who was probably from the Domitilla family. An account of Petronilla's life was written in the sixth century when a basilica built near the cemetery of Domitilla was dedicated to her. At that time, more information surfaced about her that was mostly implausible. The author ignored archaeological facts and confused Petronilla's story with the holy martyrs Nereus and Achilleus, whose narratives were also contaminated by apocryphal texts. According to this account, Petronilla died from a fever during Domitian's reign and therefore was not a martyr. Her tradition in art, however, regarded Petronilla as Saint Peter's daughter, who was born in Galilee and moved with him to Rome. In order to save her from indiscreet onlookers, Peter pretended that she had fever every time he had visitors. Eventually Petronilla let herself die to save her virginity and to avoid marriage to Flaccus, a Roman noble.

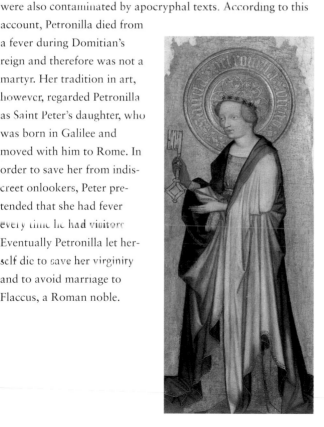

Name
Originally Latin, meaning "a rocky place"

Earthly Life
Unknown, before the fourth century; Rome

Characteristics and Activity
Virgin and martyr popularly considered to be Saint Peter's daughter

Patron
Mountain climbers

Special Devotions
Invoked against dangers on trips and fevers

Connections with Other Saints
Nereus and Achilleus, Peter

Venerated
Evidence of her cult dates to between the fourth and sixth centuries

Feast Day
May 31

Guercino, *The Burial of Saint ▲ Petronilla* (detail), 1623. Rome, Musei Capitolini.

Master Bertold of Nördlingen, ◄ *Saint Petronilla* (detail), 1415. Bonn, Rheinisches Landesmuseum.

313

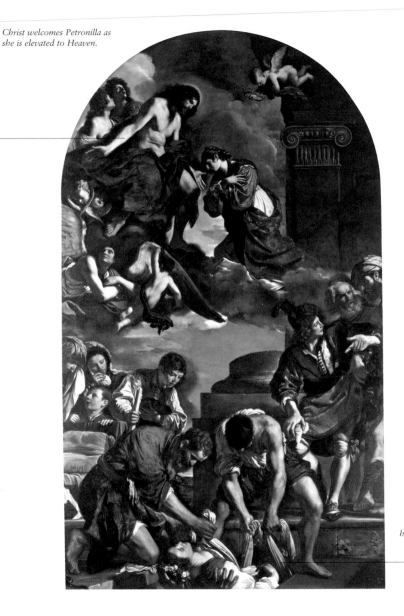

Christ welcomes Petronilla as she is elevated to Heaven.

The saint is lowered into her tomb with flowers in her hair.

▲ Guercino, *The Burial of Saint Petronilla*, 1623. Rome, Musei Capitolini.

Philip has the traditional appearance of an apostle; he is dressed in a tunic and pallium (cloak). He sometimes holds a cross, since he is supposed to have suffered martyrdom by crucifixion. His other emblem is a dragon.

A Galilean from Bethsaida, Philip joined Jesus after he met John the Baptist and became one of the Twelve Apostles. The Gospels speak of him in a number of episodes: Jesus asks Philip to gather food from the crowd before he miraculously multiplies the bread; a number of Greeks who wanted to see Jesus ask Philip; and finally, Philip himself asks Jesus, "Show us the Father and it is enough for us," and Jesus answers, "Whoever has seen me has seen the Father." Other information about this apostle comes from a number of legends that confuse him with a deacon who was also named Philip and was mentioned in the Acts of the Apostles. After Pentecost and the descent of the Holy Spirit, Philip probably traveled to preach in Phrygia and suffered martyrdom in Hierapolis by being stoned and then crucified. The *Golden Legend* narrates how before moving to Hierapolis, Philip preached for twenty years in Scythia and defeated a huge dragon that resided in a statue of Mars there. Philip also had two virgin daughters who always traveled with him. According to some sources, he must have died a martyr when he was more than eighty-seven years old.

Philip
Apostle

Name
From Greek, meaning "horse-lover"

Earthly Life
First century

Characteristics and Activity
One of the Twelve Apostles, he followed Jesus after having known John the Baptist

Connections with Other Saints
The Twelve Apostles

Feast Day
May 3, with James the Less

Saint Philip (detail), ▲ from the sixth century. Ravenna, Arcivescovile Chapel.

Leonardo da Vinci, ◄ *The Last Supper* (detail), ca. 1495–98. Milan, Santa Maria delle Grazie.

Here a statue of winged Victory defeats false gods and holds the words Dei manibus victoria (Victory by God's hands).

The statue of Mars, the god of war, is fully armed with a wolf and a woodpecker at his feet. The Romans held these to be the god's sacred animals.

Christ appears on the cross to support and bless Philip, who brings those who were slain by the dragon's noxious breath back to life.

The dragon's venomous breath killed many of those present when they breathed it even for just for a short while.

According to the Golden Legend, pagans from Scythia had captured Philip and attempted to make him offer a sacrifice to a statue of the god Mars.

The dragon, a symbol of the Devil, suddenly emerged from the base of the statue and killed many of those present with its breath.

The monster's first victim was the son of a priest, who was preparing the sacrifice.

▲ Filippino Lippi, *The Apostle Philip in the Temple of Mars*, 1487–1502. Florence, Santa Maria Novella.

Raphael is typically portrayed as an angel with huge wings. He can be distinguished from other angelic figures because a boy accompanies him and often holds a fish. In medieval imagery, he is dressed as a pilgrim.

Raphael
Archangel

In the Bible, Raphael is defined as one of seven angels in God's presence, and apocryphal texts call him an archangel. In the Book of Tobit, after the righteous Tobit becomes poor and blind and invokes the Lord, God sends Raphael. Tobit sends his young son Tobias on a journey to claim ten silver talents that he had lent twenty years earlier. During the trip from Assyria to Media and finally on to Rages, Raphael not only shows Tobias the surest path, but he saves him from a number of dangers. He never reveals that he is an angel until the journey's end. Raphael helps Tobias catch a huge fish that tried to eat him as he took a bath in the Tigris River. Then he helps him marry Sarah, the daughter of Raguel, by teaching him how to free her from a demon that made her kill seven previous husbands on their wedding nights, leaving her a widow. After the debt is collected, Raphael returns with the bride and groom to Tobit's house. By following the angel's directions, Tobias is able to cure his father Tobit's blindness.

Name
Originally Hebrew, meaning the medicine of God

Characteristics and Activity
Archangel who accompanies Tobias

Patron
The blind, teenagers, patron of journeys

Special Devotions
Always venerated as a healer

Connections with Other Saints
The archangels Michael and Gabriel

Venerated
His cult was quite widespread, especially in the East

Feast Day
September 29, together with Gabriel and Michael

Giovanni Girolano Savoldo, ▲
Tobias and the Angel, ca. 1550.
Rome, Galleria Borghese.

Antonio del Pollaiolo, ◄
The Archangel Raphael and Tobias (detail), ca. 1470.
Turin, Galleria Sabauda.

317

Tobias is generally por-
trayed as a young man,
little more than a boy.

Wings distinguish the
angel Raphael.

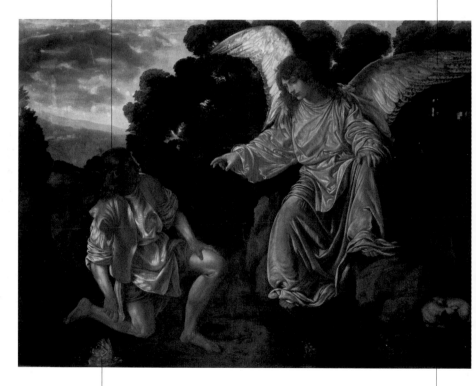

The fish refers to the most com-
mon episode between Raphael
and Tobias. The liver and bile
were extracted from the huge fish
that tried to devour Tobias and
used to heal two people.

This dog was not just invented
by the artist, but is an attempt to
closely follow the biblical text,
which tells of how a dog also
followed Tobias on his journey.

▲ Giovanni Girolamo Savoldo,
Tobias and the Angel, ca. 1530.
Rome, Galleria Borghese.

This saint is shown dressed as a pilgrim and holds a staff and seashell. A wound can be seen on his leg and a dog carrying a piece of bread frequently accompanies him.

Roch

Despite widespread veneration of Saint Roch, sure facts about him are few. Roch was born into a noble family of Montpellier (France) during the fourteenth century. He felt called to live a hermit's life, gave all his belongings to the poor, and then set out on a pilgrimage toward Rome. During that time, a terrible epidemic of the plague broke out and spread throughout Europe. Many pilgrims turned back toward their homes because they feared catching the disease. Roch, instead, dedicated himself to caring for the sick and had such success that it was not long before he became known as a miracle worker. He completed his pilgrimage and reached Rome. However, on the way back, he caught the plague himself and was not helped by anyone. He decided to take shelter alone in the forest and wait for death in prayer, but he was visited by an angel who cured him and a dog who brought him bread each day. Finally, Roch was healed and set out once again toward Montpellier. At this point in the story, the various legends of Saint Roch do not agree; according to one version, Roch was arrested near Angera in Lombardy and thrown in jail as a spy, where he remained for the rest of his life; another recounts how he returned to Montpellier, where he died.

► Veit Stoss the elder, *Saint Roch*, ca. 1504. Florence, Chiesa della Santissima Annunziata.

Name
Originally Germanic

Earthly Life
Fourteenth century;
France, Italy

Characteristics and Activity
A hermit who took a pilgrimage to Rome, where he aided plague victims

Patron
Surgeons, pharmacists, those who work the earth, gravediggers, pavers, pilgrims, travelers, invalids, the poor, prisoners

Special Devotions
Invoked against the plague

Connections with Other Saints
One of the Fourteen Holy Helpers

Venerated
Immediately after his death

Feast Day
August 16

Cesare da Sesto, *Saint Roch* ▲ (detail), from the *Polyptych of Saint Roch*, 1523. Milan, Museo d'Arte Antica del Castello Sforzesco, Pinacoteca.

The staff is a pilgrim's symbol.

When Saint Roch caught the plague, no one wanted to care for him. When he took refuge in a forest, an angel cured him and made water well up in a spring.

The seashell originally identified pilgrims who had visited Santiago de Compostela in Spain but eventually became associated with all pilgrims, including Saint Roch.

A sore from the plague on Roch's thigh is his main attribute in art.

The dog, which brings bread to Saint Roch, originated from a legend of a dog that brought food to the saint when he fell sick.

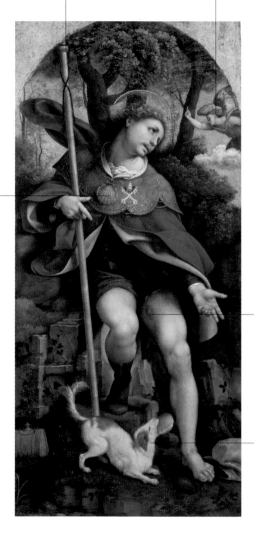

▲ Cesare da Sesto, *Saint Roch* (detail), from the *Polyptych of Saint Roch*, 1523. Milan, Museo d'Arte Antica del Castello Sforzesco, Pinacoteca.

Romuald is generally depicted with a long beard wearing the white habit of the Camaldolese Benedictines. His attributes are the book of the Bible; a demon that tempts him; and a ladder, which he saw his monks climb to Heaven in a dream.

Romuald

Romuald was born into a noble family of Ravenna, Italy, around A.D. 950. After witnessing a bloody duel there, he and his father decided to become monks and lead a life of prayer and atonement. His first monastery was Sant'Apollinare-in-Classe. He dedicated much of his time to studying the Desert Fathers, and he was inspired by their eremitic life to renew his own monastic order. He felt that monastic life should be much more demanding and, especially after a brief period of staying in Spain in a monastery modeled after another in Cluny, he wished to rediscover the ancient rule used by the Cenobites of the East. Although he hoped for silence and a chance to retreat from the world, he was often called to appointments with important members of the clergy and politics. He helped convert Otto III, who named him abbot of Sant'Apollinare. After just a year, however, Romuald resigned and retreated to Monte Cassino. In 1012 he founded the hermitage and monastery of Camaldoli, which gave the new order its name: the Camaldolese Benedictines. He died in Val-di-Castro in 1027.

► Giuseppe Bazzani, *The Dream of Saint Romuald*, ca. 1750. Mantua, Museo Diocesano.

Name
Originally from Lombardy, meaning, "he who commands gloriously"

Earthly Life
About A.D. 950–1027, Italy

Characteristics and Activity
Benedictine abbot who founded the Camaldolese order

Patron
The Camaldolese order

Connections with Other Saints
Benedict

Venerated
Canonized in 1595 by Pope Clement VIII

Feast Day
June 19

Fra Angelico, *Crucifixion* ▲ *and Saints* (detail), ca. 1440. Florence, San Marco.

A long beard is
one of this saint's
characteristic traits.

An angel clubs a demon that was
tormenting Saint Romuald. This
is an image of the temptations of
ascetic life.

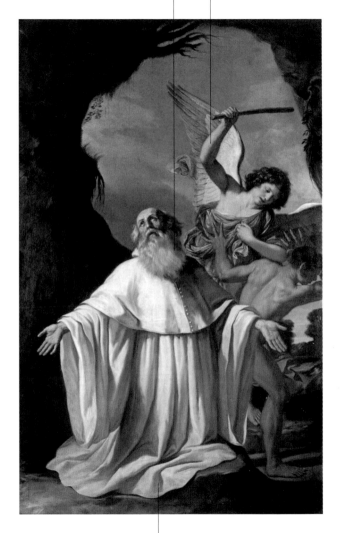

The Camaldolese Benedictines, the
order founded by Romuald, wore a
white habit.

▲ Guercino, *Saint Romuald*,
from the seventeenth century.
Ravenna, Pinacoteca Comunale.

She often has roses in her hair, a symbol that was chosen because of its similarity to her name. Because she is a hermit, her symbols are also a crucifix and skull.

Rosalia

Reports about Saint Rosalia are legendary and spread after her relics were uncovered in 1624. A woman who was devoted to the saint was healed through Rosalia's intercession, and the location of the saint's body was revealed to her in a dream. The presumed bones of Saint Rosalia were found on Mount Pellegrino, near Palermo, Italy.

Nearby there was a cavern with an inscription in Latin, "I Rosalia, daughter of Sinibald, lord of Quisquina and Rosae, decided to live in this cave for the love of my Lord Jesus Christ." From then on, a legend spread that she was the daughter of Duke Sinibaldo and lived during the reign of King William I during the twelfth century. Because of her service to Queen Margaret, William's wife, Rosalia received Mount Pellegrino as a gift from the sovereigns, and there she retreated to an eremitic life in order to dedicate herself to penance and prayer. Hagiographical studies of Saint Rosalia have proposed that she made such a choice to avoid a marriage that her father had arranged for her. She often changed caverns to keep from being discovered, and an angel showed her where to hide.

Name
Perhaps a diminutive of "rose"

Earthly Life
Twelfth century, Sicily

Characteristics and Activity
A virgin who lived as a hermit in a cave on Mount Pellegrino

Special Devotions
Invoked against plague epidemics

Venerated
Initially spread in the thirteenth century, taken up again in the seventeenth century, when her relics were discovered

Feast Day
September 4

◀ Valerio Castello, *The Glory of Saint Rosalia,* from the first half of the seventeenth century. Collezione Credito Bergamasco.

Rosalia Novelli, ▲ *Saint Rosalia with a Garland of Flowers Held by Cherubs* (detail), ca. 1650. Palermo, San Francesco Saverio.

Rose
of Lima

Rose is a young woman who wears a Dominican habit. Her emblems are roses, a lily branch, a crown of thorns, and the child Jesus in her arms. As patron of the port of Lima, she sometimes holds an anchor.

Isabella Flores y de Oliva was born in Lima in 1586 to Spanish parents. She seemed "as beautiful as a rose" and was given that nickname by a maid who took care of her. Years later, when she entered the lay order of Dominicans, Isabella chose the name Rose of the Virgin Mary. When her family found itself in serious economic difficulty because of a flawed investment, Isabella earned a living by working in the fields and sewing until late at night. When she was twenty she decided not to marry and got permission to take religious vows at home as a Dominican tertiary. Since there were no convents in Peru, a small cell was built for her behind the garden of her father's house with a bed made of a layer of grain stalks. There Rose lived in solitude and penance, facing sickness and spiritual trials with extraordinary peacefulness. Her goal was to imitate the poor and crucified Jesus. In 1614, since Rose was sick and

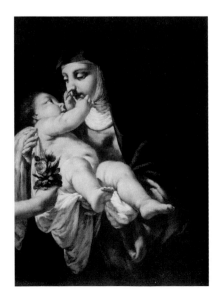

alone, the Maza couple took her in for the last three years of her life. She died on August 24, 1617, on the feast of Saint Bartholomew. Rose, who was thirty-one, had waited years for that occasion, the day of her "eternal marriage."

Name
Rose

Earthly Life
1586–1617, Peru

Characteristics and Activity
A Dominican tertiary, this virgin worked and prayed for the Church among the indigenous people of America

Patron
Florists, gardeners, Dominican sisters, patron of Latin America, Peru, Philippines

Venerated
Canonized in 1671, she is the first American saint

Feast Day
August 23

▲ *Saint Rose of Lima* (detail), from a processional banner, 1775–1800. Legnano, San Magno Basilica.

◄ Giovanni Battista Lucini, *Saint Rose of Lima* (detail), ca. 1680. Crema, Banca Populare di Crema.

Scholastica is typically dressed in the black habit of a Benedictine nun. Among her attributes are the book of the Rule of Saint Benedict and a dove, a symbol of her soul that Benedict saw fly toward Heaven.

Scholastica

Scholastica was Saint Benedict's sister— perhaps his twin sister—and therefore was born around A.D. 480 in Norcia, Italy. She was consecrated to God ever since she was a young child. Early on she lived in a convent at Sublacum and then in Plombarola at the foot of Monte Cassino. The few facts known about her are from the writings of Saint Gregory the Great, who describes Saint Benedict's life and many marvelous events as proof of his holiness. Scholastica and Benedict had the custom of meeting in a house that was about halfway between their two monasteries. At their final meeting, Scholastica insisted that her brother stay the night to discuss spiritual matters, but Benedict was determined to return and not break the monastery rule. Scholastica prayed God to hear her, and suddenly a terrible storm struck, forcing Benedict to stay the entire night. A few days later, after he had returned to the abbey at Monte Cassino, Benedict saw Scholastica's soul rise to Heaven in the form of a dove.

Name
Quite common in the fifth century

Earthly Life
About A.D. 480– about 547, Italy

Characteristics and Activity
Saint Benedict's sister; she was a Benedictine nun and abbess

Patron
Benedictine order, children who suffer from convulsions

Special Devotions
Invoked against storms and lightning bolts, and for rain

Connections with Other Saints
Benedict

Venerated
Within the order from the moment of her death

Feast Day
February 10

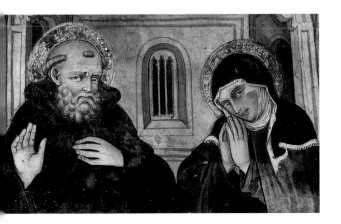

Anonymous, *Saint Scholastica,* ▲ from the end of the twelfth century. Subiaco, Sacro Speco.

Anonymous, *Saint Benedict* ◄ *and Saint Scholastica* (detail), from the fourteenth century. Subiaco, Sacro Speco.

Sebastian

Between the seventh and eighth centuries, Sebastian was portrayed as a man holding a cross or a palm branch, or wearing the crown of glory. In the Middle Ages, he was depicted as a knight with a bow and arrows. The most common representation of this saint, however, is from the Renaissance: a young man who is tied up and shot with arrows. He is sometimes dressed as a soldier, and his symbols are arrows and the palm of martyrdom.

Name
Originally Greek, meaning "venerable"

Earthly Life
Third and fourth centuries; France, Italy

Characteristics and Activity
This Praetorian guard converted and suffered martyrdom

Patron
Athletes, archers, tapestry makers, traffic cops

Special Devotions
Invoked against the plague

Connections with Other Saints
Roch and Christopher, protectors against the plague and unexpected death

Venerated
Since the High Middle Ages

Feast Days
January 20 in the West, December 18 in the East

▲ Sodoma, *Saint Sebastian* (detail), 1526–31. Florence, Palazzo Pitti.

Sebastian was a soldier originally from Gaul, probably from Narbonne. He moved to Milan and was recruited in Diocletian's army. After he converted to Christianity, he took advantage of his position to help other Christians who were imprisoned. When he was discovered, the emperor condemned him to death. Sebastian was tied to a column, shot with arrows, and left for dead. Eventually a widow named Irene found him and healed him. Sebastian once again came before Diocletian at the emperor's palace, berating him for the persecutions. The emperor ordered him to be seized and clubbed to death, and the saint's body was thrown in the Cloaca Maxima, Rome's main sewer. A Christian woman, after being advised in a dream by Sebastian himself, later found the saint's body and buried it in the catacombs.

◀ Antonello da Messina,
Saint Sebastian (detail), 1475.
Dresden, Gemäldegalerie.

An angel sent by God tells Chromatius that he is healed.

The destruction of idols, a sign of renouncing pagan gods and adopting the Christian faith, was necessary for Chromatius to be healed.

This sick man is Chromatius, the prefect of Rome, who had called Sebastian to cure him.

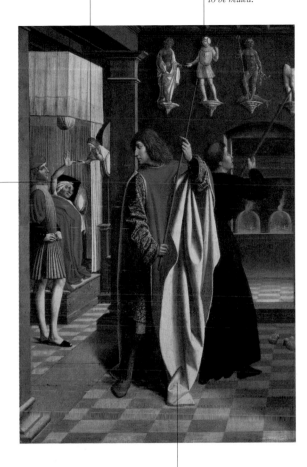

Here Sebastian does not wear military garb, although he is recognizable because he destroys idols in Chromatius's house.

▲ Master of Saint Sebastian, *Saint Sebastian Destroys the Idols*, 1497–98. Philadelphia Museum of Art.

The crown, a symbol
of power, identifies
the emperor.

The scepter, an instrument of
command, also symbolizes
power and royalty.

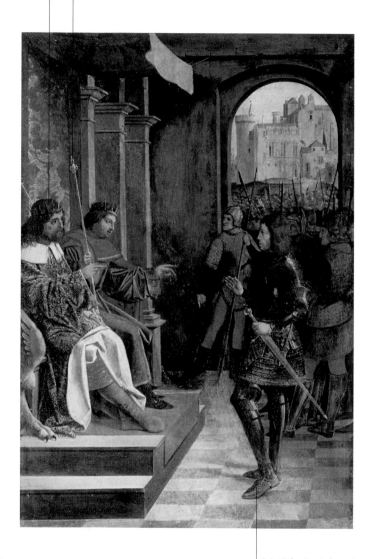

▲ Master of Saint Sebastian,
*Saint Sebastian Before Emperors
Maximian and Diocletian*, from
the middle of the sixteenth century.
Saint Petersburg, Hermitage.

*Saint Sebastian is shown in
armor as he stands before the
two emperors, Maximian and
Diocletian. Here they appoint
him as their personal guard.*

In popular tradition, Sebastian's wounds were compared to Christ's. Perhaps this is why the artist has painted five arrows.

Emperor Diocletian, who commands Sebastian be executed, is shown here in a turban, a symbol of pagan faith.

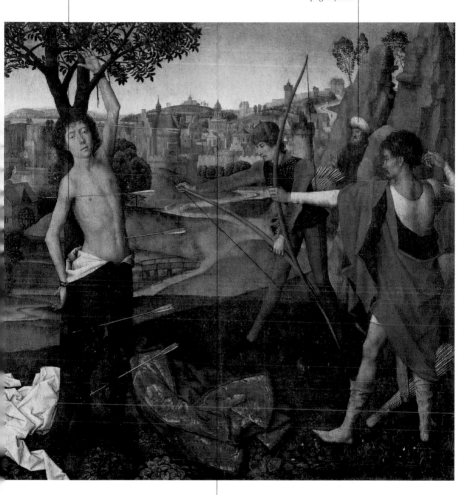

Here is the imaginary city of Rome, where the saint's martyrdom was thought to have taken place.

▲ Hans Memling, *The Martyrdom of Saint Sebastian*, ca. 1475. Brussels, Musées royaux des beaux-arts.

This column with a rope that winds around it is where Sebastian was tied and shot at with arrows.

Irene was a Christian widow, which is why she is dressed in a dark, modest dress and wears a veil on her head.

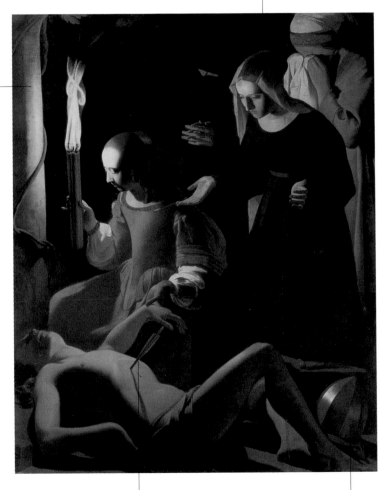

A single arrow, which is deeply buried in the saint's apparently life-less body, indicates the punishment he suffered.

A helmet near Saint Sebastian's feet identifies him as a soldier. He was one of the emperor's guards.

▲ Georges de La Tour, *Saint Irene Heals Saint Sebastian*, ca. 1649. Berlin, Gemäldegalerie.

▶ Albrecht Altdorfer, *Saint Sebastian Being Clubbed*, 1509–16. Saint Florian near Linz, the Abbey collection.

Sebastian, who had been healed by the widow Irene, came before the emperor to declare his faith and condemn him for his persecutions of Christians.

Sebastian was actually martyred with clubs, yet artists preferred arrows, which miraculously did not kill him.

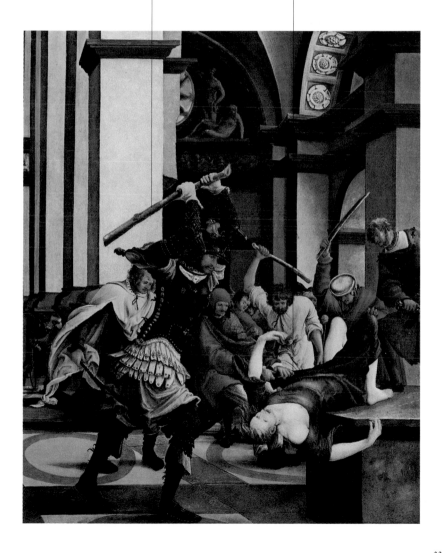

Here arrows recall the punishment that the saint suffered. In this scene they are only a symbol, since the saint's body is being thrown into the Cloaca Maxima after he was clubbed to death.

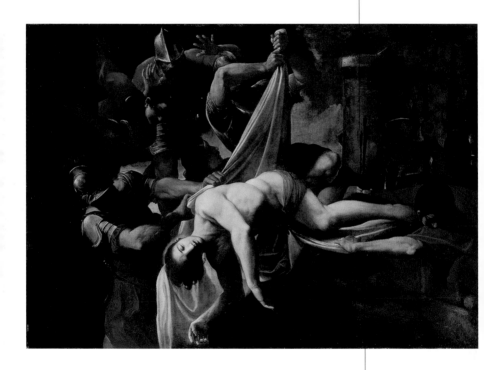

Throwing the martyr's body from the high wall of the sewer shows the soldiers' intention of discarding it with contempt.

▲ Lodovico Carracci, *Saint Sebastian Thrown into the Cloaca Maxima*, 1612. Los Angeles, J. Paul Getty Museum.

Simon is typically portrayed as an apostle dressed in a pallium (cloak) and tunic. His emblem is a saw, with which he was supposedly martyred, according to apocryphal sources. Normally he is shown together with another apostle, Jude, who is sometimes called Thaddeus.

Simon
Apostle

The evangelists called the apostle Simon the "Canaanite" or "Zelotes," so he has generally been thought to be either from Canaan in Galilee or a member of the Zealots, a Palestinian resistance movement that struggled against the Romans. Apocryphal sources, such as Abdias's *Historia certaminis apostolici*, say that he was the brother of Saint Jude, or Thaddeus, and Saint James the Less, who were children of Alpheus and Saint Mary of Cleophas. These same sources recount how Simon and Jude preached in Persia, where pagan

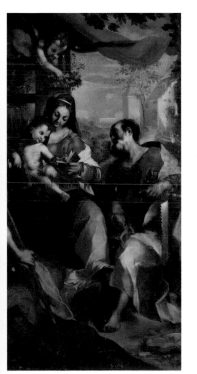

priests killed them. The *Golden Legend* follows those same sources, while other traditions say that Simon was sawed in two. According to other unreliable facts narrated by Eusebius, Simon was James's successor as bishop of Jerusalem during that holy city's destruction. Others tell of Simon preaching in Egypt, Libya, and Mauritania. Finally, according to Hegesippus, the apostle suffered martyrdom under Trajan in A.D. 107, when he was 120 years old.

Name
Originally Hebrew, meaning, "God has heard"

Earthly Life
First century, Middle East

Characteristics and Activity
Apostle

Patron
Fishermen

Connections with Other Saints
The Twelve Apostles

Venerated
Since an early date

Feast Days
October 28 in the West, July 1 in the East

Saints Simon and Jude ▲ (detail), from the *Grimani Breviary* (plate 101), ca. 1500. Venice, Biblioteca Marciana.

Federico Barocci (copy), ◄ *Madonna with the Child Jesus, Madonna Between Saints Jude and Simon* (detail), from the sixteenth or seventeenth century. Milan, Arcivescovado.

After preaching about Christ, Simon and Jude had statues destroyed, and demons came out from within them.

After the idols had been toppled, the priests rushed at Simon and Jude and killed them.

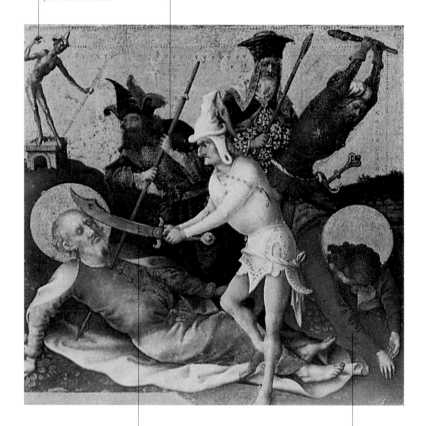

The artist's source here is the Golden Legend, *which does not specify how Simon was slain.*

According to tradition, the apostle Jude preached with Simon and was martyred with him.

▲ Stefan Lochner, *The Martyrdom of the Apostles* (detail), 1435–40. Frankfurt, Städelsches Kunstinstitut.

This saint is shown in a Carmelite habit. Among his attributes are a flame, which alludes to the fire of Purgatory, and a scapular, which according to tradition he received from the Virgin Mary.

Simon Stock

Facts about Simon Stock are scarce. He was perhaps a native of the region of Kent in England. When he was young, he went on a pilgrimage to the Middle East and joined a small community of hermits called the Observantine Carmelites. When he returned to Europe around 1247, he devoted his time to promoting the Carmelite order. At the time, the community was developing and transforming from an order of hermits to a mendicant one, modeling itself after the new Franciscan and Dominican religious families. Simon was named superior general of the order in London and founded a number of university houses.

He died in Bordeaux in 1265. After his death, a legend spread that the Virgin Mary appeared to a certain Saint Simon with a scapular, promising him: "This shall be a privilege unto thee and all Carmelites; he who dies in this habit shall be saved." This legend was soon linked to Simon Stock, and his vision of Mary became a widespread theme in art.

Name
Originally Hebrew, meaning "God has heard"

Earthly Life
Thirteenth century; Europe, the Middle East

Characteristics and Activity
Carmelite friar, among the main promoters of the Carmelite order in Europe

Patron
The Carmelite order

Venerated
Since the fourteenth century, at first locally

Feast Day
May 16

Giovanni Battista Tiepolo, ▲ *Our Lady of Carmel with Carmelite Saints and Souls from Purgatory* (detail), 1721–27. Milan, Pinacoteca di Brera.

Andrea Michieli, ◄ *The Madonna Gives the Scapular to Simon Stock,* from the beginning of the seventeenth century. Rovigo, Duomo.

A confraternity in procession prays for
the souls of the dead. This is an image of
the militant church, in contrast with a
vision of the triumphal church.

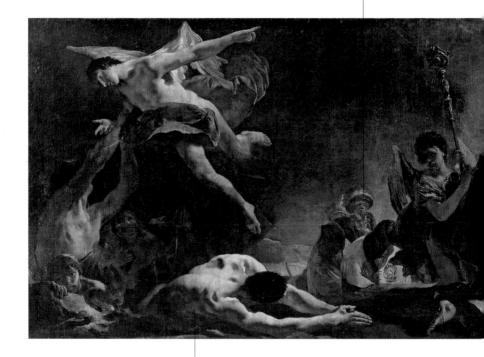

The body rising from the earth
symbolizes a soul in Purgatory
that is saved thanks to the Virgin
Mary's intercession.

▲ Giovanni Battista Tiepolo, *Our Lady
of Carmel with Carmelite Saints and
Souls from Purgatory*, 1721–27.
Milan, Pinacoteca di Brera.

The Virgin herself gives the large
scapular to Simon Stock. She appeared
to him and promised that anyone who
wore it would be saved.

The small scapular,
which is also called a
tiny habit, was reserved
for members of the
confraternity.

Teresa of Avila was
a reformer of the
Carmelite order.

Simon Stock is dressed
in a Carmelite habit
and carries the book of
the order's rule.

Stephen

Stephen is typically depicted in a deacon's vestments, wearing a dalmatic, surplice, and diagonal stole. He can also have a monk's tonsure (shaved head). His symbols are the rocks that were used to stone him, the palm of martyrdom, and a book.

Name
Originally Greek, meaning "crown"

Earthly Life
First century, Palestine

Characteristics and Activity
Deacon and first martyr

Patron
Deacons, sling shooters, builders, chiselers, pavers, quarry workers

Special Devotions
Invoked against migraines and for a peaceful death

Connections with Other Saints
The Twelve Apostles

Venerated
Already celebrated in the fourth century; his cult spread in the fifth century, when his tomb was found

Feast Days
December 26 in the West, December 27 in the East

▲ Hans Memling, *Triptych with the Rest During the Flight to Egypt* (detail), ca. 1480. Paris, Musée du Louvre.

The Acts of the Apostles (6–7) speaks of Stephen as the first of seven deacons who were appointed to distribute food each day within the first Christian community, especially to widows. He was a "man full of faith and the Holy Spirit," who "full of grace and power, did great wonders and signs among the people." He was probably a Jew of Hellenic origin, since the apostles chose deacons from within the Greek community. Stephen was quite knowledgeable in the Scriptures, which enabled him to argue at length with the Sanhedrin. He was brought before the tribunal after being accused of pronouncing blasphemous words against Moses and God. As he argued, based on the Scriptures, that the Jews were resisting the Holy Spirit and refusing to recognize the Messiah, those who looked

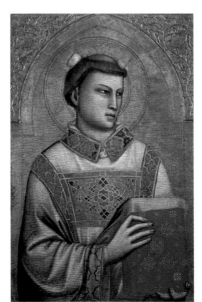

at him saw the face of an angel. Enraged, the priests rushed at him and led him outside the city to be stoned. As he died, Stephen said he could see the glory of God in Heaven.

◀ Giotto, *Saint Stephen* (detail), 1320. Florence, Museo Horne.

The dalmatic, a deacon's vestment, is a main element in identifying Stephen, who was the first deacon named by the apostles.

The turban is a sign of a different culture, and therefore a different faith.

The gesture of counting on one's fingers is a sign of a teacher who speaks with authority.

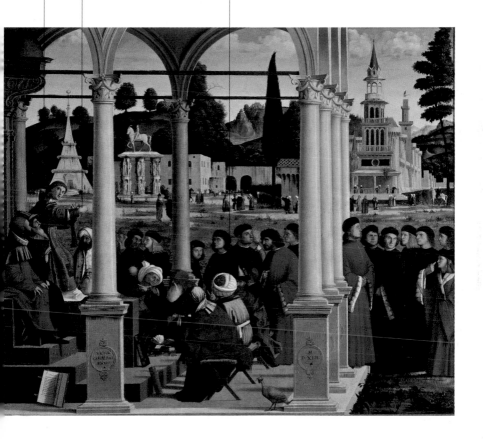

▲ Vittore Carpaccio, *Dispute Between Saint Stephen and the Doctors of the Sanhedrin*, 1514. Milan, Pinacoteca di Brera.

In Stephen's vision, just before he is
stoned to death, Christ appears in glory
to the right of God the Father.

The angels
part the
clouds. This
refers to the
words of Saint
Stephen, who
said he saw the
heavens open.

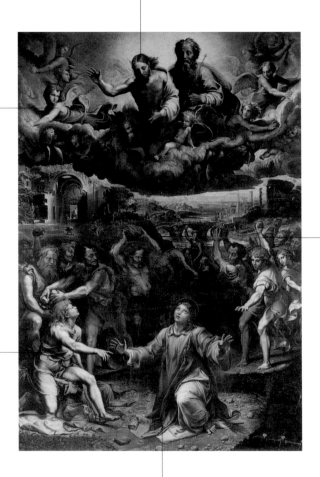

The rocks that
Stephen was
stoned with
became his
main emblems
in art.

The young
man helping
to stone
Stephen is
Saint Paul, or
Saul, before
his conversion.
Stephen's
murderers left
their cloaks
with Saul as
they slew the
disciple.

Once again Stephen, the
first martyr, is shown in
a dalmatic, a deacon's
vestment.

▲ Giulio Romano, *The Stoning of
Saint Stephen*, ca. 1523. Genoa,
Santo Stefano.

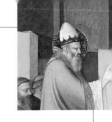

Sylvester is shown in papal attire. His attributes are the bull, because he resurrected one that a sorcerer had killed; a dragon, which according to legend he tamed; and a baptismal font, in memory of his baptizing Emperor Constantine.

Sylvester

Sylvester was the first pope after the Roman emperor Constantine gave freedom to Christians in A.D. 313 with the Edict of Milan. His pontificate lasted twenty years. During this time the church, which had just emerged from hiding and persecution, had to combat heresies and establish relations with the emperor of the East. At the same time, it had to build an ecclesial organization that could last. Constantine is strongly linked to this period in church history, especially because Roman tradition held that an emperor was the legitimate representative of divinity and therefore should control the Christian Church like any other religious organization. For example, it was Constantine, not the pope, who convened the Council of Nicaea in 325. The good relations between Sylvester and Constantine led to the legend of the pope baptizing the emperor and curing a leper. However, Sylvester died on December 31, 335, and Constantine was baptized just before his death in 337.

Name
Originally Latin, meaning "forest-dweller"

Earthly Life
Fourth century, Rome

Characteristics and Activity
Pope during Constantine's reign as emperor; the ecumenical Council of Nicaea against Arianism was convened during his pontificate

Patron
Domestic animals, cattle; builders and quarry workers, since he built many churches

Feast Days
December 31 in the West, January 2 in the East

Maso di Banco, ◄
Stories from the Life of Pope Sylvester and Constantine: Saint Sylvester Tames the Dragon (detail), ca. 1337. Florence, Santa Croce.

Teresa is shown wearing the Carmelite habit. Among her attributes are an arrow that pierces her heart; a heart with the initials of Jesus, IHS (she called herself Teresa of Jesus); and a dove, symbol of the Holy Spirit.

Teresa
of Avila

Name
There are two possible derivations: from the Greek, meaning "huntress," and from German, meaning "lovable and strong woman"

Earthly Life
1515–1582, Spain

Characteristics and Activity
Virgin, mystic, and Doctor of the Church, reformer of the Carmelite order and founder of the Discalced Carmelites

Patron
Carmelites, upholsterers, patron saint of Spain

Special Devotions
Invoked to free souls from Purgatory and against heart disease

Connections with Other Saints
John of the Cross, Peter of Alcántara

Venerated
Canonized in 1622

Feast Day
October 15

Teresa de Cepeda y Ahumada was born into an aristocratic family on March 28, 1515, in Avila, Spain. After six years of education with the Augustinian nuns, she entered the Carmelite convent of Avila when she was twenty. She suffered from malaria and had to leave the convent for a while to recover. When she returned, she found that the once-cloistered convent had been enlarged and was too often filled with laypeople, so she isolated herself, dedicating as much time as possible to prayer and reading the Fathers of the Church. During these years, her mystical experiences and ecstatic visions began to occur and are recorded in her writings. In 1560 she began to reform her order by calling it back to its original rule. Teresa founded the convent of Saint Joseph in 1562, where she moved in with thirteen sisters. Despite initial opposition to her project, the superior of their order approved their way of observing the rule. This renewal was such a success that it was extended to the men's branch of the order in 1568 with the collaboration of Saint John of the Cross. Teresa died in Alba de Tormes on October 15, 1582.

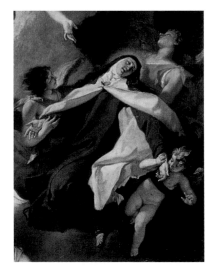

▲ Guido Cagnacci, *Madonna with Child and Saints* (detail), ca. 1630. Rimini, San Giovanni Battista.

◀ Sebastiano Ricci, *Ecstasy of Saint Teresa* (detail), ca. 1727. Vicenza, San Marco in San Girolamo degli Scalzi.

The arrow is a visible sign of a wound of love, an attempt to translate the mystical experience of a soul's love for God into an image.

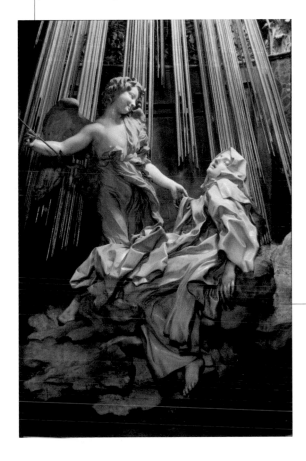

The cloud signifies rising toward Heaven.

▲ Gian Lorenzo Bernini, *The Ecstasy of Saint Teresa*, 1644–52. Rome, Santa Maria della Vittoria.

The Virgin Mary, who appeared to the mystic on the feast of the Assumption in 1561, gave her the necklace of her order as a sign of divine grace.

In her vision Saint Joseph gave her a white mantle as a sign of purification from sin.

Teresa affectionately called Saint Joseph her "glorious father" and "patron."

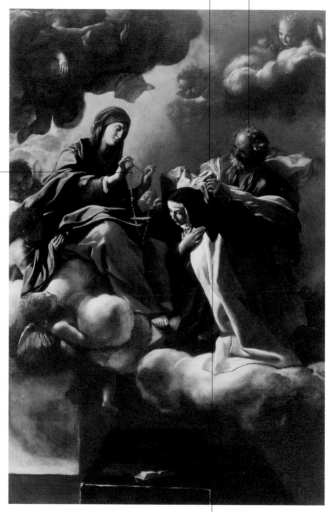

▲ Giovanni Lanfranco, *The Vision of Saint Teresa of Avila,* ca. 1617. Rome, Monastery of San Giuseppe delle Carmelitane Scalze.

Teresa had an important vision in 1561 that confirmed her intention of reforming her order despite opposition to the renewal.

His image in art is essentially medieval; he is shown as a soldier, and his only symbol is Christ's cross.

Theodore

Theodore is one of the most venerated soldier-martyrs in the Eastern Church. All that is known about him comes from a speech that Saint Gregory of Nyssa gave near Theodore's tomb in Euchaita, present-day Turkey, and from a later biography. Beginning in the tenth century, Theodore split into two figures in popular devotion, a general and a soldier that were really the same person. He was originally from the East, a Christian recruit in the Roman army during the reign of Emperor Galerius. When it was proclaimed that all soldiers were to offer sacrifices to the Roman gods, Theodore refused and, according to some non-Christians, set fire to the temple of Cybele near the Iris River in Amaseia. As a result, he was tortured on the rack and condemned to starve in prison. After he received comforting visions there, he was burned alive on February 17 in either A.D. 306 or 311. Veneration of this soldier-martyr began at his tomb in the small town of Euchaita and later spread to the West during the Middle Ages.

Name
Originally Greek, meaning "gift of God"

Earthly Life
Fourth century, Anatolia (Turkey)

Characteristics and Activity
Soldier and general martyred in Anatolia

Patron
Soldiers, recruits; patron of Venice since the eleventh century

Venerated
First in the East and the Byzantine Empire, then in the West since the seventh century

Feast Days
In the West, the general is remembered on February 7 and the soldier on November 9; in the East, the general is celebrated on February 8 and the soldier on February 17

Saint Theodore, a portable ◄ wall icon from about the middle of the fourteenth century. Vatican City, Biblioteca Apostolica Vaticana, Museo Cristiano.

Thomas is portrayed as an apostle dressed in a tunic and pallium (cloak). His attributes are a carpenter's square and a lance; during the seventeenth century, these were reduced to just the square. Sometimes he holds a belt.

Thomas
Apostle

Name
Originally Aramaic, meaning "twin"

Earthly Life
First century, Palestine

Characteristics and Activity
Apostle

Patron
Architects, artists, carpenters, surveyors, judges, builders, and sculptors

Special Devotions
Invoked against eye inflammations

Connections with Other Saints
The Twelve Apostles

Venerated
His cult began in India and spread to the Middle East, then Europe

Feast Days
July 3 in the West, October 6 in the East

▲ Caravaggio, *The Doubts of Saint Thomas* (detail), ca. 1600–1601. Potsdam, Sanssouci Bildegalerie.

▶ Leonardo da Vinci, *The Last Supper* (detail), ca. 1495–98. Milan, Santa Maria delle Grazie.

The apostle Thomas, also called Didimus by Saint John the Evangelist, appears in three gospel episodes. First, he decides to follow Jesus when it is dangerous for Jesus and his followers to return to Judea. He says to the other apostles, "Let us also go, that we may die with him" (John 11:16). Thomas is also the uncertain apostle who asks Jesus, "Lord, we do not know where you are going, how can we know the way?" Jesus answers, saying, "I am the way, and the truth, and the life" (John 14:5–6). Finally, Thomas is incredulous at the Resurrection and does not even believe his companions' testimonies, declaring, "Unless I see in his hands the print of the nails, and place my finger in the mark of the nails, and place my hand in his side, I will not believe" (John 20:25). When Jesus appears, however, he is ready to believe and proclaims, "My Lord and my God" (John 20:28). Nothing else is known about Thomas except tales from apocryphal texts that were repeated in the *Golden Legend*, which say he was martyred in

India. His image in art has been exclusively based on his doubts, which were repeated in the narrative of Mary's Assumption to Heaven and became the characteristic trait of this apostle.

A cardinal's hat represents Saint Jerome, who was not a cardinal, but the pope's secretary.

Jesus' cross identifies Saint Helen, Constantine's mother.

Jesus leads Thomas's hand to touch the wound in his side so that he might believe in the Resurrection.

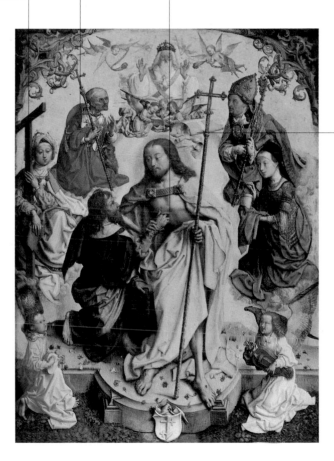

The banner is a sign of the victory of life over death, a symbol of the Resurrection.

▲ Master of the Altar of San Bartolomeo, *Altar of Saint Thomas*, ca. 1460–1500. Cologne, Wallraf-Richartz-Museum.

When Mary was assumed into
Heaven, once again Thomas was not
present. According to the Golden
Legend, *she later appeared to him to
give him proof.*

Mary gives Thomas her belt as a sign
that she was brought to Heaven with
her physical body.

Thomas runs to reach
Mary and the apostles,
but he arrives too late to
witness the Assumption.

▲ Jacopo Palma il Vecchio,
Assumption of the Virgin, ca. 1513.
Venice, Gallerie dell'Accademia.

Since he was stoutly built, Thomas is typically portrayed as a full-figured Dominican friar. His attributes are the sun on his chest, a symbol of sacred learning; a pen; the dove of inspiration; and sometimes an ox because of his nickname, "dumb ox."

Thomas
Aquinas

Thomas was born in the castle of Rocca Secca in Italy around 1225, the son of a knight named Landulf. For his education, he was sent to the abbey at Monte Cassino— where the abbot was a powerful vassal—and then to Naples, to the university there that had been recently founded by Fredrick II. In Naples he met some Dominicans, the preaching brothers of Saint Dominic, and decided to devote himself to a religious life. His father opposed his decision and had him pursued by his brothers and imprisoned. Thomas eventually prevailed and studied under Saint Albert the Great. His numerous writings, which culminated in *Summa theologica,* represent the most systematic attempt to give Christian doctrine a scientific, philosophical, and theological foundation. He died at Fossa Nova in Latina on March 7, 1274, as he was traveling to the Council of Lyons, which was being convened by Pope Gregory X.

◄ Lippo Memmi and Francesco Traini, *The Triumph of Saint Thomas* (detail), from the first half of the fourteenth century. Pisa, Santa Caterina.

Name
Originally Aramaic, meaning "twin"

Earthly Life
About 1225–1274; Italy, Paris, and Cologne

Characteristics and Activity
Dominican friar and theologian

Patron
Academics, pencil makers, booksellers, scholars, schools, students, theologians, universities

Special Devotions
Invoked against lightning bolts and as a protector of chastity

Connections with Other Saints
Albert the Great, his teacher

Venerated
Canonized in 1323; his veneration is heavily supported by the Dominicans

Feast Day
March 7

Bernardo Daddi, *Madonna,* ▲ *Saint Thomas Aquinas, and Saint Paul* (detail), ca. 1330. Los Angeles, J. Paul Getty Museum.

349

The woman who tried to tempt Saint Thomas was shut in the castle of Rocca Secca.

Two angels comfort Thomas after he is tempted and bring him a chastity belt.

Thomas armed himself with burning embers to chase away the woman who tried to seduce him.

Thomas is dressed in the white habit and black cloak of the Dominican order.

Books show Thomas's dedication to study.

▲ Diego Rodríguez de Silva y Velázquez, *The Temptations of Saint Thomas Aquinas*, ca. 1631. Orihuela, Diocesan Museum of Sacred Art.

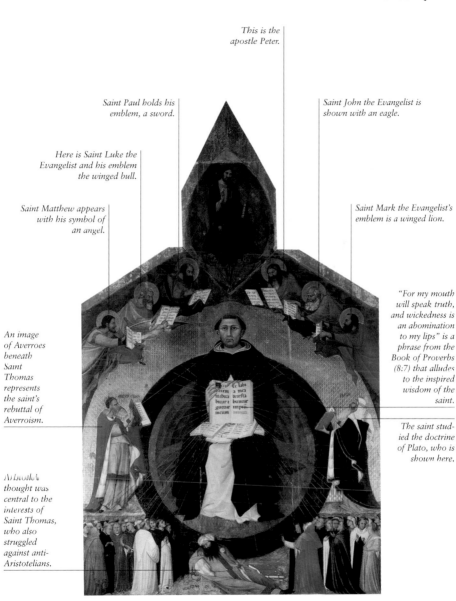

This is the
apostle Peter.

Saint Paul holds his
emblem, a sword.

Saint John the Evangelist is
shown with an eagle.

Here is Saint Luke the
Evangelist and his emblem
the winged bull.

Saint Matthew appears
with his symbol of
an angel.

Saint Mark the Evangelist's
emblem is a winged lion.

An image
of Averroes
beneath
Saint
Thomas
represents
the saint's
rebuttal of
Averroism.

"For my mouth
will speak truth,
and wickedness is
an abomination
to my lips" is a
phrase from the
Book of Proverbs
(8:7) that alludes
to the inspired
wisdom of the
saint.

The saint stud-
ied the doctrine
of Plato, who is
shown here.

Aristotle's
thought was
central to the
interests of
Saint Thomas,
who also
struggled
against anti-
Aristotelians.

▲ Lippo Memmi and Francesco Traini,
The Triumph of Saint Thomas, from
the first half of the fourteenth century.
Pisa, Santa Caterina.

Thomas Aquinas

The four Doctors of the Western Church surround Saint Thomas Aquinas as he reaches Heaven. He was also declared a Doctor of the Church.

A flowering lily branch is an emblem of Saint Dominic's.

The pen represents the saint's many writings.

Here is the dove of divine inspiration.

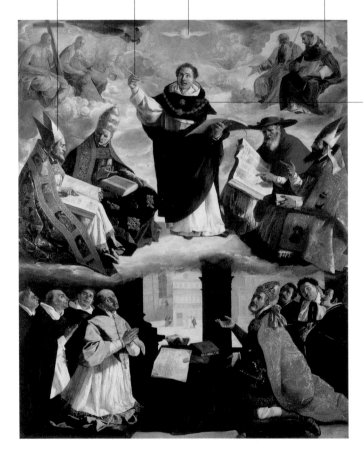

▲ Francisco de Zurbarán, *The Apotheosis of Saint Thomas Aquinas*, 1631. Seville, Museo de Bellas Artes.

The sun or a brilliant star on Thomas's chest represents his holy teachings.

This saint is depicted in a bishop's attire, including a miter and staff. His emblems are the sword with which he was martyred and a palm branch.

Thomas Becket

Thomas Becket was born in London around 1117. He studied theology and canon law and went on to serve as archdeacon and collaborator to Theobald, bishop of Canterbury. King Henry II appointed him chancellor and asked him to be his personal advisor. Thomas seemed perfectly suited for these roles and demonstrated boldness and ambition, reaching an understanding with the king that allowed him to defend the laws firmly. The two became friends. When Theobald died in 1161, the king chose Thomas to be the next bishop of Canterbury. Thomas was ordained a priest on June 3, 1162, and consecrated bishop the next day. As soon as he had assumed his new position, Thomas fought strenuously for the clergy to be exempt from political jurisdiction, which earned him the king's hatred. Beginning in 1164, Thomas was forced to retreat to a Cistercian monastery in France. After Pope Alexander III intervened, the situation seemed to settle down and Thomas returned to his diocese. He was considered a traitor, however, and was isolated by the high clergy. A short time later, on December 22, 1170, four knights entered the cathedral of Canterbury and murdered the bishop.

Name
Originally Aramaic, meaning "twin"

Earthly Life
About 1117–1170;
England, France

Characteristics and Activity
Chancellor for Henry II of England, he was named bishop of Canterbury and died a martyr for having defended the church's independence from the state

Patron
The English College in Rome, coopers, brush makers

Venerated
Canonized three years after his death

Feast Day
December 29

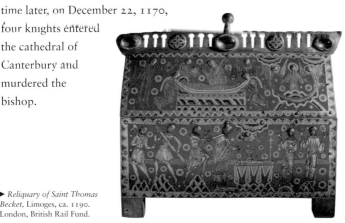

► *Reliquary of Saint Thomas Becket,* Limoges, ca. 1190. London, British Rail Fund.

Anonymous, ▲
The Martyrdom of Saint Thomas Becket (detail), from the middle of the fourteenth century. Spoleto, Giovanni e Paolo.

The long sword with
which Saint Thomas
was slain became his
emblem in art.

The bishop's
head bleeds.

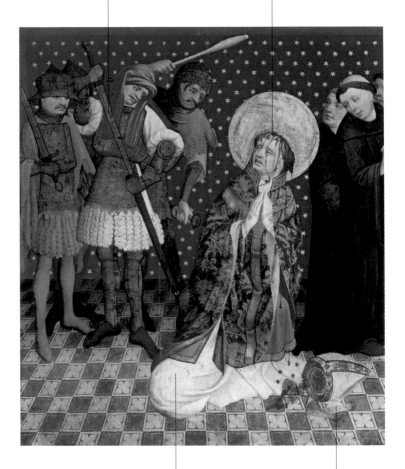

The assassination
occurred in the
cathedral during
evening prayers.

The miter identifies
Thomas as a bishop.

▲ Master Francke, *The Martyrdom
of Saint Thomas of Canterbury,*
from the fifteenth century.
Hamburg, Hamburger Kunsthalle.

Ursula is typically portrayed in royal garments and wears a crown. Among her attributes are the palm of martyrdom; the arrow that killed her; a white banner with a red cross, which signifies victory over death; and a boat. She often wears a wide cape that shelters her handmaidens.

Ursula

The legend of Saint Ursula and her handmaidens comes from an account written in the tenth century that was based on the eighth-century discovery of young women's relics at an ancient Christian cemetery in Cologne, Germany. The name of Ursula, an eleven-year-old child, was featured on one inscription that was connected with the relics. This inscription was probably mistakenly interpreted and fostered the legend of her martyrdom with eleven thousand virgins. The *Golden Legend* retells the story and includes elements from legends of the first virgin martyrs and saints such as Maurice and Acacius. Ursula, the daughter of a Christian king in Britain, accepted to marry the son of a pagan king on one condition: she would first travel on a pilgrimage. She set off with eleven thousand virgins, a thousand for herself and for each of her ten handmaidens. They reached Rome, but upon their return, in Cologne, the group found the city besieged by Huns and were massacred by them. Ursula, who was spared at first because of her great beauty, was slain by Attila when she refused to marry him.

Name
Latin diminutive of bear, meaning "strong"

Earthly Life
Fourth century; England, Rome, and Cologne

Characteristics and Activity
A British princess consecrated to God, she agreed to marry a pagan prince so he might convert; as she returned from a pilgrimage to Rome, she was slain by Attila and the Huns at Cologne

Patron
Girls, students, the Ursuline order

Venerated
Especially during the Middle Ages

Feast Day
October 21

◄ Hans von Metz (?), *Saint Ursula*, ca. 1430. Heintz Kisters collection.

Vittore Carpaccio, *Stories* ▲ *of Saint Ursula: The Couple Meet and Departure for the Pilgrimage* (detail), ca. 1495. Venice, Gallerie dell'Accademia.

An angel appeared to Saint Ursula and announced that she would be a martyr.

The crown on Ursula's head is her royal emblem.

▲ Master of the Saint Ursula Legend,
The Legend of Saint Ursula:
The Angel Appears, 1492–96.
Cologne, Wallraf-Richartz-Museum.

A white banner with a red cross became
an emblem of Saint Ursula's, a sign of
victory over death by martyrdom.

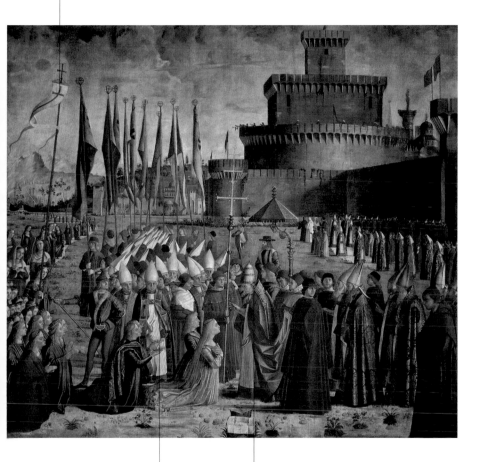

Ursula's crown
is her attribute
in art.

The British pope Cyriacus wears the
papal tiara, a three-tiered crown. He wel-
comed Saint Ursula and her companions
to Rome and then accompanied them on
their return voyage.

▲ Vittore Carpaccio, *Stories of Saint
Ursula: The Pilgrims Meet Pope Cyriacus
at the Walls of Rome*, ca. 1495.
Venice, Gallerie dell'Accademia.

Once again the
crown helps identify
Saint Ursula.

The arrow with which
Ursula was slain became
her attribute in art.

Pope Cyriacus, who had decided to
accompany Ursula and her followers on
their return, suffered martyrdom together
with the eleven thousand virgins.

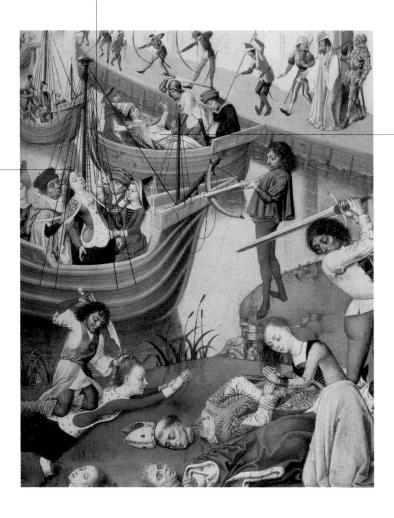

▲ Master of the Saint Ursula Legend,
*Legend of Saint Ursula: The Massacre
by the Huns*, ca. 1480–1500.
Bruges, Groeningemuseum.

One short side of the reliquary chest holds an image of the Madonna and Child; the other shows a picture of Saint Ursula protecting her companions.

Ursula holds the arrow with which she was martyred and appears together with her virgins and Pope Cyriacus, who can be recognized by his papal tiara sticking up in the background.

The first episode of Ursula's story begins with the young princess landing at Cologne with her following.

▲ Hans Memling, *The Reliquary of Saint Ursula*, 1489. Bruges, Memlingmuseum.

In the second episode, the pilgrimage proceeds toward Italy; they arrive in Basel by ship and cross the Alps by foot.

The third episode shows Ursula and her company's arrival in Rome. There they are welcomed by Pope Cyriacus, who blesses her. Inside the building, men are being baptized and will be followed by the virgins.

Valentine

Name
Originally Latin, meaning "may you be healthy and strong"

Earthly Life
Third century, Italy

Characteristics and Activity
Bishop and martyr

Patron
Lovers, epileptics, those in love

Special Devotions
His special protection over lovers began in the Middle Ages, since it was believed that birds began nesting on February 14

Venerated
In the High Middle Ages in Italy and France; widespread devotion to him in Germany, where most images of this saint originated

Feast Day
February 14

▶ Bartholome Zeitblom, *Saint Valentine Heals an Epileptic* (detail), from the beginning of the sixteenth century. Augusta, Staatsgalerie.

It seems that two Saint Valentines—a bishop and a priest who are both remembered on February 14 in the Roman Martyrology—have been combined. The Roman priest Valentine was decapitated in A.D. 268 during the reign of Claudius the Goth. He was martyred because he helped the prefect Asterius and his family convert to Christianity after curing their daughter, who had been blind since the age of two. He was buried along Via Flaminia, where Pope Julius I built a basilica in his honor. Bishop Valentine, instead, was beheaded in 273 during the persecutions of Emperor Aurelian. The philosopher Craton invited him to Rome after hearing of Valentine's ability to work miracles. There the bishop healed the philosopher's son on the condition that he and his entire family become Christians. As a result, Valentine was imprisoned, forced to offer sacrifices to the Roman gods, clubbed, and executed. His body was taken by his disciples to Terni on Via Flaminia. The coincidence of the two Valentines' burial places and martyrdom led to them being identified as the same person.

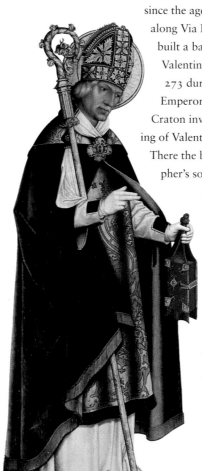

Lucilla, the prefect's daughter who was cured of her blindness, is baptized after her conversion. Popular tradition gave her a name connected with light (luce).

An angel brings a palm of martyrdom for Valentine.

Saint Valentine baptizes the prefect's family. He will be martyred for doing so, as the angels holding the palm branch foreshadow.

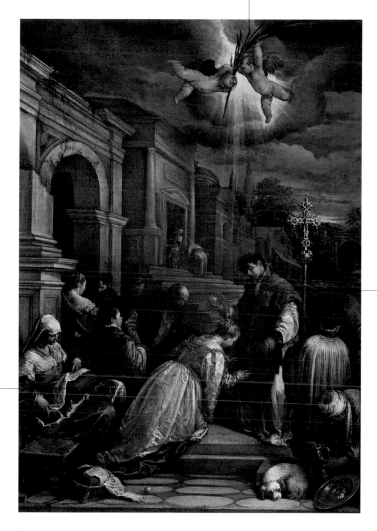

▲ Jacopo Bassano, *Saint Lucilla Baptized by Saint Valentine*, ca. 1575. Bassano del Grappa, Museo Civico.

Bishop Valentine wears a bishop's miter. Here the artist depicts the actual bishop of Terni from his own time.

The pastoral staff, or crosier, identifies saints who are bishops.

Idols are brought before Valentine to adore, according to the normal procedure of trials against Christians.

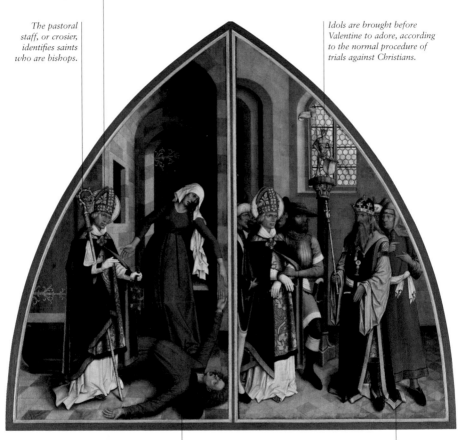

The saint, who has the ability to work miracles, heals an epileptic.

The emperor, who is characterized by his crown, conducts the trial of the miracle worker.

▲ Bartholome Zeitblom, *Saint Valentine Heals an Epileptic; Saint Valentine Refuses to Adore Idols,* from the beginning of the sixteenth century. Augusta, Staatsgalerie.

The grieving Veronica holds a veil with an image of Christ, who sometimes wears a crown of thorns.

Veronica

Popular tradition holds that the woman holding material with an image of Christ's face is one of the women who followed Jesus on his way to be crucified at Calvary. She compassionately wipes his face after he falls under the weight of the cross, and a miracle occurs: the image of Jesus' face remains on the fabric. It was later known as Veronica's veil or shroud. The veil has been kept at Saint Peter's Basilica in Rome ever since the eighth century and was especially revered during the fourteenth and fifteenth centuries, when Veronica's veneration and popularity increased. Who this pious woman was, however, remains uncertain. She often appeared in sacred images of the Gospels, especially those depicting the Passion of Jesus. The name Veronica, which is never mentioned in the Gospels, seems to have been derived from the Latin words *vera icon* (true image). Thus her legend was developed around her presumed name. Despite this, an attempt has been made to identify Veronica as one of the other women in the Gospels based on the apocryphal gospel of Nicodemus, particularly the hemorrhaging woman whom Jesus heals (Mark 5:21).

Name
In the Middle Ages her name was connected with Berenice, which is from the Greek, meaning "bringer of victory"

Earthly Life
First century, Palestine

Characteristics and Activity
She dried Jesus' face on the road to Calvary

Patron
Wardrobe workers, cleaners, textile merchants, photographers, embroiderers

Special Devotions
It was believed that those who gazed on the Shroud of Veronica could avoid a violent death; invoked against sterility

Venerated
Her cult is quite ancient and was popular during the Counter Reformation

Feast Days
July 12; traditionally February 3

▲ Rogier van der Weyden, *Triptych with Christ Crucified* (detail), ca. 1445. Vienna, Kunsthistorisches Museum.

► Hans Memling, *Diptych with Saint John the Baptist and Saint Veronica* (detail), ca. 1480–83. Washington, D.C., National Gallery, Samuel H. Kress Collection.

363

Saint Veronica typically
holds the shroud open to
display the image.

She is mournful and
frequently weeps.

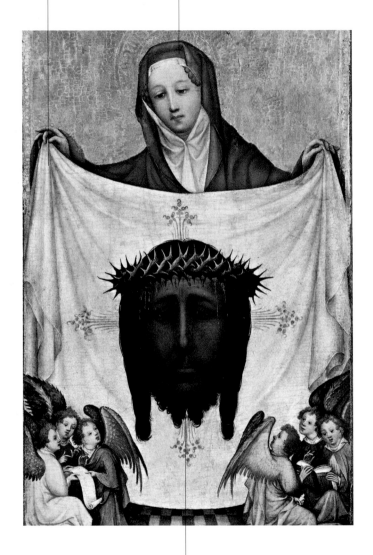

▲ Master of Saint Veronica, *Saint
Veronica with the Shroud of Christ*,
ca. 1420. Munich, Alte Pinakothek.

*The image of Jesus remained on the
fabric that she used to wipe his face as
he walked toward Calvary.*

Jesus advances toward Calvary under the weight of the cross.

This condemned man, a thief, ascends toward Calvary with Jesus and suffers the insults of the crowd. He eventually repents and recognizes Jesus as the Son of God.

Veronica can be recognized in the crowd because she holds the fabric that she used to wipe Jesus' face, which his image was imprinted on.

This man, another condemned thief, instead joins the crowd in insulting Jesus.

▲ Hieronymus Bosch, *The Ascent to Calvary,* 1515–16. Gand, Musée des beaux-arts.

Vincent is typically shown wearing the white habit and black cloak of the Dominican order. He generally holds a flame and a book, which are his attributes.

Vincent Ferrer

Vincent Ferrer was born in 1350 in Valencia, Spain. He entered the order of Saint Dominic in 1367 and soon distinguished himself with his preaching. He went on to teach theology and philosophy at Lerida and Valencia. A decade later, when Pope Gregory IX died, the church divided in the Western Schism, with one pope in Rome, Urban VI, and another in Avignon, Benedict XIII. Vincent had collaborated with Benedict XIII ever since he was still Peter de Luna, the then cardinal of Aragon. When the Council of Constance was unsuccessful in healing the break in the church, Vincent, as the Avignon

pope's seemingly irreplaceable confessor, had the task of informing the pope that the king of Aragon did not recognize him and was withdrawing his political support. This began the process toward unity, which was achieved in 1417. Church unity was central to Vincent's mission, and he persuaded Catharist and Waldensian dissenters to convert and attempted to end the Hundred Years' War. He died in 1419 in Vannes, Brittany, as he was journeying to preach.

Name
Originally Latin, meaning "victorious"

Earthly Life
1350–1419;
Spain, France

Characteristics and Activity
An admired Dominican friar and preacher, he worked relentlessly for the unity of the Roman Church

Patron
Construction workers, brick and tile makers

Special Devotions
Invoked against epilepsy and headaches

Venerated
His cult spread a number of years after his death, beginning in France and expanding throughout Europe

Feast Day
April 5

▲ Ercole de' Roberti, *The Miracles of Saint Vincent Ferrer* (detail), from the base of the *Griffoni Altar*, ca. 1473. Vatican City, Pinacoteca Vaticana.

◀ Francesco del Cossa, *Saint Vincent Ferrer* (detail), from the *Griffoni Polyptych*, ca. 1473–75. London, National Gallery.

In Italy, Vitus is depicted as a young man. In Germany, he is portrayed as a little boy, sometimes with a white rooster or the palm branch of martyrdom.

Vitus

The earliest facts about Saint Vitus come from the Hieronymian Martyrology, the catalogue of martyrs attributed to Saint Jerome which states that Vitus was from Lucania, in southern Italy. A later account, based on Jacobus de Voragine's *Golden Legend* and artistic images, tells of how Vitus, a Christian, was born in Sicily. At a young age, he had the ability to work miracles. His pagan father and the prefect Valerian, however, tried to convince him to renounce his Christian faith. They coaxed him, threatened him, and even resorted to torture. He was imprisoned with his tutor, Modestus, and his nurse, Crescentia, yet the three were miraculously freed by an angel and brought to safety in Lucania. News of Vitus's talents reached the emperor Diocletian, who had a son who suffered from epilepsy. The emperor decided to ask the tiny Vitus for help, and his son was cured. Vitus, however, was still tortured afterward when he refused to offer sacrifices to the Roman gods. An angel freed him once again, yet eventually he, Modestus, and Crescentia were martyred in Lucania.

▲ Veit Stoss the elder, *Saint Vitus in the Furnace*, 1520. Nuremberg, Germanisches Museum.

▶ Lorenzo Lotto, *Madonna with Child and Saints* (detail), 1506–8. Recanati, Pinacoteca Comunale.

Name
Originally Latin, meaning "he who has life within"; it was used by the first Christians to express faith in eternal life

Earthly Life
Fourth century, Lucania (?)

Characteristics and Activity
Miracle worker who was martyred under Emperor Diocletian

Patron
Actors, dancers, epileptics, sheet-metal workers

Special Devotions
Once invoked against lethargy; poisonous animal bites; fear of water; and Saint Vitus's Dance, a nervous disorder

Connections with Other Saints
One of the Fourteen Holy Helpers

Venerated
From Italy to Germany to Bohemia

Feast Day
June 15

Crescentia, Vitus's nurse, is
shown as a saint with a halo
even though she is perhaps
entirely legendary.

Vitus is portrayed as a
young boy. According to
tradition, he was little more
than seven years old.

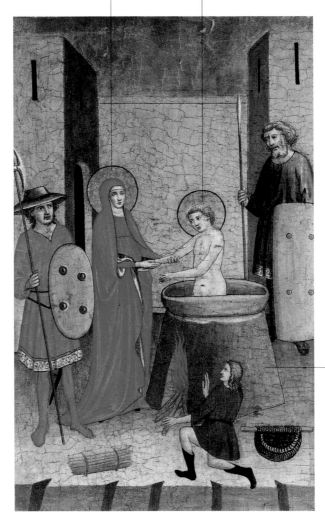

Vitus was
immersed in a
cauldron of boil-
ing pitch during
one of Emperor
Diocletian's
attempts to
torture him. He
emerged from it
unscathed, and it
became his
emblem in art.

▲ Marchigiana School, *Scene from the
Life of Saint Vitus,* from the middle
of the fifteenth century. Vatican City,
Pinacoteca Vaticana.

Wolfgang is typically shown in a bishop's attire, including a miter and pastoral staff. His attributes are a hatchet, because he understood where God wanted him to build a chapel by throwing one from a mountain; a church model, which refers to the hatchet episode; and the Devil, who constantly tormented him during his passionate sermons. He is only rarely shown with a wolf.

Wolfgang

Wolfgang was born in Swabia, in Germany, around A.D. 924. He received a Christian education at the Benedictine monastery of Reichenau on Lake Constance. Early on, he was a teacher at the cathedral school of Trier but then returned, in 965, to a monk's life at the monastery of Einsedeln in Switzerland. He was ordained a priest in 968 and became a missionary in present-day Hungary to the Magyars, who had become sedentary and had ceased raiding. After his mission there, he eventually settled in Regensburg, in Germany, where he was elected bishop in 972. He began by reducing the diocese so that beyond the rivers Regen and Naab, in Bohemia, there could be a Bohemian bishop. He promoted reforms in monastic life and had God's blessing, which he received—according to legend—when relics miraculously moved from one part of an altar to another. Wolfgang died on October 31, 994, during a missionary trip to Puppingen, in present-day Austria.

▶ Michael Pacher, *The Argument of Saint Wolfgang*, from the *Altar of the Fathers of the Church*, ca. 1480. Munich, Alte Pinakothek.

Name
Originally Germanic, meaning "walks like a wolf"

Earthly Life
About A.D. 924–994; Germany, Switzerland

Characteristics and Activity
Benedictine monk who dedicated himself to preaching and became bishop of Regensburg

Patron
Woodcutters, since his attribute is a hatchet; carpenters

Special Devotions
Invoked against gout, abrasions, and skin inflammations

Venerated
Concentrated in Bohemia

Feast Day
October 31

Michael Pacher, *The Devil* ▲ *Holds the Missal for Saint Wolfgang* (detail), from the *Altar of the Fathers of the Church*, ca. 1480. Munich, Alte Pinakothek.

A bishop wears an ecclesial hat, or miter, and a richly decorated cope during a liturgical celebration.

Two raised fingers, according to tradition, indicate a precise kind of benediction.

The crosier is a bishop's pastoral staff, a symbol of his task of shepherding souls.

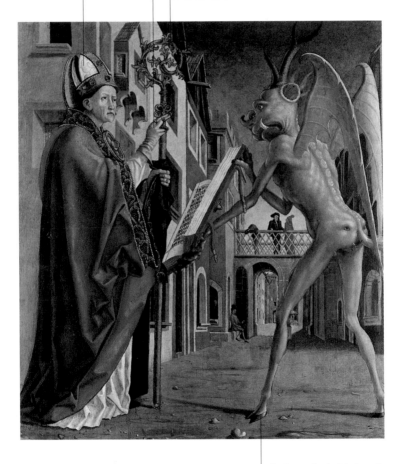

▲ Michael Pacher, *The Devil Holds the Missal for Saint Wolfgang* (detail), from the *Altar of the Fathers of the Church*, ca. 1480. Munich, Alte Pinakothek.

The demon that had frightened the entire congregation during one of Wolfgang's well-attended sermons is now forced to hold the book for the bishop.

Zeno wears a bishop's robes and a miter and carries a pastoral staff; his attributes are fishing gear and one or two fish. In Dialogues, *Gregory the Great narrates how Zeno used to fish in the Adige River.*

Zeno
of Verona

Zeno was originally from Africa, most likely from Mauritania. Given the influence of African writers on his own texts, he was probably educated there. He eventually founded the first church in Verona, where he was bishop from A.D. 362 until his death in 372. The saint was quite committed to facing ongoing challenges from paganism and the Arian heresy, which were causing disorder in the Verona church. In his sermons, he discussed and rebutted Arianism a number of times, as evidenced in his writings—close to a hundred sermons of various lengths that demonstrate his intense pastoral activity in Verona. It seems that his primary goal was to establish and reinforce the faith of the people and clergy by being an example of humility and charity, thus encouraging them to serve the poor. Zeno founded a number of churches and had great esteem for those who practiced celibacy. For this reason, within his expansive vision of the church, he gave special attention to consecrated virgins and to convents.

Name
Originally Greek, meaning "divine," "of Zeus"

Earthly Life
Fourth century; Africa (?), Verona

Characteristics and Activity
First bishop of Verona

Patron
Fishermen

Special Devotions
He was invoked to help infants to walk and speak, and against floods

Venerated
Since the middle of the fifth century

Feast Day
April 12

Renato Birolli, *Saint Zeno* ▲ *the Fisherman* (detail), 1931. Milan, Civico Museo d'Arte Contemporanea.

On the following pages:
Albrecht Dürer, *Adoration of the Most Holy Trinity* (detail), 1511. Vienna, Kunsthistorisches Museum.

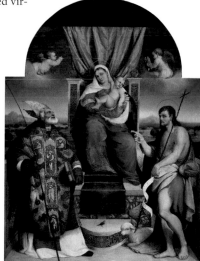

► Jacopo Bassano, *Madonna and Child and Saints John the Baptist and Zeno* (detail), 1538. Borso del Grappa, Parish church.

Appendixes

Sources

The iconography of the saints has taken its own path in the course of art history, drawing from hagiology—narratives and catalogues of the saints—and its canonical or apocryphal sources.

Bible
The Bible is the revealed text of Christianity, made up of the New Testament and the Old Testament.

Apocryphal Texts of the New Testament
Written between the second and ninth centuries, these texts are not considered divinely inspired or historically reliable and therefore are not part of the canon. They narrate stories of Jesus' childhood, the Passion, the Resurrection, the life of Mary and Joseph, the acts of the apostles after the Ascension, and the Apocalypse. In the East they were widely read during the Middle Ages, while in the West they were almost completely ignored, although they were referred to in later writings.

Acts of the Martyrs (*Acta Martyrum*)
These are the most ancient sources for hagiology, official records of the trials of early Christian martyrs that were the basis for their sentences and execution.

Passions of the Martyrs (*Passiones Martyrum*)
These religious and edifying texts come in two varieties: one is based on historical elements and the other on imagination, a "hagiographic romance."

Martyrologies
These are catalogues of martyrs and saints that are arranged according to the calendar of their feasts and anniversaries. They include the saint's story, a description of their death, and the identification of their persecutors. One of the earliest known was written in the fifth century (the Syriac Martyrology); the Hieronymian Martyrology (fifth and sixth centuries) has been the foundation for all the martyrologies of the Middle Ages and the modern world.

Historical Martyrologies
These are compilations of the ancient martyrologies that include a simple remembrance of martyrs with summaries or abstracts of their passion or life.

Roman Martyrology
A revision of previous martyrologies, it was compiled after the Council of Trent in 1584 by Pope Gregory XIII and is continually being brought up to date.

The Golden Legend
Jacobus de Voragine wrote this incredibly popular hagiographic text between 1257 and 1267. It was followed, albeit with less success, by Bernard Gui's *Speculum Sanctorale* in 1329 and Peter Calo's *Legendarium* in 1348.

Lives of the Saints
Ever since the Middle Ages, biographies of the saints have multiplied, such as Thomas de Celano's work on Saint Francis. These also include autobiographies by the saints themselves, and continue to this day.

Acta Sanctorum
John van Bolland began this compilation of the lives of the saints in Antwerp in 1643. The Jesuits who continue his work are called "Bollandists."

Symbols and Attributes

Acacia branch: Acacius
Alms: Elizabeth of Hungary,
 Laurence
Ampoules: Januarius
Anchor: Clement, Nicholas,
 Rose
Angel: Bonaventure, Matthew
Apron of roses: Elizabeth of
 Hungary
Arrows: Christina, Sebastian,
 Teresa, Ursula
Aspergillum: Martha
Backpack: James
Banner: Florian
 White with a red cross:
 Ursula
 with a white lily: Alexander
Baptismal font: Sylvester
Beehive: Bernard
Bees: Ambrose, Bernard
Bell: Anthony Abbot
Bible: Romuald
Billhook stuck in his head:
 Peter Martyr
Boat: Peter
Book: Albert, Basil, Benedict,
 Bernard, Bonaventure,
 Bridget, Catherine of Siena,
 Gregory, Ivo, James,
 Jerome, John the
 Evangelist, Laurence, Luke,
 Mark, Matthew, Nicholas,
 Paul, Peter, Stephen,
 Vincent Ferrer
 of the Rule: Clare, Monica,
 Nicholas of Tolentino,
 Scholastica
Bowl, baptismal: Francis
 Xavier
Boy: Raphael
Bread: Frances, Nicholas

Basket of: Elizabeth of
 Hungary
Three loaves of: Mary of
 Egypt
Breasts, severed: Agatha
Bucket of water: Florian
Bull: Sylvester, Thomas
 Aquinas
 Winged bull: Luke
Bundle of sticks: Benedict
Candle: Blaise
 Lit candle: Agatha, Bridget
Cane: Benedict
 T-shaped: Anthony Abbot
Cape: Martin
Chains: Leonard
Chalice with snakes: Benedict,
 John the Evangelist
Child Jesus in their arms:
 Cajetan, Rose
Child Jesus sitting on a book:
 Anthony of Padua
Child Jesus on his back:
 Christopher
Child with a shell: Augustine
Children
 Epileptic: Valentine
 Three in a washtub: Nicholas
Column: Alexander
Comb for carding wool: Blaise
Cope over a Franciscan habit:
 Louis of Anjou
Cowl, white: Benedict
Cross: Helen, Philip
 of an abbot: Maurus
 with green leaves: Bruno
 on a staff: John the Baptist
 X-shaped: Andrew
Crow: Paul the Hermit
 with bread in its beak:
 Benedict

Crown: Barbara, Bridget,
 Catherine of Alexandria,
 Elizabeth of Hungary,
 Louis of Anjou, Louis of
 France, Ursula
Crown of martyrdom: the
 Four Crowned Martyrs
Crown of thorns: Acacius,
 Louis of France, Rose
Crucifix: Bonaventure, Bruno,
 Catherine of Siena, Clare,
 Francis Xavier, Jerome,
 Margaret of Antioch,
 Margaret of Cortona,
 Mary of Egypt, Mary
 Magdalene, Monica,
 Nicholas of Tolentino,
 Rosalia, Theodore
Crutch: Maurus
Dagger
 in the chest: Peter Martyr
 in the heart: Justina
Dalmatic: Laurence, Stephen
Demon: Romuald, Wolfgang
 in chains: Bernard
Doe, wounded: Giles
Dog: Roch
 Black and white: Dominic
 White: Bernard
Dove: Basil, Gregory,
 Scholastica, Teresa,
 Thomas Aquinas
Dragon: George, Justina,
 Margaret of Antioch,
 Martha, Michael, Philip,
 Sylvester
Eagle: John the Evangelist
Empress: Helen
Epileptic child: Valentine
Eucharistic host: Bernard
Eyes on a plate: Lucy

Falcon: Bavo
Fish: Andrew, Zeno
Fishing nets: Andrew
Flame: Simon Stock
held: Vincent Ferrer
Fleur-de-lis: Louis of Anjou,
 Louis of France
Flowers: Dorothy
Foundlings: the Innocents
Furnace: Erasmus, Vitus
bull-shaped: Eustace
Girdle: Thomas the Apostle
Globe
Earthly globe underfoot:
 Bruno
Gridiron: Laurence
Guardian angel: Frances
Habits
of an abbot: Benedict
Augustinian: Monica,
 Nicholas of Tolentino
Benedictine: Giles, Romuald,
 Maurus, Scholastica
of a bishop: Augustine,
 Erasmus, Giles, Januarius,
 Nicholas, Thomas Becket,
 Valentine, Wolfgang, Zeno
Black with a white veil:
 Frances
of a cardinal: Charles
 Borromeo, Jerome
Carmelite: Simon Stock,
 Teresa
Cistercian: Bernard
*of a cleric (long, black
 cassock)*: Cajetan, Ivo,
 Ignatius
of a deacon: Laurence,
 Stephen

Dominican: Dominic,
 Thomas Aquinas, Vincent
 Ferrer
Franciscan: Elizabeth of
 Hungary, Francis, Louis of
 Anjou, Margaret of
 Cortona
Papal: Gregory, Leo
of the Poor Clares: Clare
of a priest: Francis Xavier,
 Valentine
of palm leaves: Paul the
 Hermit
Hair, long: Agnes, Mary of
 Egypt, Mary Magdalene
Halberd: Matthew
Hat: James
Cardinal: Bonaventure,
 Jerome
Pilgrim: Francis Xavier
Hatchet: Wolfgang
Head
held in hands: Dionysius
wound: Peter Martyr
Heart
shot with arrows: Augustine
burning: Anthony of Padua,
 Augustine, Francis Xavier
with a cross: Bridget
with a dagger: Justina
with thorns: Ignatius
winged: Cajetan
Horn, hunting: Cornelius
Horn, unicorn: Agatha
Indians: Francis Xavier
Jar: Mary Magdalene
Keys: Peter, Petronilla
Bunch of keys: Martha
Knife: Bartholomew, Christina

Knight with a crucifix: Eustace
Lamb: Agnes, John the Baptist
Lamp: Clare
Lance: Florian, George,
 Michael
Letter: Alexis
Lily: Aloysius Gonzaga,
 Anthony of Padua, Cajetan,
 Catherine of Siena, Clare,
 Dominic, Francis Xavier,
 Gabriel, Nicholas of
 Tolentino, Rose
Lion: Januarius, Jerome, Mary
 of Egypt, Paul the Hermit
Winged lion: Mark
Medicine jars: Cosmas and
 Damian
Millstone: Christina, Florian
Miter: Bonaventure, Bruno,
 Nicholas, Thomas Becket,
 Wolfgang, Zeno
Miter at his feet: Bernard
Three miters: Bernardino
Model of a church: Wolfgang
Monogram of Christ (IHS):
 Bernardino, Bridget,
 Ignatius, Teresa
Monstrance: Bonaventure,
 Clare
Motto
Humilitas: Charles
 Borromeo
*Omnia ad maiorem Dei
 gloriam*: Ignatius
Musical instruments: Cecilia
Nails: Erasmus
of the Cross: Helen
Noose around his neck:
 Charles Borromeo

Olive branches: Bruno
Palm branch: all martyrs
Papal tiara: Clement, Gregory,
 Leo
Pastoral staff (crosier):
 Ambrose, Nicholas,
 Thomas Becket, Valentine,
 Wolfgang, Zeno
of an abbot: Benedict,
 Bernard
of an abbess: Clare
Peacock quill: Barbara
Pen, or quill: Albert, Thomas
 Aquinas
 with inkwell: Bridget
 of peacock feathers: Barbara
Pig: Anthony Abbot, Blaise
Pilgrim: James, Roch
Pincers: Agatha, Apollonia
Pitcher: Elizabeth of Hungary
Princess: Elizabeth of Hungary,
 Ursula
Puppy: Margaret of Cortona
Raven: Erasmus
Riding whip: Ambrose
Rooster: Peter
White rooster: Vitus
Rosary: Cajetan
Roses: Rosalia, Rose
 Apron of: Elizabeth of
 Hungary
Saw: Simon
Scale: Maurus, Michael
Scapular: Simon Stock
Scepter: Louis of Anjou, Louis
 of France
Scholar: Ivo
Scourge: Benedict
Scroll: Ivo

Shell: James
Ship: Nicholas
Shovel: Maurus
Shroud: Veronica
Skin, flayed: Bartholomew
Skull: Bruno, Cajetan, Jerome,
 Margaret of Cortona,
 Mary of Egypt, Mary
 Magdalene, Paul the
 Hermit, Rosalia
Soldier: Acacius, Alexander,
 Florian, Martin, Maurice,
 Michael, Theodore
Sores: Job
 on his leg: Roch
Spheres, three golden: Nicholas
Spoon, wooden: Martha
Square, carpenter's: Joseph,
 Thomas
Staff: Alexis, Christopher,
 James, Roch
Stag with crucifix in its horns:
 Eustace
Stairs: Alexis, Romuald
Star
 on his chest: Nicholas of
 Tolentino
 on his forehead: Dominic
Stigmata: Catherine of Siena,
 Francis
Stones: Stephen
 Building stone: Thomas
 Aquinas
 Sun on his chest: Thomas
 Aquinas
Surgical instruments: Cosmas
 and Damian
Sword: Acacius, Bavo,
 Catherine, Cornelius,

James, Martin, Maurice,
 Michael, Paul, Thomas
 Becket
T-shaped cane: Anthony Abbot
Teeth, extracted: Apollonia
Tools
 Carpenter's: Joseph, Thomas
 Farrier's: Eligius
 Goldsmith's: Eligius
 Sculptor's: the Four Crowned
 Martyrs
Torch, lighted: Agatha,
 Dominic
Tower: Barbara
Unicorn: Justina
 Horn: Agatha
Wheel: Catherine of
 Alexandria
Windlass: Erasmus

Protectors and Patrons

Academics: Thomas Aquinas
Accountants: Matthew
Actors: Vitus
Advertisers: Bernardino
Ambassadors: Gabriel
Animal breeders: Mark
Animals:
 Domestic animals: Anthony Abbot, Sylvester
 Horned animals: Cornelius
 Yard animals: Brigid
Archaeologists: Jerome
Archers: George, Sebastian
Architects: Barbara, Benedict, Thomas
Armenia: Bartholomew
Artisans: Joseph
Artists: John the Evangelist, Thomas
Astronomers: Dominic
Athletes: Christopher, Sebastian
Bailiffs: Ivo
Bakers: Elizabeth of Hungary
Bankers: Matthew
Barbers: Cosmas and Damian, Louis of France
Barren women: Andrew, Anthony of Padua, Elizabeth, Leonard, Veronica
Bartenders: Dorothy
Basket makers: Anthony Abbot, Paul
Beekeepers: Ambrose, Bernard
Bees: Ambrose
Beggars: Alexis
Bell ringers: Barbara
Benedictine nuns: Justina
Bird catchers, fowlers: John the Baptist
Blacksmiths: Brigid , Eligius, Leonard

The blind: Michael
Blood donors: Januarius
Boaters: Clement
Boilermakers: Maurus
Bookbinders: Bartholomew
Booksellers: Jerome, John the Evangelist, Laurence, Thomas Aquinas
Boxers: Bernardino
Bread: Nicholas of Tolentino
Builders: Barbara, Peter, the Four Crowned Martyrs, Sylvester, Stephen, Thomas, Vincent Ferrer
Butchers: Anthony Abbot, Bartholomew
Cabinetmakers: Joseph
Candle makers: Bernard
Captains: Clement, Christopher
Carders of wool: Anne, Blaise
Carpenters: Joseph, Louis of France, Thomas, Wolfgang
Castaways: Anthony of Padua, Catherine of Alexandria
Catechists: Charles Borromeo
Chastity: Thomas Aquinas
Chefs: Laurence, Martha
Chemists: Benedict
Children: Clement
 Abandoned: the Innocents
 with convulsions: Anthony of Padua, Cornelius, Scholastica
Cleaners: Anne, Clare, Veronica
Clergy: Charles Borromeo
Clerks: Bonaventure
Climbers: Christopher
Coal workers: Maurus
Cobblers: Peter
Communications workers: Gabriel

Conductors: Christopher
Coopers: Thomas Becket
Cows: Brigid
Cutlers: John the Baptist
Dancers: Vitus
Deacons: Laurence, Stephen
Death, peaceful: Catherine of Siena, Joseph, Michael, Stephen
Dentists: Apollonia, Cosmas and Damian
Diplomats: Gabriel
Distillers: Louis of France
Doctors: Blaise, Cosmas and Damian, Luke
Doorkeepers: Alexis, Peter
Drivers: Christopher, Frances
Dyers: Helen, Maurice
Ecologists: Francis
Economists: Joseph
Electricians: Lucy
Embroiderers: Anne, Clare, Veronica
Engaged girls: Agnes
Engineers: Benedict
England: George
English College in Rome: Thomas Becket
Engravers: Clement
Epileptics: Valentine, Vitus
Europe: Benedict
Exiles: Joseph
Farmers: Bartholomew, Benedict, Blaise, Isidore, Leonard, Margaret of Antioch, Roch
Farriers: Eligius
Fathers: Joseph
Fencers: George, Michael
Fire brigades: Florian, Laurence
Firemen: Barbara, Florian, Laurence

Fishermen: Andrew, Erasmus, Nicholas, Peter, Simon, Zeno
Fish vendors: Andrew, Peter
Florists: Rose
Flower growers: Francis
Forest rangers: Eustace
France: Dionysius, Joan, Louis of France
French Academy: Louis of France
Fruit vendors: Christopher, Leonard
Furriers: Bartholomew
Gardeners: Agnes, Dorothy, Mary Magdalene, Maurus, Rose
Gilders: Clare, Luke
Girls: Ursula
Glass merchants: Anthony of Padua
Glass workers: Laurence, Luke
Goldsmiths: Anne, Eligius, Januarius
Gondoliers: Clement
Good weather: James
Gravediggers: Roch
Guatemala: James
Gunners: Barbara
Haberdashers: Louis of France, Michael
Hairdressers: Cosmas and Damian, Louis of France, Mary Magdalene
Handicapped: Giles, Maurus
Harvest: Mark
Harvesters: Peter
Healers: Brigid
The homeless: Joseph
Horses: Giles, Hippolytus
Hosts: Laurence, Martin
Hoteliers: John the Baptist, Julian

House painters: Bartholomew
Hunters: Eustace
Husbands: George
Hypochondriacs: Job
Infants: Nicholas of Tolentino
Invalids: Roch
Investigators: Peter Martyr
Italy: Francis, Catherine of Siena
Journalists: Gabriel
Judges: Ivo, Thomas
Junk collectors: Anne
Jurists: Ivo
Knights, knighthood: George, John the Evangelist
Laborers: Isidore
Lathe workers: Anne
Latin America: Rose
Lawyers: Ivo
Leather workers: John the Baptist
Lepers: Giles, Job
Lost items: Anthony of Padua, Helen
Lovers and those in love: Valentine
Luthiers: Cecilia
Magistrates: Ivo
Maids: Martha
Manufacturers of
 bells: Agatha
 bricks: Vincent Ferrer
 brooms: Anne
 brushes: Thomas Becket
 buttons: Gregory
 glass: Anthony of Padua, Laurence, Luke, Mark
 gloves: Anne, Bartholomew, Mary Magdalene
 guns: Barbara
 keys: Peter
 lace: Anne
 mattresses: Blaise

 mats: Paul the Hermit
 nails: Helen
 pencils: Thomas Aquinas
 perfume: Mary Magdalene, Nicholas
 rope: Francis, Paul
 sausages: Anthony Abbot
 scales: Michael
 socks: Anne, James
 spices: Michael
 starch: Charles Borromeo
 tapestries: Francis, Sebastian
 tiles: Vincent Ferrer
Manuscript illuminators: Luke
Marble workers: Clement, Louis of France
Maternity: Nicholas of Tolentino
Mentally ill: Leonard
Merchants: Francis, Michael, Martin
Messengers: Gabriel
Midwives: Cosmas and Damian
Milkmen: Brigid
Milliners: Catherine of Alexandria, Clement, James
Miners: Anne, Barbara
Missionaries: Francis Xavier
Mothers: Monica
Mothers in childbirth: Anne, Elizabeth, Erasmus, Leonard, Monica
Mountain climbers: Christopher, Maurice, Petronilla
Movers: Christopher
Musicians: Cecilia, Gregory, Leo
Nannies: Agatha, Catherine of Alexandria, Giles

Naturalists: Albert
Navigators: Anne, Nicholas
Newlyweds: Dorothy
Notaries: Catherine of
Alexandria, Ivo, Luke,
Mark
Nurses: Agatha (male nurses),
Catherine of Siena
Nursing women: Catherine of
Alexandria
Nutritionists: Martha
Ophthalmologists: Lucy
Opticians: Mark
Orators: Catherine of
Alexandria, Dominic
Orders
 Augustinian: Nicholas of
 Tolentino
 Benedictine: Scholastica
 Camaldolese: Romuald
 Carmelite: Simon Stock,
 Teresa
 Cistercian: Bruno
 Dominican friars: Peter the
 Martyr
 Dominican nuns: Rose
 Franciscan: Louis of Anjou
 Franciscan Third Order:
 Louis of France
 Jesuit: Ignatius
 Order of Saint Louis: Louis
 of France
 Ursuline: Ursula
Orphans: Anthony of Padua
Oxen: Sylvester
Pastry chefs: Laurence
Pavers: Roch, Stephen
Peru: Rose
Pharmacists: Cosmas and
Damian, James, Roch
Philippines: Rose

Philosophers: Catherine of
Alexandria
Photographers: Veronica
Pilgrims: Bridget, Christopher,
James, Jerome, Nicholas,
Roch
Plasterers: Bartholomew
Poets: Brigid, Cecilia,
Francis
Police: Michael
The poor: Ivo, Laurence,
Nicholas, Roch
Popes: Gregory
Porters: Bonaventure,
Christopher
Portugal: Anthony of Padua
Postal workers: Christopher,
Gabriel
Preachers: Bernardino,
Dominic
Pregnant women: Anthony of
Padua, Margaret of Antioch
Printers: Augustine
Prison guards: Hippolytus
Prisoners: Anthony of Padua,
Leonard, Roch
Prosecutors: Ivo, Joseph
Protection against
 backache: Laurence
 blindness: Louis of France
 breast diseases: Agatha
 colic: Erasmus
 common colds: Cosmas and
 Damian
 curses, evil omens, bad spells:
 Ignatius
 dangers from travel:
 Petronilla
 deafness: Louis of France
 epilepsy: Cornelius, Vincent
 Ferrer

fever: Nicholas of Tolentino,
Petronilla
fires: Agatha, Florian,
Laurence
floods: Florian, Zeno
gout: Maurus, Wolfgang
hail: Christopher
headaches: Catherine of
Alexandria, Catherine of
Siena, Peter Martyr,
Stephen, Vincent Ferrer
heart disease: Teresa
hemorrhages: Bernardino
hoarseness: Bernardino
hurricanes: Christopher
lethargy: Vitus
lightning bolts: Barbara,
Scholastica, Thomas
Aquinas
the plague: Bruno, Catherine
of Siena, Charles
Borromeo, Francis Xavier,
Nicholas of Tolentino,
Roch, Rosalia, Sebastian
poisonous animal bites: Vitus
rabid animal bites: Vitus
rheumatism: James,
Maurus
Saint Vitus's Dance: Vitus
shingles (herpes zoster):
Anthony Abbot
skin irritations: Wolfgang
snakebites: Paul
sore throat: Blaise
storms: Helen, Margaret of
Antioch, Paul, Scholastica
sudden or unexpected death:
Barbara, Christopher
toothaches: Apollonia,
Christopher
violent death: Veronica

volcanic eruptions: Agatha
whooping cough: Bavo
Radio: Gabriel, Joan
Radio employees: Gabriel
Radio operators: Gabriel
Railway workers: Christopher
Rain: Scholastica
Recruits: Anthony of Padua,
 Theodore
Repentant sinners: Margaret of
 Cortona, Mary of Egypt,
 Mary Magdalene
Roman Catholic publishing:
 Paul
Rotisserie owners: Laurence
Russia: Nicholas
Sacred music: Leo
Sailors: Clement, Erasmus,
 Francis Xavier, Nicholas of
 Tolentino
Sandpit workers: Bernard
Scholars: Jerome
Schools: Thomas Aquinas
Scientists: Albert
Scotland: Andrew
Scouts: George
Sculptors: Anne, the Four
 Crowned Martyrs
Seamstresses: Dominic
Servants: Martha
Shepherds: Blaise
Sight: Augustine, Jerome, Lucy,
 Thomas
Silkworm breeders: Job
Singers: Cecilia
Soldiers: George, Ignatius,
 Martin of Tours, Maurice,
 Theodore
Souls in Purgatory: Nicholas
 of Tolentino, Teresa
Spain: James, Teresa

Speleologists: Benedict
Spinners: Catherine of
 Alexandria
Stamp collectors: Gabriel
Stationers: John the Baptist
Stonecutters: Blaise, Clement,
 the Four Crowned
 Martyrs, Stephen, Sylvester,
 Thomas
Strikers (soccer): Stephen
Students: Aloysius Gonzaga,
 Jerome, Nicholas, Thomas
 Aquinas, Ursula
 of the natural sciences: Albert
Surgeons: Cosmas and
 Damian, Luke, Roch
Surveyors: Thomas
Sweden: Bridget
Swiss Guards: Maurice
Tailors: Anne, Bartholomew,
 Catherine of Alexandria,
 John the Baptist, Martin
Tanners: Bartholomew
Tax collectors: Matthew
Teachers: Charles Borromeo,
 Gregory
Teenagers: Michael
Telecommunications: Gabriel
Telegraph: Joan
Television: Clare, Gabriel
Television advertisers: Gabriel
Tellers: Matthew
Terminally ill: Acacius,
 Alexis, Anne, Margaret
 of Antioch
Theatines: Cajetan
Theologians: Augustine,
 Bonaventure, John the
 Evangelist, Paul, Thomas
 Aquinas
Throat doctors: Blaise

Tinsmiths: Vitus
Tourists: Francis Xavier
Traffic police: Sebastian
Translators: Jerome, Mark
Travelers: Bridget, Christopher,
 Julian, Roch
Trips: Michael
Typesetters: John the
 Evangelist
Universities: Thomas Aquinas
Upholsterers: Teresa
Venice: Mark, Theodore
Virgins: Agnes
Wainwrights: Catherine of
 Alexandria
Wardrobe workers: Veronica
Watchmakers: Peter
Wax workers: Ambrose
Weapons instructors: Michael
Weavers: Bernardino,
 Bonaventure, Louis of
 France
Wind-instrument players:
 Blaise
Women: Monica
Women seeking husbands:
 Anthony of Padua
Woodcutters: Wolfgang
Wool merchants: Bernardino
Workers: Joseph
Writers: John the Evangelist,
 Luke
Young people: Aloysius
 Gonzaga

Artist Index

Photographic References

Sergio Anelli/Electa, Milan
The Electa Archive, Milan
The Photo Archive of the Musei Capitolini, Rome
The Scala Group Archive, Antella (Florence)
Arthotek, Weilheim
Cameraphoto, Venice

The Ministero per i Beni e le Attività Culturale
kindly allowed images from the following entities to
be reproduced:

The Soprintendenza per il patrimonio storico
 artistico e demoetnoantropologico of Brescia,
 Cremona, and Mantua;
The Soprintendenza per il patrimonio storico
 artistico e demoetnoantropologico of Milan,
 Bergamo, Como, Lecco, Lodi, Pavia, Sondrio,
 and Varese;
The Soprintendenza per i Beni Architettonici e del
 Paesaggio of Milan;
The Soprintendenza per il patrimonio storico artis-
 tico e demoetnoantropologico of Piedmont and
 Turin; and the Soprintendenza per il patrimonio
 storico artistico e demoetnoantropologico of
 Venice.

The editor would also like to thank the many pho-
tographic archives of museums and the public and
private entities that provided photographic material.